Acclaim for *Irene Vilar's*

THE LADIES' GALLERY

"A heartrending and dramatic literary debut, wherein Vilar reveals the dark side her parents always tried to suppress."
—*Miami Herald*

"A beautiful memoir, humorous and compassionate."
—*Newsday*

"These are postcards from the edge . . . heartbreaking . . . funny . . . political . . . breathtakingly beautiful."
—*Detroit Free Press*

"This memoir introduces us to a writer bound to make an impact. . . . It is a mark of Vilar's art that her story seems warm and alive."
—*Boston Globe*

"Startling, raw, and affecting, a painful exercise in which memoir as therapy becomes memoir as art."—*Philadelphia Inquirer*

"The three women portrayed in [*The Ladies' Gallery*] come alive passionately. . . . There's a tropical elegance embedded in her prose, one which gives great depth to her characters."
—*Village Voice*

THE LADIES' GALLERY

THE LADIES' GALLERY

a memoir of family secrets

Irene Vilar

TRANSLATED FROM
THE SPANISH BY *Gregory Rabassa*

FOREWORD BY *Carlin Romano*

other press new york

Other Press edition 2009
Copyright © 1996 Irene Vilar

Originally published in hardcover in the United States as *A Message from God in the Atomic Age: A Memoir* by Pantheon Books, a division of Random House, Inc., New York, in 1996. Published in paperback in the United States by Vintage Books, a division of Random House, Inc., New York, and simultaneously in Canada by Random House of Canada Limited, Toronto, in 1998.

A portion of this work was originally published in *Points of Contact* (Fall/Winter 1995). Grateful acknowledgment is made to Schocken Books for permission to reprint an excerpt from "The Siren" by Franz Kafka, from *Parables and Paradoxes*. Copyright © 1946, 1947, 1948, 1953, 1954, 1958, and renewed 1975 by Schocken Books Inc. Reprinted by permission of Schocken Books; published by Pantheon Books, a division of Random House, Inc.

Production Editor: Yvonne E. Cárdenas
Text design revisions for this edition by Simon M. Sullivan

10 9 8 7 6 5 4 3 2 1

A portion of the proceeds from the sale of this book will go to The Sisterhood is Global Institute (www.sigi.org) sisterhood is global institute

LIBRARY OF CONGRESS CATALOGING-IN-PUBLICATION DATA
Vilar, Irene, 1969-
 [Message from God in the atomic age]
 The ladies' gallery : a memoir of family secrets / Irene Vilar ; translated from the Spanish by Gregory Rabassa ; foreword by Carlin Romano.—Other Press ed.
 p. cm.
 Originally published: A message from God in the atomic age. New York : Pantheon Books, 1996.
 ISBN 978-1-59051-323-1 (pbk. reprint)—ISBN 978-1-59051-373-6 (e-book)
 1. Mentally ill women—Biography. 2. Puerto Rican women—Biography. 3. Mentally ill—Family relationships—Case studies. 4. Vilar, Irene, 1969—Mental health. 5. Lebrón, Lolita, 1919—Mental health. 6. Mendez, Gladys—Mental health. I. Rabassa, Gregory. II. Title.
 RC464.A1V55 2009
 616.890082097295—dc22

 2009002609

This memoir is a true story. However, certain names and identifying characteristics have been changed to protect the privacy of the individuals portrayed in this book. The author has also reconstructed conversations to the best of her recollection.

To the memory of my brother
Miguel Vilar Méndez
1961–1994
(truly one of *the last of the just,*
though we were blind)

and
To Dan

The Sirens, too, sang that way. It would be
doing them an injustice to think that they wanted
to seduce; they knew they had claws and sterile wombs, and
they lamented this aloud.

FRANZ KAFKA

FOREWORD
by Carlin Romano

The memoir depends on memory, but not only on that faulty tool. Consider what a Muse of Perfect Memoir—let's call her "Vera"—might require of earthly practitioners.

Total recall, for one thing. Fierce honesty. Astounding reportorial abilities that suggest Tom Wolfe on steroids. Extraordinary empathy that recognizes other people's sorrows and dreams, even as such people pass through the author's scenes as "others."

Add a gift for narrative panache. A philosopher's nose for key moral concepts embedded in the tale. A historian's skill at identifying convincing cause and effect. Modesty about the importance of one's daily experiences, lest the memoir become a calendar-book emptied onto paper.

Given such demands of perfection, we might expect would-be self-scrutinizers to place their diaries back in the

drawer. Then there's the recent assault by media society on memoirs for misrepresenting facts and personal histories, for settling scores, for confusing reality and fiction. Put all the factors together and it's remarkable that the genre continues to expand, both quantitatively as part of American publishing and imaginatively as part of literature.

Yet it may be that the gap we perceive between Vera's demands and what mere mortals produce is making us kinder as a literary culture. We may be more inclined these days to take every memoir on its own terms, the way we've always greeted each novel. The day seems closer when the literary world may define *memoir* as "a fiction the author wishes to believe about his or her life, facts (if not batteries) included." So long as the nonliterary see memoir as the natural spouse of nonfiction—a genre whose wedding vow to its partner is to live up to Vera's rules—that evolution will of course remain slow.

This republication of Irene Vilar's absorbing 1996 work, originally issued as *A Message from God in the Atomic Age* and largely finished by Vilar by the time she was twenty-one, enters the now fluid state of its genre with explosive elements for all who care about the form. For even after James Frey, whose delegitimized, de-Oprahfied reputation shattered into his book title (*A Million Little Pieces*), and Augusten Burroughs, whose *Running with Scissors* sliced away the separation between a real and invented psychiatrist, and Nasdijj, that Navajo memoirist who wasn't a Navajo, we've not quite seen this before.

That is, a superbly evocative tale, a first book translated by no less than Gregory Rabassa, a book already transmuted by a title change in its paperback edition, now outed by its own author as less than the truth. Is it still authentic, as every drop of blood is the blood of a person, but not all of that person's blood?

In her new memoir, *Impossible Motherhood: Testimony of an Abortion Addict*, published simultaneously with this edition by Other Press, Vilar, now 40, calls *The Ladies' Gallery* "proof of the lie I have at times made of my life." She admits that her "clear-cut tale of three generations of women in one family (my grandmother, mother, and myself)," a trio "intent on self-destruction against the backdrop of political struggle," leaves out the "transference horror script I lived out with the man I loved." *The Ladies' Gallery*, she says now, is "true, but it could have been truer."

Every reader of the wrenching story between these covers should thus know what she or he is getting into.

When *A Message from God in the Atomic Age* appeared in 1996, the acclaim for this poignant, stream-of-consciousness meditation by the then twenty-seven-year-old native of Puerto Rico, granddaughter of the Puerto Rican nationalist Dolores "Lolita" Lebrón, resonated across the literary landscape. The original title referred to a religiously inspired memo Lebrón had sent to President Eisenhower. This critic, in the *Philadelphia Inquirer*, called *Message* "startling, raw, and affecting, a painful exercise in which memoir as therapy becomes memoir as art." The *St. Louis Post-Dispatch* saw "a lesson in acquiring spiritual grace and understanding." The *Village Voice* detected "a tropical elegance" in Vilar's prose. Yet there were reservations, too. *The Independent* compared Vilar's approach to the "self-absorption of a patient in analysis," referring to some of the passages about Vilar's time in hospital psychiatric wards.

The book remains the same, with no major changes by the author. In it, Vilar tells the intertwined story of three women challenged by life— "the Child, the Nymph, the Old Lady"— whom she compares to Homer's "sirens." One critic described

Vilar's troika as "enchantresses and destroyers," though "the main people they destroy tend to be themselves."

The crucial family history begins with Vilar's maternal grandmother, Lolita Lebrón, an activist for Puerto Rican independence. On March 1, 1954, she famously climbed the stairs to the visitors' gallery of the U.S. Congress and, wrapped in the Puerto Rican flag, opened fire with three nationalist compatriots, shooting (but not killing) five congressmen. "I did not come here to kill," she announced. "I came here to die." For her crimes, the United States sentenced her to fifty-seven years. She served twenty-seven before receiving a pardon from President Carter.

Precisely twenty-three years after the crime, on March 1, 1977, Vilar's troubled mother, Gladys, was being driven back from a son's wedding by her lothario husband of more than twenty years. Eight-year-old Irene sat in the back. Shortly into the trip, Gladys threw herself from the moving car, killing herself at age thirty-seven. She left her daughter with only "a piece of black lace" in her hand from trying to hold her mother back.

Eleven years later, Vilar, by then a troubled eighteen-year-old senior at Syracuse University who'd precociously begun college three years before, tried to commit suicide twice during one week—once by cutting her wrists, once by swallowing a bottle of Tylenol with vodka and turning on the gas. Diagnosed as an "acutely psychotic individual" and having survived with the help of "bright-colored pills" and a hospital stay, she began this lyrical account of her life—a tale of suicidal depression, of a girl of Semitic lineage born in Arecibo, Puerto Rico, of an island she describes as "not big enough, not small enough. Not lucky enough!"

In *The Ladies' Gallery*, Vilar alternates scenes from her earlier life, sometimes virtual reveries, with finely observed moments from, and reflections about, her three days in Syracuse's Hutchings Psychiatric Hospital and forty days in University Hospital. In the second hospital, after her suicide attempts, she reads Carl Jung, Melanie Klein, D. W. Winnicott, and tries to make sense of her predicament. The narrative oscillation resembles that in a favorite autobiography she read growing up, Jacobo Timmerman's *Prisoner Without a Name, Cell Without a Number*, in which the action shifts between Timmerman's prison experiences as a survivor of the 1976–83 Argentine dictatorship and his earlier life.

Vilar hurtles from a colonized island and home surrounded by sugarcane to challenging new settings. First she arrives at the experimental Boynton School in Orford, New Hampshire, where she dreams of becoming a saint. Then she enters a convent school in Castellón de la Plana, Spain, where she mulls over her broader family tree of aunts and uncles. Finally it's on to Syracuse University. The story reads as if someone on high—a Muse of Suffering, perhaps—had ordered torturous struggle with one's homeland, one's emotions, one's unnerving family, to play out.

In this book, the young woman we meet treats herself, like a Sartrean heroine, as a subject who resists being made an object by her unhappy history. Having lost her mother and a brother to tragedy, she's left with her incorrigible ladies'-man father, nicknamed by locals "the Rooster," who married her mother when Gladys was only fifteen. Another brother becomes a heroin addict. In reaction, Vilar grasps at safety-valve lives. Throughout, we feel the battle with her history, her profound sympathy for her mother. ("How can it be that at the age of thirty-six a

beautiful and intelligent woman, with the vitality of the latitude in which she'd been born, fades away like this and no one notices?") And we hear of Vilar's resistance to her first stepmother, Blanquita, who tries to erase Gladys from their home.

There are many moments from Vilar's childhood: the comfort of her dog, Lassie; her brothers calling her Dumbo; Blanquita making a bonfire of her mother's clothes. Vilar isn't sure who she is. "Hispanic female?" she asks early on. Intimations of low self-esteem, of the belief that everything is "a big failure" in her family, surface. There are foreshadowings of this self-described "mini Madame Bovary" and her attraction to older men in her attention to the New Hampshire school's founder, Mr. Boynton, then seventy-four. (She notes how "the timid discovery of my own sensuality" took place in New Hampshire, then writes, in the hospital, "I would spend many nights thinking about Mr. Boynton's strong hands," which she'd witnessed in action—she'd watched him milking a cow.)

The Ladies' Gallery does not disguise Vilar's core impulses to the extent she thinks when she offers her broad apologies in *Impossible Motherhood*. Already, to her credit, she confesses in her first book to believing that she has nothing to give a man except her memories and "my body." She notes a doctor's comment that "I'm very open, I don't establish boundaries." She betokens her resistance to giving birth—the future leitmotif of *Impossible Motherhood*—writing of "the invasion in my stomach." She admits, "The womb is something that I'd throw into the garbage if I could," just as she concedes, "to defend abortion is absurd."

The college scenes of fighting with her boyfriend when he reads her diary, then downing fifteen Nodoz after they have a fight, project the same extreme personality we'll see in *Impossi-*

ble Motherhood. And the vignettes of her fellow patients at the hospital—emaciated Kelly, whose "body looks more and more like the folds of her bedcovers," and Ana Mani, who "circulates throughout the floor with a plastic-bristled brush," trying to brush everyone's hair—signal the already arrived attentive writer, present here even in such grotesque moments as when she touches the nose of her mother's corpse, and feels it give way.

Vilar's impulsive sexuality, which will shape a larger part of her life in *Impossible Motherhood*, receives its grounding here. Always, it seems, men want her, and she wants some man: Eduardo, the older guest on a cruise, who repeatedly pins her fifteen-year-old body against a cabin wall before eventually deflowering her; Esteban, the Harvard economist who spots her in a Caracas hotel lobby and starts kissing her at the bar. The Vilar we meet in *Impossible Motherhood*, an ambassador-at-large of sex waiting to happen, is already present. By the end of *The Ladies' Gallery*, only the hardest of hearts can resist taking Vilar's side on her journey of self-discovery. And yet anyone who reads *The Ladies' Gallery*, then moves on immediately to *Impossible Motherhood*, must fight against a feeling of being duped.

In the second book, we learn the previously untold story of Vilar's marriage in 1990 to her Syracuse professor of Latin American Literature and Theory, thirty-four years her senior. He'd been her professor in the fall of 1986, when she was only sixteen, and later became, she writes in the new book, her "master."

Vilar's life story now becomes "an exploration of family trauma, self-inflicted wounds, compulsive patterns." Whereas *The Ladies' Gallery* toward the end describes a kind of induced

"miscarriage," Vilar reveals now an "addiction to abortion": twelve in eleven years with her child-averse husband, and three more with an on-and-off boyfriend she met in the frozen meat section of a supermarket. She would explain her "lack" of responsibility, she reports now, by telling people she was "not good with pills."

We learn that it was fear of losing her "disturbingly handsome" lover that "inspired" her suicide attempts in *The Ladies' Gallery*. That a concern with "the privacy he needed" spurred her move to an apartment of her own. Her master, it turns out, was the person who moved her to University Hospital and "visited every evening of the three months I lived there." At the height of her infatuation, Vilar "never stopped thinking about him from morning to night" and regularly "made love without birth control: without thinking about the consequences." Perhaps most important, we grasp that it is to hold on to her partner that the conflict-avoiding Vilar agreed to write *The Ladies' Gallery*, in which she now says she "historically romanticized" her misery. The master even fed her the odd, closing notion of the book, that her mother's death was not her doom but her redemption. "You should be thankful she died," he told her.

Free to write as she pleases, Vilar alters her emphases in *Impossible Motherhood*. Whereas in *The Ladies' Gallery* she tells us that on a milestone trip to Mexico in the summer of 1987, "I spent my time digging up corpses," we learn in the new book that she also "shamed" her way through Mexico, having sex with Rodolfo, a worker in the archives, and Irish Timothy, a seller of pen samples, and an unnamed, yoga-devoted Aztec whom she met at a phone booth. Still further lovers pop up in, you might say, the interstices of *The Ladies' Gallery*, where they are invisible: Michael, a teaching assistant

from Holland who comforts her; James Merton, another middle-aged professor.

This is not the place to examine, in detail, *Impossible Motherhood*, its "life of boating, academia, writing" that ended definitively with Vilar's 2003 marriage to a poet she met at Bennington College and the two young children she gave birth to from her sixteenth and seventeenth pregnancies. Nor is one behooved to comment much on the master, whose rules for his relationship with Vilar—no holding hands, no showering together, no children, no brushing one's teeth in the other person's view—suggest the dubious charm of a man who ultimately called her a "whore" and struck her for the first and last time.

Rather, it is the place to size up, in the light of *Impossible Motherhood*, what to make of the first book. To judge how one reads an earlier memoir that's been deconstructed, outed, modified, contextualized, by a later one.

To be sure, Vilar regrets much. She speaks of the "poverty of my spirit," the "poverty of my life." Perhaps it was the *Detroit Free Press* that inadvertently captured one aspect of Vilar's story, sizing it up as "postcards from the edge." Not just the edge of sanity or survival, but the edge of truth. One can't place automatic blame on her. Normally those who distort in their memoirs seek to disguise frailty, weakness. That's only partly the case with Vilar. Here it's as if there was too much pain for one book. In *Impossible Motherhood*, she tells us, "I have written this version of my life hoping my future lives are less inauthentic." Apropos of the master, she refers to "the quiet sleight of hand that were his edits of my work." Did they include eliminating himself? Vilar does not say.

"Woman," she writes early in this book, "is either

inexplicable or, like one of Gabriel García Márquez's characters, a gothic spinster, weaving, Penelope-like, her own death shroud." One might add her thought on that earlier writer, the girl she still was as she began: "What is the past at eighteen?" The invitation is to take Vilar at her word now: "I've discovered that my personal history alters constantly as more is 'remembered' or released into my consciousness, recasting in this way my sense of self and the lives I've led."

Think of *The Ladies' Gallery*, then, as "a truth, possibly partly fictional, that the author once chose to believe about her life, facts included." Think of it as an act of literature, a delicate book of "self-figurations," one more version of the evolving, disturbing writer known as Irene Vilar.

THE LADIES' GALLERY

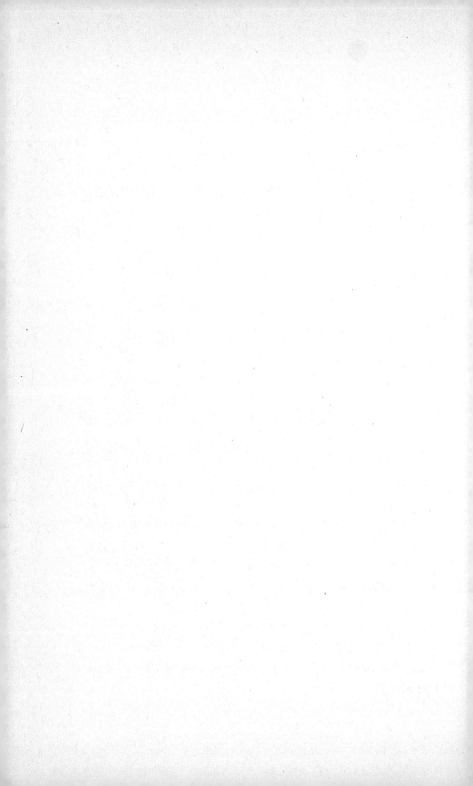

PROLOGUE

Distance is the soul of beauty.
SIMONE WEIL

MARCH 1, 1954. In the afternoon, a young woman together with three men entered the House of Representatives of the United States of America and opened fire. Next day, the front page of the *New York Times* would show the same woman wrapped in the revolutionary flag of Puerto Rico, her left fist raised high. What the *Times* would not quote were her words, "I did not come here to kill. I came here to die." An old battle cry of Puerto Rican nationalism. She would be sentenced to fifty-seven years in prison for assault and conspiracy to overthrow the government of the United States.

MARCH 1, 1977. On the twenty-third anniversary of the attack on Congress, her daughter commits suicide in Puerto Rico. The mother is flown secretly to the island for a day to attend the funeral.

FEBRUARY 1, 1988. A gray winter day: the daughter's daughter becomes a suicide patient at Hutchings Psychiatric Hospital, in Syracuse, New York.

～～ Repetition informs my life. A teacher of mine once told me not to fear repetition, "Just don't be blacklisted by it." Well, I am the product of repetitions. Of family secrets. Every family has its own; usually it is the untold family story a child is destined unwittingly to repress, or to repeat. We inherit these secrets the way we inherit shame, guilt, desire. And we repeat.

My inheritance? In school, a story that became a metaphor for me, a mask magnified by nostalgia. Granddaughter of a Puerto Rican nationalist, a woman who spent twenty-seven years of her life in the women's prison at Alderson, West Virginia. How did she manage to make from a prison cell a room of her own, a place where one could withstand torture and, at the same time, write? I don't know. But now that I can read her poems, I see that her writing was a deliberate act to evade conjecture on her destiny and on that of her family and her nation. In jail she was a solitary woman who imagined herself as entrusted with a specific task: that of writing and living in relation to the "luminosity" of religious experience. (On a November evening in 1957, she had one of her first visions. The ceilings of her cell burst into flames, and amidst the fire a voice came unto her from a blue silky flower, instructing her to write the "Mensaje de Dios en la Era Atómica"——A Message from God in the Atomic Age—which she subsequently produced and mailed to President Dwight D. Eisenhower. A few days later, she was transferred to St. Elizabeth's Hospital, in the District of Columbia,

where she remained for six months.) In one of her poems a prisoner faces his torturer as pain is about to be inflicted, and stares at him with absolute incomprehension.

Granddaughter of Don Paco Méndez, landowner, Lolita's quasi-husband. A man who after the Operation Bootstrap of the 1950s—a program calculated to undermine Puerto Rico's agricultural economy—monopolized land transportation on the island and advocated staunchly conservative, pro-American views. This is the same man I had met once on the bridge of Arecibo. My father had stopped the car so that I could see the people under the bridge fishing with huge nets. Don Paco Méndez was there, dressed in black. An old man walking slowly with a cane and holding on to the hat on his head, securing it against the sea breeze. My father asked me if I recognized my grandfather and pointed to the old man crossing the bridge. He then introduced me to the man who, in some remote time, had been my mother's father. I was startled by his face. I recognized, in those ancient Semitic features—the trembling smile, the pair of alert, dark eyes magnified by old age, still clinging fiercely to life—something of my mother: the south of Spain, the look of a tormented people who had traveled long enough, a part of my childhood. It was the summer of 1987; I was eighteen and that semester had read Américo Castro's essays on Spain and the Jews. Méndez, I had discovered, was not a *cristiano viejo* name, but the remnant of an untold story, of forced conversions. A whole new world was being revealed to me as I repeated that name, Méndez, and contemplated that face and stamped it in my memory. So many things became clear afterward. They told me he died the next year. He was ninety years old.

Granddaughter of Padre José María Vilar, a Catholic priest from Spain who, in the early 1930s, soon after setting foot in the port of San Juan, fell in love with a local woman from Fajardo, Irene Santiago. Love, so they said, forced him to desert the Holy Trinity and prompted his acceptance of an offer from a Protestant and later an Episcopal church. By 1930, America's dominance had found, in the crisis of the Catholic Church, a way into a spiritual and cultural world that was increasingly coming apart. Since 1898, America, its flag, its government, its rules, its language—the English language—had been the measure of life in Puerto Rico. *"Ya somos* yankis," said the criollo Ramón Castañer in a letter of 1898 to his uncle in Majorca as the American soldiers landed on the southern beaches of Guánica carrying with them the Protestant ethos: a new utilitarian credo which for my grandfather Vilar reconciled love, faith, and politics.

Grandmother Irene, my father's mother, widowed young, and with a crazed passion for horse races. But she also knew how to take care of the children's health, for she was a nurse. My middle brother, Cheito, was born three months premature and was given the last sacraments. However, Abuela Irene decided to feed him with an eyedropper and carried him everywhere snuggled in a small pillow she carefully tied to her left arm. She was a gambler. One day she made a big win with a bet on Delirante, a long-shot horse that nobody else would take a chance on. Cheito was her next big hit. He actually grew to be six feet tall.

Niece of Padre José Vilar and of Padre Miguel Vilar, my father's brothers. Two Episcopal priests, who read Jesus Christ's redemptive message into Che Guevara's diaries, Albizu

Campos's nationalist speeches, and Father Romero's social commitment to the poor: our vernacular varieties of liberation theology. Tío José was a very quiet person. Next to him one always felt the guilt that comes from not having sacrificed enough. Tío Miguel drank wine, liked soccer, and inherited his mother's love for horse races. They both also inherited her instinct for caring and her rage against injustice.

With time I discovered that my two families were burdened by a failed asceticism.

Niece of Lolita's only son, my mother's younger brother. They say that shortly after his mother was imprisoned he drowned in the Lago Dos Bocas while playing with a yo-yo. He courageously went after the yo-yo, it is said, and was never seen again.

Was Lolita's commitment to Puerto Rico his diving board?

Where I come from, rape, metaphorical and literal rape, is considered the spark of our history, and solitude its human consequence. It's in most of the novels and essays on Latin America one reads today in school: the frenetic pleasure-seeking Spaniard creating the angry mestizo, a bastard forced to wander through mountains or deserts in search of the absent father. (After James Joyce's *Ulysses*, perhaps the "search for the father," as well as the Labyrinth, became the fountain of all our possible metaphors.)

But where was *she* all this time? Woman is either inexplicable or, like one of Gabriel García Márquez's characters, a gothic spinster, weaving, Penelope-style, her own death shroud. In my case, mother lies somewhere between caring love and an abrupt departure, between her life and what was left of her life

in my life, a tolling blue silky flower and a black hat. In the case
of Lolita, her destiny unfolded in her country's name and, de-
spite a leftist ideology, in God's name: the prismatic view which
carries all the birth-pangs of Latin America's political con-
sciousness. Lolita was to become the legendary woman who
stripped herself of all "womanhood." A sense of offering, of
sacrifice in all that she said and did, was always there. And her
religiosity still amazes and disturbs many. My grandmother ob-
viously saw herself as a martyr for the liberation of Puerto
Rico. At some level, a woman firing a gun at congressmen of the
United States of America must have been rather shocking. Yet,
when I listen to people of my grandmother's generation speak,
not only in Puerto Rico or in Latin America but also in the
United States, I realize how much they see themselves, many
of them, in Lolita's "act." With apprehension, certainly, but
also with some gratitude. For she "did it for them." My grand-
mother must have seen it in the same terms.

As I entered the hospital I was far from knowing the
reasons for my sadness. Many times, faint at the very sight of a
clock's hands turning past the hour, I would sink sideways into
my chair, clinging to the second that had just elapsed. It was as
if the time had come and I was being summoned to answer. And
each time not finding a voice of my own. And to answer what?
At eighteen it is college time, it's still college time today, at
twenty-one; but now I have no more of that strange belief that
everything could stretch, that nothing is hard to recover. In col-
lege one has that Borgean sense that it is possible to be many
without even trying to be one (since everything is there for you
to choose). And to answer this question demands a sort of ex-
pository skill, a shuffling of ideas which I was not able to do.

Like many a woman of my age, I was living a life of intuitions,
I was growing up, I was in need of distance, which at eighteen
is difficult to come by.

Distance is a proposition that points to an audience besides
yourself.

Distance is a book.

*Face up, the start of another day is unbear-
able. You feel that nothing is ending and
nothing is beginning. Maybe if you close your eyes and get away
from the light of day you can put an end to that anguish. I tried to
move. Starting with my arms and then my hips, back, and head.
Finally, I managed to move my legs and, with the greatest effort,
I succeeded in turning onto my side. Now I could see the green
wall, and I would have completed the turn if it hadn't been for the
crunch of the icy plastic under the sheets. I got a good grip on the
edge of the bed so I wouldn't slip and lose the position that it had
taken me so long to reach. Yes, I would stay in that position with
my nose pressed against the wall and my right wrist bent under
the weight of my thigh. It wasn't a comfortable position, but at
least I wasn't on my back: the light of day wasn't beating down
on me anymore. For some reason my body took on grotesque pos-*

tures, as if challenging me or mocking my clumsiness. *Whose huge foot was that hanging from the light?* I looked at the nails eaten away by some alien fungus, the wrinkled heel, the callused ankle, and I felt the same embarrassment I had felt as a child when my stepmother, Blanquita, insisted on making me walk like a young lady, slowly, gracefully. Like the young lady I never was.

A woman's voice tells me that it's breakfast time. I try to answer but it's impossible. On my skin I feel the cold morning that a short while before I'd seen at the end of the hallway, framed in the tiny window that opened onto the blue winter sky. I'd gone to bed with my clothes on the night before and now I would only have to put on my boots. The nurse arrived from the end of the hall and, with a tug, pulled off the blanket, leaving me uncovered. Get up, she said, as if she were talking to an insect, or a corpse.

I made an effort and emerged from my numbness. I remembered who and where I was.

At three o'clock on Monday afternoon, February 1, 1988, I was sitting in the waiting room of the Hutchings Psychiatric Hospital. I was wearing a red coat and the leather boots Papa had given me four years before, when I'd come to the university. I was tired, the palms of my hands were very warm but I had no feeling in the fingers. They were my hands, yes, but they felt like someone else's, I looked at them with suspicion. I'd arrived nearly at dawn, and after several hours of questioning they had me take some bright-colored pills and then deposited me in the waiting room across from a mirror. The mirror was reflecting pale colors: the green of the hospital, the white of the disinfectant, the sad gray . . . I was beginning to feel a heavy weight on my shoulders. I made one last effort to move my eyelids, which seemed to have a life of their own. Among so many inert objects, the bluish red of

my coat gave me back something of my own. At least it was something, to look at yourself and feel the irises of your eyes becoming painfully smaller, as if on their way to blindness.

At the end of University Avenue stands the Hall of Languages, a kind of gray sandstone castle. From the very first day the gray of that building enhanced the distance that separated me from everything, from what I'd left behind, from the smell of salt that I missed in the air. In Syracuse the air smells of sausage and detergent.

I don't know how long I was like that, sitting in front of that mirror. As if born out of the hospital colors, that larval feeling began, a small, curled-up creature that the mirror was giving back to me. An anomalous creature, somebody who had been given pills to take. It was clear that I was that somebody and that something in my body had broken down. The orderlies straightened up the bent thing; it walked. I thought they were taking me to an operating room, to cure me, to remove death from inside me, to rid me of the ghosts, the ones I imagined I'd eluded by coming to Syracuse. They were going to give me back the joy of living. But instead they led me into an elevator and brought me to a room where a bright white light shone over a woman who was also dressed in white, sitting at a desk with my belongings: the Ralph Lauren perfume, the silver earrings, two ballpoint pens, an incomplete jacks game, a black eyeliner pencil, some seashells I'd found on the beach at Palmas Altas, my checkbook, several letters written and never mailed . . . My black purse was there on the floor with a tag with my name: "Myrna Irene Vilar."

I wanted to tell the orderlies who were pulling me along that I didn't have the strength to follow anymore. I wanted to sit down. Come back later. But they wanted to know if I had any sharp objects on me. They searched my pockets. They pulled my ring off.

*The woman asked me for my hairband and something in me said
no. But I obeyed.*

⌁ *I'd just moved into a house on Buckingham Street and
that day I'd begun to fix the place up. I'd stopped going to my lit-
erature classes. On Sunday, January 31, I opened the boxes and
found Mama's picture. It was the last photograph taken of her. I'd
carried that picture with me ever since I was a little girl. Every-
thing, sadness, death, and even the cheapness of the metal frame,
informed that photograph and its absurd proportions. I wanted to
hang it on one of the walls. After all, that woman of clear beauty
was my mother. I could hear the rain beating on the roof of the
balcony and I could also hear my mother's voice in the sound of
the rain, and something in my blood made the connection, and
while I was standing on a chair, struggling to straighten out the
picture, my mother's voice persisted. I shouldn't have been hear-
ing that voice. Things hadn't been going well for me lately, and
the refuge I needed was somewhere else. Perhaps in my index
cards. I had been shuttling between the library and my room
armed with index cards that were becoming increasingly oppres-
sive, but Mama's overpowering voice went on; hundreds of voices
sprang from hers, talked among themselves, spoke to me, about
me, on my behalf, voices from my index cards—the illusion of a
busy life—notes for a diary I would one day turn into a critical
book about Three Sirens, or cycles: the Child, the Nymph, the
Old Lady, three generations of women in my family. But what I
imagined was a clever project was fast becoming a chaos of three-
by-five cards I couldn't bother to read because they brimmed with
pride, wanton self-assertiveness, self-conscious family epigrams,
too glorious to be taken seriously now, now that I could barely
stand on my own feet. As I stepped down from the chair, the other*

voices faded away, but Mama's went on. It started to invade me, to get inside me. It said, "Hurry up, Irene! You can only be one of us."

⟶ The alarm clock said seven o'clock. I'd slept all night and I woke up quite ill. I knew why. But something in me wouldn't let me vomit. Perhaps the smell of gas and the voices outside in the hallway. I kept staring at the little fluorescent hands of the clock. The bottle of pills was on the table . . . empty. And the bottle of Popov vodka, also empty. I had the feeling I'd been outside all night, in the rain.

I remember, distantly, that someone was knocking on the door.

⟶ Last night I heard a cry that went on till dawn, like the howling of a coyote. Loud at first, down the hall, and then faintly moaning as its presence paced back and forth across the room. I could see it through the blanket over my head, at the doorway, aiming its plaintive howl at me. When I awoke the sheets gave off the smell of freshly burnt cane. Without much hope I closed my eyes, wanting to hear that familiar ring of machetes being wielded in the fields surrounding my house in Palmas Altas at sugar harvest. But instead here were the quick, firm steps of the nurses passing in the corridor. Back and forth.

I finally awoke to my second morning in Hutchings. In the main hall and along the corridors some people were walking, their arms slack. Others raised their arms as if pleading for help, as if being in flight. Others seemed to be talking to themselves or to invisible others. We all go about half-bewildered by all the sun pouring in through the window. Last night it was the moon that bewildered us. We move along corridors that lead through rectangular parlors into yet other corridors. The sound of steps on the

white tiles is loud, along with the squeak of litters and wheel-chairs, but nothing from outside can be heard. It's raining on the other side of the window. I always liked the thrashing sound of rain beating against trees and roofs. But these walls enclosing us are hermetic.

Why do you want to die?
Since last night no one has come except to ask that question, and its fierce echo resounds all around me. At first just hearing it was enough to make me cry. But then I couldn't help smiling at the parade of neurologists, psychiatrists, psychologists, social workers—I don't know who else—and the things they said. I was slowly becoming a spectator of my own fable, of the place and the men and women around me, almost all of them young people full of lethargy, turning about and shuffling along the corridor. The effect of the pills must have been wearing off.

I go up to one of the nurses. I want to see the doctor. Impossible. "Impossible" is not an answer, it's the parrot's monologue of the psychiatric hospital. The doctors come only in the afternoon.
Breakfast is brought on individual trays. A well-dressed young woman with long, shiny hair pushes the cart. No one makes the slightest movement. Fatigue must have also killed hunger. One of those walking in the corridor approaches, stands looking at me unabashed, walks behind me and without warning grabs me in his arms and squeezes me. The nurse with the food cart pushes him away. Later on I'll hear that I'm in Ward C, with the psychotics, schizophrenics, and catatonics.
Two orderlies come out of nowhere, take me by the arms, and escort me to the room of the day before. They give me a small

glass full of shiny pills and another with orange juice. The lithium journey was about to start.

Vilar!

I walk toward where the voice is coming from, slowly. Two orderlies take me to a room with a lot of machines, another orderly connects me to a dozen colored cables. The machines are producing graphs and numbers. They disconnect the machines, fill out a form that was lying on top of a pile of papers. You're okay. You're normal. They take me to another ward.

I'm seated on a bench. A woman in a sari, with long white hair, comes over and takes my arm. You're looking very well. I'd like to get away, and that's been my attitude from the beginning, because today all they've done is ask me questions. But the woman's fingers grip me forcefully. In her other hand she's holding a leather case. I'm captivated by the sari, paralyzed, fascinated by the shape of the folds and by the colors around her tiny body. Over her shoulders she's wearing a white starched cape. I've been looking at her for quite some time. Her case reads DR. J.C. The interrogation will be forthcoming. Maybe this time will be different; maybe Dr. J.C. in her sari will be different. But doctors are always the same. Have you got a boyfriend? I should be answering now but I continue staring at the sari; she opens her case and takes notes. What about? My silence, certainly. Well? What does my silence mean to her? She's waiting for me to tell her I'm in love. Should I play the adolescent, sick Juliet they imagine me to be? Yes, I'm in love, but my problems have nothing to do with love. Dimples appear in her face. You should rest. It would do you good to finish your studies and then take a long vacation. The words are those of someone far away.

If my problem wasn't a boyfriend it must surely have been my father, or maybe my country.

That's common with people like us who leave home. One misses so much.

"Yes."

"And what do you miss?"

"I miss Lassie."

"Who is Lassie?"

"My dog."

"Where is it?"

"She died long ago."

She smiles.

"And the climate here doesn't help much, eh?"

"No."

"And how warm is it back home?"

"Hot."

"I see, just like India. So you were raised on a plantation in Puerto Rico?"

Plantation, yes, plantation. Maybe.

At some time, to someone, I must have mentioned the sugar-cane that surrounded my home as a child, and the smoky, bitter smell of harvest time. I could not shake myself free from it. Everything since I woke up this morning smells bitter to me. There is no plantation, no exotic lasting anything, but I let her go on.

"And how would it be if you returned to your family and rested for a while?"

"Where?"

"Back home."

Home? The smell of the coast, the mixture of rotting sea-weed and diesel fuel, rings of red fire burning dark sugar into the

wind . . . girls bathing in their slips, and their skirts billowing about their chests as they jump . . .

She is taking a long time to read my records. Is she looking for a clue? She is scratching her ears. She moves uncannily, as if she has no feet.

"A good rest, my darling, and all will be in the past."

She wraps herself in her pink sari like my grandmother Lolita must have wrapped herself in the Puerto Rican flag. India seems such a far-off place.

The past, what is the past when you are eighteen?

⟶ *In a corner someone was singing softly. I raised my eyes to see who it was, and I met Monica. She had pressed her face against the large window, her mouth half open, whispering lullabies. It had snowed the night before, and it seemed to me that I had seen her looking out across the street. Monica was a huge, almost spherical black woman. She must have noticed my observing her because she moved from the window and came over to sit beside me.*

She begins telling me stories; really the same one over and over. She's pregnant, she's traveling on a train, and she feels the need to go to the bathroom. She goes into one, she lifts up her skirt, sits down, and waits a long time. She gets up, flushes, sees her baby going down the toilet. She's told it to me several times, and always in the same words, the same mixture of joy and sadness. Every so often she lets out a thunderous laugh. I stop paying attention to her. Abruptly, without permission, she attacks my tray and finishes my meal. I'd like to say something to her, but I don't know what. She hands me back the tray and proceeds to ignore me. She rolls her eyes; they're dull. All of her tension is concentrated in her fists, in her clawlike hands. Without looking at

anybody, she returns to her corner by the window and collapses into sobs and shrieks. I want to go over to her, but two orderlies get there before me and carry her off, her arms and legs flailing, like a bundle of dirty laundry, to Ward C probably.

Whatever became of Monica? The image of that woman shitting children into a phantom train toilet haunted me for a long time, calling into doubt the reality of my own suffering. I was a student at a private university in New York, a little bourgeois Puerto Rican girl. I'd soon be transferred from Hutchings to University Hospital, a journey through madness with seemingly no exit. There the self is reshuffled by the voices of shadows, family, tradition, history, chance. These are the witnesses we need to wrestle and interrogate, the better to free ourselves from them. All those familiar (or unfamiliar) witnesses swirl about you, as you think or write: memory enlarged or diminished by whatever happened or could have happened. And just as those voices eventually become you as you write, you, in turn, to make your story meaningful, become part of those voices, a closing of the circle that is endurable only as you write.

The sea extends on every side. Storms followed by sudden calms. The coastal plain a green glimmer beneath the blue sky. It is still covered with sugarcane that year. The road cuts through the cane linking town after town, spare houses built up near the grinding mills close to the sea, chimneys casting long shadows in the barren landscape. The trade winds stir the cane that grows high at the edge of the road. Machetes sweep down and across the stalks, cutting them close to the ground; leaves fall, littering the road, and the soil gives off heat with the smell of sugar. My brothers and Don Toño, the gardener, catch land crabs in the canefields; dogs and roosters and croaking frogs, the *coquís* . . . I could add to this picture, seen at sunset from my window (a postcard you can still buy in a supermarket), a few waving palms, some coconut husks, more of the sea, the sky . . . but not much more. Mem-

ory, a young troubled woman looking for the past. Where? Everywhere, because even the picturesque landscape of the haciendas and *colonias* (the great farms of the corporations that control most cultivated land in the municipalities where cane is sown) was already in extinction by the time of my childhood. So there is not even the landscape of the colonized to be offered here. Even that is past; not completely lost, but grown into the ground, below the ruined shells of the haciendas' warehouses, old abandoned barracks left from times of slavery . . .

I never liked the mosquito net over my bed. But between me and the net was that black woman who sometimes used to take care of me and whose name I can't remember. That's how her grandmother died, she said, of a mosquito bite, in the late 1920s, at age seventy-eight, having been born a slave around 1848. She and her old mother lived on the road to the beach, right across from the pounding surf, in a house roofed with galvanized iron sheets, with three rooms, two bedrooms and a small living room with a window facing the sea. There was no TV in that house, and the woman ceaselessly looked outside the window. Like a refracting view of my childhood she is always the woman staring into the distance with a fixed look, at a point in the ocean invisible to me, beyond the pounding surf, a point that always gave me the illusion of being somewhere else. Where? What was she looking at? "Mother . . ." I wanted to run away, run across the fields to our house, to play with my brothers, my good dog Lassie. But the old woman's hand clasped my arm in its wooden grasp, for minutes on end, her doll face staring at the ocean, where her ancestors came from the coasts of Africa and other Caribbean islands, and spoke about her grandmother, the slave who died of *perniciosa,* or maybe it was malaria because of the incredible appetite she felt

once the fever had gone down. Two years after the abolition
of slavery, in 1875, her mother was born. How much better it
was to dance than watch TV. Lots of dances, good accordion
players, tambourines. In the late 1920s she was a young woman
and, of course, like many young women of her condition, she
worked for Central Monserrate. They needed somebody to
carry sacks of seed and spread the manure. After work, her old
mother would take her to the ballrooms. Men would come back
late, tired. But it was nice. Now she too was tired, she was in her
seventies, old like her mother and grandmother. Three genera-
tions of women. No, they were not women. They were part of
the barren landscape seen at sunset from my window . . .

——— Maybe I would have preferred believing that the drafty
house with a thousand doors where I grew up had no an-
tecedents, that its Draculas and stepmothers were entirely mine:
the treasured secrets that frightened me and only me. Today I
can still claim it as my own, though there is no escaping those
other houses, the ones in dreams and literature that mingle with
the memory of it and make me think that Palmas Altas, the
house of my childhood, was already, like so many other houses
of ours, inhabited by secondhand ghosts springing up at me
from the cracked doors and ceilings; family stories echoing sto-
ries read to me as a child and refunded into books I myself read
as a grown-up. A fecund treasure box of real and imaginary
memories.

It was a house that belonged to the Land Authority, and it
was rented out to Papa as he was a land surveyor for the Cam-
balache Sugar Mills in Arecibo. We'd been living there since
1969, but the house had been built in the forties as part of the
sugar project on the northern coastal plains. It was an inviting,

open house, and no matter how many exterminators and car-
penters Papa brought to plug up all the crannies in the door
and window frames, all sorts of mice, tarantulas, flying cock-
roaches, ticks, scorpions, gongolies, centipedes, and unforgiv-
ing red ants would sneak in through some overlooked hole, and
once even a *juey*, a land crab, moving like the sea variety, curled
up on the kitchen floor to lunch on old lettuce leaves.

Three days before my birthday, Lassie appeared. From the
top of a tree I'd climbed I could see a dog stretched out across
one of the dirt roads that led into the canefield. I watched it for
a long time and saw that it wasn't moving even though the sun
was beating down directly on its black body. I went down to the
kitchen, folded a package of salami under my blouse, and went
out to the road to find it. It remained there, looking at me with
its brown eyes half-open, but it still didn't stand up or wag its
tail the way the tangy dogs that visited the house from time to
time did. So I took the salami and moved it closer to its nose.
Nothing. It was still motionless. I touched its little belly and it
was so hot that it burned my hand. I petted it more and then it
lifted its tail a few inches off the ground, as if trying to show
joy, but quickly dropped it. I ran to get Papa because the dog
was acting very much like the hawksbill turtle we had at home
that got sick and had to be taken to the doctor in San Juan and
stayed there and never came back. Papa and Don Toño, who
was cleaning up the yard, went with me and confirmed that it
was a sick dog. They sent for a blanket and put it under her and
carried her to the car. On the way I asked Papa if, since I would
turn six in three days, he would let me keep the dog as a present.
Papa said yes. After two days they brought her back. She was
limping on one leg and seemed sad, but when she saw me and
heard the name Lassie which I'd chosen for her, she started

running on the other three, wagging her tail back and forth as if she'd known me all her life. From then on we did everything together. When I ate I would bring her meal, when I bathed I would wet her down with the hose, when I went out she went with me, when I went to bed I would wrap her in her blanket on the balcony, and when they gave me those terrible cod liver oil pills I would slip them to her and nobody was any the wiser. Our closeness worried Mama, because Lassie might give me ticks, and when Mama finally found one crawling up my leg she told me I wasn't to let the dog in. To shut the doors.

⟶ Through one of those many doors would one day come Blanquita. Ever since Mama's death the house seemed more wide open than usual. In the morning, before getting dressed, I would inspect the dresser drawers in case some creature had hidden in the clothing or the underwear—the panties more than anything else: I would shake them in the air several times before putting them on. The thousands of people who came to Mama's funeral (though actually to see Lolita) during those first days of March had loosened everything, right down to the flagstones. Doña Sofía, at the eating place in town, would prepare our meals in lunch baskets that we would stop by to pick up on our way back from school. At night I did my homework next to Papa, who absentmindedly sketched out projects on thin surveyor's paper, claiming that these were farms, buildings, and even whole cities, when all I could see were lines and numbers. Only a few months had passed since Mama had "gone away," as we said then. You feel the pain less that way and there's still the promise of a return. Besides, there was the dressing table with her things. In one of the drawers,

wrapped in bras and panties, there were half a dozen bottles of Bal à Versailles perfume. I got into the habit of perfuming the furniture, the towels, even the bedclothes, with Bal à Versailles. That smell helped me sleep, and dream about my mother's return. I was eight years old now and I would repeat to myself that this was all one of Mama's jokes, since she'd spoken to me so many times about the day when she wouldn't be there. But, little by little, I stopped thinking about Mama's jokes. I was under the influence of the dense fragrance of Bal à Versailles and waited for the incomparable miracle that only a child could expect: seeing her come out of a mysterious bottle of perfume.

One afternoon early in 1978, Papa left me in the care of my brother Fonsito and went off in his car, saying that he was going to pick up somebody I would like to know. It was already almost nightfall when he returned with an elegant and pleasant woman. I was studying my English lesson for school and while he changed and got ready for dinner, she came over to my desk, put a package on my English book, and asked me to open it. They were little Italian cookies, all wrapped in tissue paper, each of different color, and covered with a fine, sweet white powder. I'd never seen anything like them.

Her name was Blanquita. She began coming to the house more and more often, and a short time later and with the same sweet smile took up permanent residence. To take care of me, they said. Papa bought new furniture and Mama's things were placed in boxes and ended up in the back of a closet among the junk furniture. First came the sweets, then the furniture, and then one day Blanquita said that so much junk piled up was dangerous, it might bring on an invasion of cockroaches.

Almost all stepmothers have a bad pedigree, it's true. The stepmother is the dark gnome who drives off the children and takes over the father and the house, the one who transforms the children's paradise into the grown-ups' hell. Stepmother: mythological serpent of the fall of the child. I knew that from fairy tales, and from my mother, who used to torture me with that nightmare. Blanquita thought she could escape that fate, and from the moment she arrived in the house she tried to fill the void my mother had left by devoting herself completely to me. And to do that she decided that it was necessary to change the house, change me, change everything: get rid of any sign that would chain our memory. "Rub it out and start from scratch"—a favorite phrase in my family. But who was to rub it out? Everything was so recent. Blanquita's life wasn't mine. For her, erasing my past was a necessity without which she wouldn't be able to start a new life; for me, it would be falling into the old trap: the familiar scorpion curling up to sting and poison me with things that will be repeated later on, becoming habit.

Nothing on this earth will erase from my memory the night when my dog Lassie died, burned by a flamboyan tree. It was 1976, the last autumn when sugarcane would be planted on the plain. It was harvest time, and the canefield that surrounded the house in Palmas Altas and the Plazuelas Sugar Mill was burning with radiant fire on all sides. In the house they knew that next year it would no longer be necessary to run to the village to take refuge if the weather changed and the trade winds suddenly came out of the West. Nor would it be necessary to clean off the ashes that would accumulate on blinds, cover flag-

stones with a slippery gray mantle, and hopelessly stain the petals of the poppies. Lassie liked the fire. At harvest time, when it was the practice to burn the fields for the next planting, Lassie didn't run or do anything. She would remain peacefully under the flamboyan, the poinciana tree, for hours on end, her eyes fixed on the burning landscape.

That night some spark, carried by the afternoon breeze, must have fallen onto the leafy branches of the flamboyan, and now that huge tree, which from a distance looked like a bucket of red paint spilling over the blue horizon, had been converted into a great ball of fire. We all went out onto the balcony to watch it from the steps and to feel the burning heat on our cheeks. A howl was heard, and we saw a shape, a reddish glow, as if it were breaking off from the flamboyan. Lassie was running back and forth in terror, trying desperately to shake herself loose from a landscape that was now enveloping her. The whole house ran after her, but I, still a little girl, had to wait on the balcony. From a car that had been racing down the highway, two men got out, practically on the run. They finally managed to put out the fire that was consuming her.

She didn't die right away. My brothers carried her in their arms to the garage and laid her down on the floor. She was still whimpering. That night I couldn't sleep. I carried my blanket out onto the balcony and I listened to her crying all night, and I moaned along with her, until I didn't hear her anymore.

It might be said that it was the first time I saw grief in a house where those who stay don't know how to shake themselves free from the memory of those who have left. A drafty, open house. Then, what is lost is still there? Is the past present

in all the fugitive forms that lost things take? Like the charred
scent of burnt hair, which one may smell forever?

⟜—— Two years later the same familiar smell would awake me
from my afternoon nap. As I saw the smoke and heard the
flames crackling, I thought they were burning garbage. But no.
I knew the scent quite well: I had precise memories of burning
fields, and of the scorched body of Lassie. I went to the window
and, in the yard, in between the fences, the fire was burning, the
pyre on which Blanquita was burning the dangerous things in
the house. It was the exorcism of my mother: she was making
her die again (she would die more times, and not just at the
hands of Blanquita), and she'd chosen the most ancient method,
so that nothing about her would survive.

She was carrying out the clothes piece by piece and furi-
ously tossing them in. Gone forever were the black vest and the
orange silk scarf, the leather boots and the black string bikini,
and the wigs and the hats and the photographs. Rub it out and
start from scratch.

I didn't say anything. It was just that the acrid and famil-
iar smell that had awakened me must have evoked a fragrance I
carried inside. I remember that after the "accident" the surgeons
had given Papa a small package with Mama's hair and that he'd
put it in one of the boxes. The fire would also put an end to her
fine, long black hair.

A missing mother—and one of whom not even her pho-
tographs remain—is a problem. Memory works on its own, it in-
vents, draws circles that never end. Blanquita wanted not to be
the stepmother of fairy tales, but she couldn't escape the spell of
Mother. (Mama, in some obscure way, had set the stage for it:
"You'll soon see, when you don't have me and when your step-

mother arrives.") In her struggle to drive off that ghost, Blan-
quita, without realizing it, was allying herself to the Vilars, the
Lebróns, the Méndezes. For them, Gladys Mirna was the daugh-
ter, the wife, the exotic mother about whom they never, not even
when she was alive, knew which tense to use when speaking of
her. The imperfect of novels? The present of ghosts? Since they
never learned the answer, Gladys Mirna had neither died nor
been forgotten by them. In Blanquita's world she went on to be
the gothic character whom, for clinical reasons, it was best not to
recall. For the sake of one's mental health.

The ashes of the bonfire: singed smiles, a doll with sad
eyes, a piece of landscape with no sky, a piece of sky with no
landscape. Clinging to the sole of a shoe a Polaroid had escaped
the fire. It's one of Mama's last pictures. She's wearing an Afro,
the wig of the seventies. She's smiling (the smile typical of
close-ups). I never understood why she preferred those wigs to
her straight hair, jet black and reaching to her waist. Sometimes
she'd take me into the yard and we'd divide her hair into two
long strands and we'd make a game of who could braid the
fastest. In the end, she got into the strange habit of wearing
wigs. The photo looked like a punishment. A gray shadow fell
across her features, darkening her eyelids, everything about her
was sunken into that lethargic look that boded nothing good. It
must have been close to the day of the "accident." The red lips
and the beauty spot at the right corner of her mouth, lightly
touched with mascara, were still there, but they revealed a sad-
ness that the "Spanish look," with its fleshy scarlet on the lips,
seemed to be trying to hide. It wasn't one of Mama's best pic-
tures, and I didn't feel like picking it up from the pile of ashes.
Besides, it wasn't photos I was looking for. I was looking for the
little package hidden in the bottom of a box . . .

I imagine one last conversation with the woman in the picture: What you're looking for isn't in the pictures, Irene, nor in the body nor in the hair that was burning yesterday in this yard. It's in the wigs, in those things that give you the illusion of being someone else every day. It's in what you've never had . . .

We can see touches of the other: the eyes, the clothes, the smile. We hear the voice, the words. Very few times do we have access to the whole person. That's what I've kept of Mama, bits and pieces, scattered objects or scenes, eight more or less sad or happy years and a singed photograph.

What did Blanquita burn? In the photo Mama was wearing a wig. All the rhetorical figures that can be drawn out of it are perhaps commonplace. Yet as I write I can't stop thinking about disguises, about a faceless mother who is constantly changing.

I awake to brilliant sunshine, but I can't see.
Shielding my eyes, I lie down and look up at
the ceiling. A woman's hand tugs roughly at my shoulder. Come
with me. I say where. The voice deepens. Come to bed. I say I am
already in bed. The woman's voice resonates. Come into my bed,
with me. And though she scares me I go with her. I try to sit up,
but still there is a blindness about me. I manage to drag myself
onto my knees, and find in the opposite bed a woman with tattoos
and scars crouching behind me, her bright, small eyes bulging.
The sunlight accentuates the livid blue of her skin.

Was I dreaming? Did I go into her bed? She winks at me
and smiles. Yes. It must have been a dream. I close my eyes and
pretend it's all a matter of enduring a little longer, just a little
longer. Since last night something has been suffocating me, per-
haps the pills (one of which must surely account for this burning

in my throat). I realize that even what comes to me naturally, like, say, a smile, now seems most contrived, a machination that I also sense in my dreams. My dreams? A passing train in whose last car my newlywed parents stand in their wedding outfits waving their hands in the air, but I cannot tell if they're gesturing good-bye or Hurry up, Irene! Come along! I stand there on the tracks to avoid swallowing Mother's flowing veil, which the winds of my dream blow into my mouth, threatening to choke me. The train is passing, but the veil is still inside me; I cannot spit it out. In the distance are my parents and others calling my name. I hear them cry my name, their lips parting silently. I wake up.

The tattoo woman looks at me from the edge of her bed, or near the arms of a man close to her. I fall asleep again. I believe I woke up once more in the middle of the night, perspiring all over, confused by voices rushing again through my mind as if through a mist, in a whirlwind. The cold sweat glued the robe to my body; I itched all over.

From time to time the woman next to me, her head resting on a man's shoulder, raises a nicotine-stained finger to her lips, requesting silence. I see it only through a haze that makes her thumb seem painfully yellow. She also winks at me as her face turns toward the man. She must be drunk. Or perhaps I am. Somewhere, the voice of a nurse is calling for lunch. No one answers, except the tattoo woman. She stands up, takes a shower cap out of her robe pocket and puts it on. "Time to eat!" The man next to her spreads his legs and spits. There follows a clatter of saucers, feet, and hands. Dazed by the noise, she raises her arms and bows to the people while she searches for something inside her robe, her shirt bursting open to show large breasts, pale white. The audience clamors, joyfully. Everything is in an uproar. She looks up at nothing in particular, bored, and leans against a table as if

disgusted by the praise everyone is heaping upon her. She is a sort of mother superior, one of those women I know by heart, the first to enter the dining room as the rest follow her. Not everyone. But mostly what seems a group of believers walking in single file, holding on to each other so as not to get lost.

A janitor struggles with the upper window, insistently whispering to me not to come close until he has opened it. A light breeze drifts across the room, bringing with it the dull rumbling of Interstate 81 South. Cars rush past us with a roar.

The tattoo woman talks of her disease, something in the blood. She can't help it, she was always someone else. That's all she ever said to me in the three days I was at Hutchings. Now she remains there, and I think I'm leaving, because this looks like a waiting room. A nurse had offered to help me bathe but I refused. That was a short while ago, when they told me to put my clothes on because it was my transfer day. Afterward I could barely hear her voice amidst the voices that swarmed upon me, voices from which I cannot shake myself free.

The guards in the front seat say this cold front is going to be the end of us all. Nowhere to run, but God bless four-wheel drive.

The car moves slowly through campus streets. It is a pleasant and alien world to me. The sight of those students effortlessly climbing the icy slope of the university makes it all seem so easy: boys and girls smiling amiably, sheltered in their coats . . . Such felicity, such desire to get something for oneself is a complete mystery to me. How will I ever graduate? Will the college take me back after this? The Dean of Arts and Sciences called home. Father is on his way. If I could only fix my thoughts on important things. Like: Would I graduate after all? Could they take me in after this? How does someone come back from a mental hospital?

Syracuse's sky is gray, that's how it was from the first day I stepped out of the rental car with Father, that June. But the longer you look, the more a light begins to penetrate the sky, grows into a deeper, brighter blue, almost beautiful. If you try hard enough, you can bring out of Syracuse's gray sky the bluest of colors.

They've really taken the long route to University Hospital, maybe because of the snow. There is Thornden Park. Here I wrote one of my first index cards. It was close to Halloween and I had bought the first pumpkin of my life, to decorate my room. I didn't know why but I wanted to carve a face on it and put a candle inside, something I had never done. The pumpkin was too heavy so I decided to cross through the park and save a few blocks. But the pumpkin grew heavier and heavier, as did my backpack and the books and the groceries. I began to cry. It happened suddenly, quietly, without warning, as if a wind had rushed inside me and out again, leaving something. A sick college girl with a heavy pumpkin. Dropping everything, I ran toward the center of the park. Soon I reached the trees and hurled myself like a wild thing along their shadows. For a long time I raced through the park. When I stopped for more than a minute, a clear panic would seize my entire body. I ran past trees and students kissing in the bushes. Eventually I slumped, exhausted, on the grass. I pressed my hands to my face, warding off light. But the panic slowly faded. As I peeked at the sun through my fingers, I thought of dying. I stood up and walked for hours, released. I entered Hendricks Chapel, where the sounds of an organ reverberated among the empty seats and against bare white columns. That is my first memory of wanting to die, but all I did was compose an index card in my mind.

Campus 1: *A descendant of the Roman Forum. Where men rallied in times of war or lingered in times of peace.*

Campus 2: *A still nature . . . Thornden Park? A lost thought, maybe. By comparison, downtown Syracuse is ragged and selfish. Salty remnant of bygone years.*

(When you decide you are going to die, something in you splits. You live two lives, half of you cries in a chapel, the other half writes an index card.)

~~~~ *The guards think that the storm tonight will be one to break all records. The snow is going to bury us all. In the rearview mirror of the car that takes me to University Hospital, I can see myself, the tense expression of an organism surviving in an alien element. Alien in the Spanish sense of the word: indifferent, idling away time, empty, deadened by an old pain perhaps.*

Are you building a case for yourself, or what? Where I'd written "I" the professor had put a question mark—"personal opinions are out of place." Similar comments were repeated within circles in red ink, scattered throughout the pages, as if they were a statement of heresy and not just a simple essay on the Gita. I was confused, trying to understand, before going into the office where the professor of religion was waiting to tell me, with cold condescension, what all those red marks meant. I suddenly remembered what the people in creative writing had said. Never use "I" in an academic work. Question: A matter of style? Answer: No, effect. A piece of academic writing is something more than a summary of opinions; rather, it is a truth that can be stated without any need to talk about oneself. Understand? I understand. But I felt good writing in the first person, and

sometimes without caps. Maybe it's true that by shifting to the
third person or the impersonal you can achieve distance. As
far as I'm concerned, that distance makes me feel like I'm
partner to a basically hostile world. Pronouns make a fasci-
nating story. I. You. He. The metamorphosis. Irene is Irene
now, or at least those are the conventions of a book, of novels.
But you know how they begin. If you are eighteen years
old and you are writing it doesn't matter whether you say I,
you, or he. It's enough just to try it out. One day the Irene
who was eighteen is disgusted with herself and doesn't know
why, and the women in her life become You, plural, mirrors.
Suicidal women. In the book, one Irene dies so that another
Irene can live, but sometimes the fascination is catching. In
1980, the American painter Pamela Djerassi Bush wrote a
book, really a long poem, that she called *Mother to Myself*.
The title comes from the poem "Face Lift," by Sylvia Plath,
and with those words the painter not only reveals her
admiration for the poet but also talks about her own experience
with motherhood. *Mother to Myself* was a personal decla-
ration of independence because its author had tied off her
tubes so she'd be mother only to her own works. A short time
later, at the age of twenty-eight, Pamela Djerassi Bush did
what the author of "Face Lift" had done fifteen years earlier.
She committed suicide. My index cards are full of women
writers at war with life: Julia de Burgos, Alfonsina Storni,
Virginia Woolf, women who loved and sang, like the Chilean
Violeta Parra, who wrote the song "Gracias a la Vida" (Thanks
to Life), to kill themselves later, in stages. Irene was there all
the time, before Irene had been born, and, as Borges would say,
behind the mask of other names (Irene Madame Bovary, Irene
Virginia Woolf, Irene Soledad . . .). She was there masked as

personas who were more alive perhaps than she. In the mean-
time the other Irene, after having tried to kill herself with gas
and razor blades and other things, entered the hospital and in
the hospital a third Irene appears. She becomes a patient, an
unfinished being.

The doctors know it; and from the first day, Dr. O. knows
that I read novels and psychology books. She didn't like me to
read Melanie Klein. (What would she have preferred? Ro-
mances of chivalry?) They know a lot about me, they have it
written down in a file with my whole history, and when I am fi-
nally able to see it, I am startled to read the things I'd said and
the things they'd heard. They didn't know what name to give
me: *Hispanic female, senior at SU, functioning with HX of mater-
nal suicide.*

⁓ I'd always wanted to keep a diary, and that Christmas,
the first I'd ever spent alone, in Syracuse, I saw my future diary
on a shelf in the University Bookstore. I stood looking at it,
with its leather binding and its little gold key hanging down. I
couldn't think about anything else, so I bought it. It was a white
notebook encased in garnet-colored velvet. I swore to myself
that from that morning on I'd be a different person. The life of
a college student, who every new semester changes courses,
professors, and classmates, is the closest thing to a surprise
package. At first those **uncertainties** are like a challenge to the
emotions. The future **doesn't exist (and** if it does exist, God or
Papa will provide). Until **one day some**one says that the future
is the only thing that exists, **only the** future. That's the begin-
ning of the race against time, against others, against yourself:
for grades, for the professors to like you, for scholarships. That
night I lay in the bathtub and kept looking at the empty diary

that was resting on the top of the toilet seat. Start all over, but from where? It couldn't be from the present; I didn't know how to say it, and I thought that I wouldn't understand anything if I didn't tell everything that had happened to me day by day since my arrival in Syracuse. For example: my first room, my roommates, my classmates, Ivan . . . Then I opened the first page and without thinking I went back to June 15, 1984—the day Papa left—and I wrote without stopping, as if it were the first day.

I woke up in the International Living Center, in a room with empty walls. I was half asleep and it took me a while to recognize the familiar whistle coming up from the street. I stuck my head out the window, and down below Papa was sticking his head out of a taxi and shouting that the plane was leaving earlier than we'd thought. He'd planned to come up and kiss me but there wasn't time. I threw him a kiss and stayed there leaning on the windowsill, not knowing what to expect. The morning breeze was brushing my face. In a corner of the window there was an empty nest full of old feathers. The window frame was digging into my ribs, but I couldn't change that position. When was the last time a bird has lived in that nest? I don't know whether or not I asked myself that question, but Papa had just left and the nest was so much like what I must have been feeling. There was my suitcase, still unopened, and on the table, also unopened, was the envelope with a check and the two hundred dollars in cash Papa had given me the night before. What could I do alone in a room with bare walls that were already beginning to have an effect on my digestive system? Suddenly I remembered that I must call Ms. Leo, the woman who was going to help me with English and, as we went

along, start coaching me for the TOEFL exam. It was the only reason I'd come in June instead of August. But I also had felt that it would be good to look the university over, see what the streets were like, the shops. Almost without thinking about it, I went downstairs. Other young people were coming out of buildings like mine, freshmen like me most likely; and they were all heading toward Marshall Street. I walked along with them.

List of things essential for an undergraduate:

telephone
roommate
stereo
teddy bear
TV
posters
boyfriend
photographs (including the one with the dog)
table and chairs
desk
lamps, etc.

At the University Bookstore, a sort of combination bookstore and miscellany shop, I bought a bunch of things to decorate my future living quarters: three posters of flowers, a crystal vase, a night table, a reading lamp, some frames for photographs, a pillow, the blue telephone, the rug . . . It's endless. I spent 160 dollars, I had 40 left. I could eat on that until I found out what to do with the check. By the door there was a table with some books, almost all about adoption, almost all with pictures of smiling babies on the cover, an invitation to caress

them. I casually thumbed through some of them, since I was in need of caressing too. *Adopt to Make the World Better. How to Adopt. A Single Mother Adopts.* I bought them all. On the street I went along with a bag full of things for my room and books to read. What more could I ask? I was telling myself now that everything was going to be fine.

At night I got hungry and was surprised to discover that I had only three dollars, a check (which would take seven days to clear), and an empty refrigerator. I counted again. The money was just enough for a frozen pizza. I had to walk a block to reach the grocery store and I thought I was going to faint from hunger. At my age that should have been as unthinkable as feeling lonely. Back in my room I cut the pizza into seven slices, one portion for each day, and settled down to wait for the time to pass. If I felt hungry and had already eaten the day's ration, I'd take out my pocket dictionary and start reading one of the books on adoption. I read without stopping until I fell asleep. At midnight my stomach was so empty I even forgot about hunger.

Hispanic? You should go to La Casa Latinoamericana and ask them to get you a tutor in English, said Marti, my roommate at the time. Marti, a girl from Honduras. She didn't know any Spanish. But she very much wanted to learn it. Marti was the one who brought in the stereo and the TV (black-and-white). She also brought her boyfriend. She was dark and he was incredibly blond and thin and had a motorcycle on which they went everywhere. At night Marti pretended to be going to bed alone, but I knew that wasn't the case. I was alert to the slightest sound. I'd hear the door creak, the footsteps on the stairs, and by the crunch of the mattress I knew he was getting

into bed with her. Every so often Marti could be heard to sigh, as if she'd just had a nightmare. By the end of the semester they no longer kept up the fiction, but I went on the same. I was alone in my bedroom and—I don't know why—I'd keep my eyes closed and pretend to be asleep.

In the morning I open my eyes and enter the world: I'm a brush, shouts the brush on the dressing table, and I'm an apple, shouts the apple next to the telephone. I'm the open umbrella in the corner by the door and it's raining, the umbrella says. I close my eyes again and everything disappears. I open them once more and everything returns with the precision of a puzzle. (It isn't that by closing my eyes the red apple next to the blue telephone dissolves, but that it becomes permanent, free from the death that was already hinted at on its skin. That's how I felt with my eyes closed, the same as being untouchable.)

"Buenos días."

The greeting awakened me as if it were coming from some faraway place. It was Marti's voice, but she wasn't speaking to me. She was speaking to a tape recorder. *Spanish in Thirty Days.*

"Buenos días. Buenos días. ¿Cómo estás?"

"Muy bien. ¿Y tú?"

You cross Walnut Park—she pointed out to me a row of smoking chimneys in the distance that were making sketches up above like a postcard from a different time—and there you'll see the building. Yes, *mija,* this is La Casa. How can I help you? On the other side of the desk the Puerto Rican girl from New York, on this side the one from the island, and between the two, like a bridge, the only language in the world. She laughed, showing her gums, and she spoke in spurts, shaking a single earring that reached almost to her shoulder and pulled her earlobe down. I feel evasive. All I know about

Puerto Ricans from New York is that they don't speak like us.
I feel like turning around and going out the way I've come.
From New York? No, from Puerto Rico. I see . . . Look,
Cindy here can help you, and from the next room voices in
Spanish, most of them with a rustic Puerto Rican intonation,
reach me. Finally Cindy arrives and leads me to an easy chair
in the parlor, and there we chat about all kinds of things, and
Cindy explains to me where I have to go and other things about
the university. She'd been born in New York to a Puerto Rican
family but had never been to the island. She was curious—do
they know Ricky Ricardo in Puerto Rico? Is it true that on the
island no boy will marry you unless you are a virgin? The truth
is I hadn't thought about it, although the question was always
there in the dark, hanging down behind everything like a bat.
Who was Ricky Ricardo?

On my way down the stairs, I ran into Margarita. Imme-
diately, as if I were looking in a mirror, I recognized her man-
ner and knew she was from the island, like me. Are you new?
Yes, are you? Right away she told me a strange story. She spoke
rapidly, unsure of herself, but since I didn't seem to be showing
understanding of her problems, she began to cry. We went over
and sat down on one of the steps, and between sobs she men-
tioned something terrible that the Jewish girls from Long Is-
land had done to her. That damned sorority, I hope it gets
struck by lightning! I didn't know what a sorority was, nor
what "the Jewish girls" were, and then she explained to me that
she was on the waiting list to become a member of one of the
most important sororities at the university. It was the dream of
her life, but she had to compete with three JAPs who were
ahead of her on the list. What are JAPs? Jewish American
Princesses . . . from Long Island, she added. I was waiting for

her to explain the whole sorority business to me, but then she gave me a cold, challenging look, and drying her tears with the sleeve of her blouse, she told me that when she registered she'd put down American. I've got the same rights as those JAPs, right? I remembered that you could declare your ethnic identity when you registered. Naturally, I didn't consider myself American, although I didn't really know what to consider myself. Hispanic female? Margarita and I both came from the island, we had more or less the same color of skin, we were both educated girls, middle class. But one of us must be lying about her nationality. Could I be the one who was lying? What was I? . . . Puerto Rico, I said when the political science professor made us all introduce ourselves, first your name, then your place of origin. "Vilar" came toward the end of the list, and a few ahead of me had already said "Puerto Rico," "Puerto Rico," "Puerto Rico." I didn't know there were so many in the class. When my turn came, I answered the same way, but smiling, hiding from my classmates' curiosity.

⸺ Walnut Park. Behind me the bells of Hendricks Chapel were striking twelve. At that hour the campus was a stew of young people with backpacks fighting in silence over possession of the day and classes. There was a blast of wind, the trees came to life, some copper-colored leaves drifted down and finally landed like dead wings, and squirrels were running over and through them. The campus was full of squirrels. Once I'd heard a Spanish teacher say that when the Romans gave a name to what is today Spain they used the Phoenician word "Hispania," which means Land of Hares. One rarely sees a hare in an American city. They must have fled, or maybe they went into hiding,

like rats. The most abundant creatures are squirrels, with an occasional skunk, the stinky ones.

It's still snowing. It's awfully hard for me to get out of bed. How much time has passed? Two hours? Three maybe? Well, it doesn't matter, if I hurry I can make class. Maxwell School Amphitheater: it horrifies me even to think about that huge hall filled with students taking notes and yawning while the professor speaks an English I really don't understand. American Government, PSC 121. It would be better if I just kept on sleeping. When you sleep, time doesn't exist anymore, or the amphitheater either. The class must be almost over by now and there's no point in getting up. Obeying the need to sleep—or something similar to sleep—I close my eyes and prolong the illusion. Most of the time it was a tunnel, and sometimes it must have been a hole I was falling through, never able to touch bottom. Finally I stop falling. I enter the dark chamber and immediately know where I am: the amphitheater. Sitting in the front row, facing the professor of political science, trying to decipher the question she's just asked me. I know that there are hundreds of eyes watching behind me. I open my mouth to say that I don't know who takes the place of the vice president when he takes the president's place, but I hear myself saying it in Spanish, and even though I realize the imbecilic mistake I've just made, I continue on because the book doesn't tell and she hasn't mentioned it in class, or if she did I didn't understand—my English isn't so good. The professor looks at me with concern, she must think I'm raving, but I manage to say, "I'm sorry."

"The Speaker of the House, stupid!" someone shouts from the back rows.

"Right," the professor says. And that's it. Class is over.

⟿ "And I thought you were just like the other Puerto Rican girls," Ivan says.

"What's the difference?" I ask him.

"The others all want to be gringas. Not you. You're like us, a Latin American."

There was something very attractive about Ivan: he was Colombian, he would be graduating soon in management, and even though he liked baseball (he wore a baseball cap and chewed gum), he spoke seriously about the problems of Latin America. *He* knew who he was and what he wanted.

That same night we went to his room and he tenderly played Jorge Negrete songs on the guitar until quite late. In the morning we talked again, and I, who'd been wounded by that business of being a gringa (we Puerto Ricans aren't one thing or the other, gringos or not gringos), mentioned an Episcopalian uncle who worked in the slums of Baltimore, my mother the socialist, and, of course, my grandmother, Lolita. Nobody could accuse her of being a gringa. An old woman of almost seventy who travels but refuses to use an American passport and creates nothing but problems for diplomats. When I finished talking, Ivan picked up his guitar again. First he stroked the strings, and then me . . . (Well, sex was like the food in Doña Sofía's lunchroom. There's nothing worse in life than being hungry when the other person is playing the guitar and you feel you've got nothing to give in exchange. What else do we women need to fall in love? I think that on that first night I practically told him my whole life. It was the only thing I had to offer him besides my body.) That November it was very cold in Syracuse.

For the nationalist leader Pedro Albizu Campos, Lolita represented a world where women and nation were synonymous:

> The brazenness of the Yankee invaders has reached the extreme of trying to profane Puerto Rican motherhood; of trying to invade the very insides of nationality. When our women lose the transcendental and divine concept that they are not only mothers of their children but mothers of all future generations of Puerto Rico, if they come to lose that feeling, Puerto Rico will disappear within a generation. The Puerto Rican mother has to know that above all she is a mother, and that motherhood is the greatest privilege God has given the human species. That there is oppression, that there is pain, that there is hunger, that there is death, we know all that; but neither pain nor hunger nor death is cured by murdering nationality in its very insides.

I had just entered the university, and though I was sharp, at the age of fifteen I didn't know any other way to reason. All the truth in the world resided in those simple words of Albizu: a syllogism written as an elegy. And always the same corollary: mother is nation.

It isn't that I rejected motherhood. When Mama died I considered myself the woman of a house where four grown men came and went at all hours and paid no attention to it. But just as being a gringa didn't tempt me, neither did being Albizu's transcendental woman. Being Lolita. Ivan saw me as a Latin American, but I felt myself to be just another woman among so many

on campus; and they were of all colors, blondes, brunettes, black, dark-skinned (the Hindu woman in the library who, every time she got out of a car, gathered up her sari like a princess; and Sylvia Tanenbaum, the Punk in Spanish 282, who fixed her red-dyed hair as she slowly read a sentence from *Pedro Páramo*). And almost all of us did the same things: we went to the library, and then to the bars on Marshall Street. You had to make friends, get a boyfriend, especially at the beginning.

Overwhelmed by so many demands, in December of that first year in Syracuse, I sat down to study the catalog for the next semester with Ivan's scientific eyes. At other times with the eyes of what I really wanted to be and didn't know—that is, with my eyes closed.

For almost two years Ivan and I would go on together, talking about Latin America like people who didn't want to be gringos. Ivan was a business administration major, and to him literature looked like café talk (he must have heard me talking to María about my interest in a course in Latin American literature). In my second year I'd taken some Latin American geography, and when I went to ask the professor if I could take an independent study, he spoke to me about a project he was working on. He showed me some sheets of very old paper on which everything was written by hand, very hard to read. "It's a demographic census of colonial Mexico," he said, growing enthusiastic over the manuscripts. "You can classify the types of death, dates, age of the deceased, sex, etcetera." Counting dead people and deciphering the descriptions of those dead was not precisely what I'd been looking for, but in the end I decided to accept. And I went back to my apartment with hundreds of dead people under my arm. Ivan thought that I was finally

studying something worthwhile. Classifying the dead was something concrete. I grew enthusiastic about my dead people, I would carry them everywhere, keep on reading and counting between classes, while I had lunch, in the bathtub. I organized endless lists; in some cases they told the stories of villages and whole families. It was like reading Juan Rulfo. I tried imagining them walking down the street, or making love, as if they were family members.

Ivan had another girlfriend before me. She was a tall, beautiful blonde. And I found out later, from my new roommate María, that she was the daughter of some Norwegian royalty and that she'd grown up in the gardens of the royal palace. Against that fairy-tale world, but also against the world of racial and political barriers that American universities are known for, the only trump card I had in my hand had to be my maternal grandmother. But which one? Dolores Lebrón, the Brooklyn seamstress? Violeta del Valle, the poet from Lares? Or simply Lolita, the heroine, the prisoner? There wasn't much doubt about it. With her history, her tragedy, my grandmother Lolita conferred on me the morbid prestige of being the granddaughter of the most political of prisoners. Twenty-seven years, can you imagine? Few had ever served more time for political reasons. I fantasized myself telling it with my mother's voice. (I was starting to imitate her during that period.)

I'd also begun to imitate María, my roommate. A loud bell sounds in the hallway; it interrupts my sleep with the same fascination as the bell at Jesús M. Rivera when it announced the end of the school day. And when I opened my eyes I could see

at the door a young girl with the face of a child, very dark hair that reached down to her shoulders, about to take a picture of me; for some days she'd been taking pictures at dawn for a class but didn't have enough light. "I'm María, your roommate next door," she said with the shrill voice of a child, or a grandmother, as she took the picture. Bombi, whose room I'd rented because she'd graduated in December, had told me that I'd have a Cuban roommate who'd grown up in Puerto Rico. "She's got all of our virtues and only a few of our defects," Gladys, my other roommate, added. "She's the daughter of a forensic pathologist who was in charge of the Vigoreaux case." I'd heard about the case. Besides, he was the same forensic expert who'd investigated the killings of the young Puerto Rican nationalists on Cerro Maravilla. We got to be friends talking about Luis Vigoreaux's corpse.

At the start of each semester you have to register and you feel like an idiot going back and forth from the registrar's office to that of your advisor. Registration is a race against the clock and sometimes against the truth. Viewed from a distance, the course list (political science, geography, history, linguistics, surveying) gives the impression of an ideal curriculum; from close up, it is simply one requirement inside another: the humanities core. My advisor is bothered when he sees that I picked Latin American Literature this semester. "Irene, aren't you a student of international relations?" He says it without looking up from his desk. "Yes, but it's one of my electives for the humanities core." The professor continues hunched over his desk, as if directing his bitterness at the paper I've just handed him. "Why not English Literature? Because it's too hard? Latino students always choose the shortest path in their electives. Since

they know Spanish, naturally . . ." I was about to tell him that I was taking Latin American Literature for a different reason, but he quickly signed and without even looking at me handed back the registration card. Good-bye.

I talked a lot with María that semester. We had much in common in spite of our differences, especially our difference in age. Everything about her was childlike, and even though she was twenty-five, she spoke with the voice of a little girl, which made you feel like sticking a raspberry Popsicle in her mouth. We always went to Phoebe's and we almost always picked out a table by the window. Strange people passed by because the university, the psychiatric hospital, and the ghetto all came together there. "Are you watching out for yourself?" "Watching out for myself from what?" "From him, silly, from him!" "Who's him?" "Whoever. The important thing is to watch out for yourself." And since I kept on asking questions, she suggested I see a gynecologist. And then she proposed using me as a model for her portfolio for things that move and things that don't move. I could serve her as a mythological woman: the one born motionless.

It was snowing one morning and with the heat of the sun the snow was turning into rain, and María came into my room all in a hurry with her camera in one hand and an umbrella in the other, telling me to hurry up because she didn't have any pictures of rain. "And besides, today I want you in motion. Dancing in the rain. Would it bother you?" She handed me the winter outfit she wanted to shoot me in and we ran out to Walnut Park. "Take the umbrella and jump!" I jump, I do it several times, even though I feel really silly. María takes pictures with one hand over the lens and the other on the handle of the tripod where

she has the camera mounted, repeating over and over for me not to stop jumping. Everything is seen through the camera: if it can be photographed, it exists, the rest is of no importance. Zoom. In her closet she has a box with thousands of photographs: poses, gestures, people. A thesaurus of expressive procedures.

———— Ivan was preparing the final material for his advisor, and I remember that day because I'd decided I'd go to Puerto Rico during the summer and see my grandmother Lolita while I was there. He offered to go with me once his exams were over. We were living together and, as on other occasions, we talked about politics. And just as when we'd made love the first time, the subject of Lolita came up again. From the very first day all I did was tell him about my intimate life; I even confided in him things I heard myself telling for the first time. I'd just met him and already I had told him everything. I didn't know why. It was the closest thing to asking permission. Two years had passed now and I heard myself just the same. I was still asking for permission. I was talking about my experiences as a child, but the real, secret protagonist was my mother, the erotic woman on the beach at Cerro Gordo or Caracoles. Who wouldn't be interested in her? Ivan listened to me silently with a mixture of curiosity and the wariness of a Latin American male. Suddenly I regretted having told him all those things, not holding anything back. I felt myself being observed.

One night I opened the door to my room and caught Ivan reading my diary. (He would say later that he did it to amuse himself while he was waiting for me to come back from the supermarket.) He must have discovered then that he wasn't the only object of my desire. That must have been the inevitable conclusion. I could have told him they were dreams, the fan-

tasies of a mind dissatisfied with statistics. That's what a diary
aspires to be, a slice of the most deeply buried part of the soul.
But even when it was that, it was unpardonable for a woman to
have dared to take the initiative . . . to fuck or to be fucked. He
kept on staring at me, feeding his rage, as he needed all the rage
possible in order to say what he was thinking. I didn't know
whether I should insult him for having invaded my privacy or
apologize for what he knew of me from reading my diary. I tried
to explain, but there is no way to explain to a boyfriend fantasies
in which he isn't the main actor. I'd written about things that I
would never have dared to tell anyone. I didn't even understand
them myself. He turned around as if to leave, but first he threw
the diary at me, telling me I could go straight to the shitty hell
I'd come from. I followed him. He stopped at the door as if
searching for an even more wounding phrase (he would have to
wait some time for that). As he left he gave me a shove against
the wall. He couldn't find the words, he didn't know how to get
back at me. María must have been on the other side of the door
all the time, and when she heard the shove she decided it was
time to intervene and she opened the door. "Come on," she
said, and she took me out into the courtyard of the building
where a party was going on. "Come on, forget about him."

That same night, as if I already knew what to do to
forget, I opened a pack of Nodoz and took fifteen pills at once.
All of them. (I'd bought them a few days before in order to
stay up all night to write my paper on Cortázar.) The next day
María kept knocking insistently on the door, saying that if I
didn't come out she would find some way to get in. When I
opened the door, there were the two of them. Ivan had come by
to ask my forgiveness. Everything was resolved, except that I
could still feel the lump of pills stuck in the mouth of my

stomach. What a fool—everything was settled and there I was, overdosed on stupid Nodoz. I ran to the kitchen and drank a quart of milk.

A short time before she graduated, María took me to Phoebe's to have a drink and we talked until late. About our plans, about Puerto Rico, about her father. I couldn't resist bringing up the subject of Luis Vigoreaux. I had still been living in Puerto Rico when his body turned up burned in the trunk of his car. During that same period there were the hearings on Cerro Maravilla. Those two stories occupied everybody's mind. No one on the island talked about anything else. My grandmother Lolita lived clinging to her television set. And María's father, it turned out, was in the middle of both stories. He was an incorruptible forensic pathologist who, instead of putting his stamp on official versions (and in Puerto Rico everyone knows what that means), limited himself to verifying the truth of the facts . . . as he found them in the bodies of the victims. The truth rested with the corpse and not necessarily in what the police said. In Puerto Rico everything is in decline, in descent; but Luis Vigoreaux would set up a greased pole at the beginning of his program *Climb, Kid, Climb,* and everybody would come out blowing bubbles. In exchange for bedroom furniture or a twenty-six-inch television set, somebody in the audience would try to climb the greased pole. It was a family program. Luis Vigoreaux, with that melodious voice that needed no microphone, directs the ceremony; beside him are his wife, wearing a wig of blond curls, and his two daughters dressed as clowns. In the center, the man on the greased pole, furiously trying to climb up. The audience shouts, Vigoreaux encourages him, his wife runs back and forth across the stage. Halfway up, the man

seems to hesitate, starts to slip. Then Luis Vigoreaux's wife and daughters surround the pole, touch it, shriek, "Climb, kid, climb!" Luis Vigoreaux was telling Puerto Rico: Get going, there is hope, it's just a matter of using your knees right and hugging the pole tightly. Get going, come on, make an effort. When they first found him in the trunk of his car the police weren't sure whether it was a man or a roasted animal. María had actually seen the color photographs in the pathology lab. What was there to see? Well, not much, a black blob, fried bones, teeth, the Rolex . . . and I, listening attentively, imagined Vigoreaux all toasted, his skin crisp and shiny like a suckling pig at Christmastime, like one of those piglets with the indifferent look that inspired so much respect in me as a child when I watched them being turned over the fire on that rod that came out of their mouth, and they were whole, from head to toe. I thought they were dying little by little over the hot coals and that it must have been horrible to die like that—and yet the piglets didn't show any pain. They seemed calm, as if they'd transcended the fire consuming them.

That's how Vigoreaux ended up, how the greased pole ended up, how *Climb, Kid, Climb* ended up, and even how Vigoreaux's wife ended up. Or rather, she ended up in jail, accused of having planned it all. Now there was nobody to tell Puerto Rico "Get going!" So there was nothing to do but talk about Cerro Maravilla.

"Did you see pictures of the boys?" I knew her father had performed the autopsy on the two young men killed by the police. I'd heard his testimony on television. He seemed sincere, but there is no way of knowing the whole truth. "I can't talk about that. It's part of the secret evidence." (Which, evidently, had been growing as the hearings progressed. And it pointed to

the police, the governor, and the FBI. It looked as if they'd invented a faction called the Grupo Macheteros as a way of infiltrating the *independentista* movement. One witness, for example, told how the police had made them kneel and how they fired in cold blood. What's it like when someone behind you is going to shoot you in the head? But in the end, nothing came of the hearings. They ended around the time I was leaving for Syracuse, and by then all that the island seemed to care about was a fly that buzzed into the courtroom every day and circled around the heads of the State Attorney and the witnesses. The television cameras magnified it, making it look like some grotesque horror-movie insect. During the three weeks of the Senate inquiry, the big issue of the day was always whether or not the fly, or one of its sisters, would alight on the heads of one of those involved.)

We returned freezing to death along East Genesee, avoiding the dark doorways of the ghetto until we reached the other ghetto, the campus. Walnut Park was snow-covered and the Christmas decorations were still hanging.

Ivan is reading in the bedroom. Last night we made love after throwing the diary into the bottom of a suitcase. (Never again would I fall into that trap.) There is no longer any anger between us, only a few scars. Now, on the kitchen table I'm writing my last paper of the semester with no other help than a dictionary and the loose pages where my class notes are scattered. I'd been reading Cortázar, and the few love scenes in *Hopscotch* kept coming back to me like an echo of many situations I'd lived. I couldn't say for sure whether the characters in the novel were meeting or parting. Well, at least I knew that.

And my thesis was that this uncertainty was a feature of the text: a man who's in one city thinking about a different one and, at the same time, looking for a woman he didn't know how to love when there was still time and only when he found out he was losing her did he love her. Convinced of the little I knew, I put a blank page in my typewriter and wrote the title of my paper: "Eroticism in Some Texts of Julio Cortázar."

It's still snowing. It hasn't stopped snowing for days. I can see the time on the clock outside the Hall of Languages. It's a quarter to twelve, the end of the class. While I struggle to climb the slippery hill, I say things to myself: "Surveying shouldn't be so hard for an engineer's daughter . . ." But I keep slipping on the hard-packed snow. (The tension, the imminence of confronting failure, brings me back to the reality of that exam day. I hear myself saying without too much conviction that everything is going to be all right.) In the distance the other students are already coming back with their surveying instruments. They must know how it's gone for them. But me? I don't even know how to use a compass! Determine the dimensions of Hendricks Chapel? Well, everything can be invented, fantasized, falsified, but Hendricks Chapel is more than a building, it's a symbol of faith itself.

"Vilar!" The professor looks at me, and while he writes an F on my paper (another one, it doesn't matter anymore) he says in a loud voice that he doesn't understand, that he doesn't know from what building on this planet I got the figures in my exam.

"What did you measure? If I were you I'd drop this course. There's still time. An F doesn't look good on your record. You know that, don't you?"

("Let's see, Irene, which way is north? Fine, now take the quadrant and stand somewhere over there, wherever you want. I'm going to take a point." Papa would station himself behind the transit and look through the glass toward where I was standing with the ten-foot rule in my hand. Lost among banana groves, gullies, and draws that separated the hills, sometimes fording streams, pushing through the dense woods, I couldn't believe that we knew where we were. With a machete or with your hand you had to push aside obstacles, branches, bamboo shoots, huge spider webs that went from tree to tree, from termite mound to termite mound. You could barely see the sky over the arch of leaves, the sun's rays barely cut through. Down below, the light was the color of algae, but we knew where we were and who we were. We were carrying out the survey. "Let's see again, Irene, which way is north?" Papa smiles because he knows that without the sky I haven't the slightest idea, and without the sky there is no up or down. Everything is a straight line that I follow in wonderment with my eyes. It seemed impossible to measure those places—the mountains aren't the coastal plain—and yet Papa went on, intent on the glass and the compass, and after several hours, deep in the growth of a mountain range that had never been surveyed until then, he brought us back over the way we'd come, as if he'd been doing it every day of his life.)

Take a drop. Drop the course. The solution was also coming out of the dark. Others have done it, lots of times. Everybody does it. It's legitimate. He'd give me a drop, it was all solved. How was I going to face the hundreds of students in the amphitheater? And the ones in Calculus? And those in my other classes? I couldn't find a way out. "Don't take it personally, it isn't personal," the secretary of the dean of admissions had told

me when I insisted on seeing the head person in the school.
Which one? There were a lot of them. And I told her the head
of all the heads. I wanted to find the center of that enormous
campus where I still had to go around with a map. "That's
impossible."

*My only baggage is my diary and a book with a red cover that I must hold tightly so the pages won't fly away (inside are the stories of Chuang Tzu, and in one of them the Chinese philosopher dreams that he's a butterfly, and when he wakes up he doesn't know who is who). I don't remember the reason for my carrying this book, but I do vaguely remember that before leaving the Hutchings Psychiatric Hospital they gave me more of the bright-colored pills, and that on the way my memory got foggy. It's hard for me to know what I ate this morning or what I did the night before, but as I walk apathetically from the one hospital to the other, things from other times cross my mind, like that day when we'd returned to the house in Palmas Altas and we went in and found the bathtub full of spiders. The nurses at University Hospital talk to the guards. They make us sign different papers. They*

*don't look at me, or they look through me as if I were transparent, or just an idiot, and they say, Fourth floor, and when you leave the elevator turn right and immediately after left and ring the bell at door 4B. The doors of the psychiatric unit are always locked.*

A child with very intense eyes comes close. I think he's going to ask me what I'm doing with a guard on each side. I don't mind his closeness and find, looking at his staring eyes, that I'm almost ready to ask him to do it, to say something. I do, but silently. He looks straight into my eyes and then goes away.

The guard hands me over to a nurse, a woman with a pleasant face who leads me along an L-shaped corridor to a large room and then to a smaller white room, and from there to another, and another. We walk side by side, in silence, and we cross the L-shaped corridor again until we reach a room with its door ajar. There are two beds inside. In the one by the wall, a very thin girl is watching me closely; the other bed is empty. It must be mine. I say hello. We exchange a few words.

That same night, in a very soft voice that I can barely hear, she teaches me about windows, how beautiful they are, especially if they're wide open and you can climb up onto the sill, dive, and take flight.

In the cool and straightforward corridors of a mental ward doors and windows are not meant to open or close.

Her name is Kelly. Around midnight we chat again. There's something fragile, a contagious sadness, in her way of talking. It doesn't seem possible to imagine her ever having been in a different situation. She is from Wisconsin. A few years back she stopped eating because she thought she looked fat. She got so thin she almost died, and her family decided to commit her.

*She was required to eat six times a day. And she began to get better, to put on a few pounds. One day, about two months ago, the janitor was fixing the window when the office informed him that he was wanted on the telephone. He went to answer and left the window open. And she couldn't resist. She ran over and threw herself out. She was on the fourth floor, and it was a miracle that she didn't die. But today they have her tied to her bed. Kelly tells me all this in a disembodied voice. I study the room. I walk toward the window and find, testing it with my own hands, that it's not very hard to open. This observation frightens me.*

⟜⟝ *The college boy, almost a child, walks up and down the corridor hunched over. The older woman, so elegant, goes back and forth along the same corridor and sometimes stops as if she doesn't know where she is. The lawyer, or the one who thinks he's a lawyer and dresses like one, spends the day asking the nurses for shock treatment. He's constantly asking to speak to Dr. L., who's the only one in the hospital who can administer electroshock. He thinks it'll simplify everything. He is all fogged up in his lawyer's costume.*

*University Hospital isn't Hutchings. Here the people are less crazy, more sad. Hutchings was closer to an asylum, with restraints everywhere. There were moments there when I was even able to forget the darkness I carried inside. The people separated into cliques, each with its special habits and wounds. In one corner the repeaters would gather. They all knew each other, and they all seemed to be great friends. They were called "repeaters" because after being released they always came back. They'd spent their lives that way, coming back to the hospital as to a reliable com-*

*mon place, after a brief parenthesis in reality. The boldest of them demanded privileges, felt healthy enough to have discovered the power of being ill, and when newcomers arrived, they put on airs, acted like lords of the manor. They considered themselves the aristocracy of the psychiatric hospital.*

*In the other corner of the room there gathered, in a manner of speaking, the chronic ones. They're really statues, monolithic beings who let nothing interrupt the slow death that keeps them there and will go on killing them, bit by bit. I never saw such defeated people. Surrendering to the enemy, the one outside and the one inside. In a certain way, the chronics at Hutchings were like the psychotics and catatonics of Ward C, only there was no need to show them much care. They took care of themselves alone. Death was taking care of them.*

*On the other hand, the hyperactives were everywhere and always in motion, going back and forth, inspecting even the dust in the corridor. They had a clever answer for everything and never ceased to be amusing. During my short stay in Hutchings, several of them treated me like a queen. My clothes must have fascinated them. One of the hyperactive girls offered to braid my hair; another proposed to tell me the complete history of the gods of the Orient; a young fellow, with the most adolescent expression I've ever seen, would smile at me all the time, and if I returned his smile he would blush and run to hide behind some partition. The hyperactives avoided going out. They're afraid of trees, dogs, people walking in the street. Inside, they can function, and perhaps that makes the doctors think that with a little therapy and lots of support they could function just as well on the outside. They leave, and in a few days they're back, or they're brought back, bewildered, convinced that outside is death . . . in slow motion.*

*And then there were the startled ones. They seemed unable to comprehend the bright day, the food, and the fact that they were inside. They just stood there, mouths half-open all the time, in permanent astonishment. And before taking the most ordinary thing into their hands, like a cup, they would examine it for a terribly long time, and only take it with distrust.*

*At University Hospital the contrasts are not so great. The patients are anorexics, manic-depressives, an occasional drug addict, all generally middle- or upper-middle-class, awash in social tedium; once in a while you'll see a harmless schizophrenic. And from time to time there are suicidals. But contrasts or no contrasts, they all look as if asleep. It is not reality, it is a dream. The other face of the American Dream. And there's a lot of monotony in this other dream, with little tics and habits that are quite contagious. I catch myself continuously shaking my legs or hunching over when I walk, and I can even hear myself speaking somebody else's phrases and repeating them in my sleep.*

*The ivy vines climb up the wall of the building and peep in the window. In the short time I've been here I've seen them grow, and I've got to protect myself; otherwise they'll reach in, get into my bed and into my dreams. I'm frightened by the possibility that all this will intersect with my life, that one day I too will be trapped, and think that the only way out is through the window. With my Chuang Tzu in my hand I tell myself that everything, even the window, is an illusion. But inside me I know it's not true. One step beyond the window and there's no second chance, not even for butterflies. But I understand Kelly so well. You feel good knowing that at any moment you can end it all—"Rub it out and start from scratch." On the other hand,*

*I'm only here, under the protection of some kind of mental charity, sunk in an amorphous, undefined mourning that doesn't end and that sometimes, especially in the morning, turns into an unbearable burden.*

*LARES, 1940. Someone goes and someone stays.*

With a baby in her arms, Lolita is climbing up the slope that leads to her parents' house. The house is on the outskirts of Lares, built on a hill in the Mirasol district, and from there, the surviving coffee trees can be seen down below, scattered across the valley. She's come to leave it with Mother Rafaela, maybe just for a while, or maybe forever. A few words will be said, some promises will be made, and she'll leave with the bad taste in her mouth of someone who doesn't want to wait and has decided to be on her way. She's twenty years old. It's the typical scene of a mother who hands over her daughter; it follows all the rules of melodrama: the abandoning mother and the abandoned daughter, separating with the promise of coming together again, knowing that it's always

that way and that there's nothing to do but choose between abandonments. *Someone goes and someone stays.*

⚓︎ She'd been alone for a long time. (She always had been, in the sense in which mystics understand the word.) Now, in the smooth language of the novels, let's say that her father, Gonzalo Lebrón, used to take her through the fields to show her the landscape along the edge of a pond of yellow water near the River Guayo (which is really only a thread of mud down the center of its channel). The truth is that his only worries revolve around the sky, which won't release a drop, and coffee, which is the only thing he knows, having worked as a day laborer in the fields. Over there, in the plots, men and women are planting midget trees, coffee plants, in rows of furrows, one after the other. Those little trees had grown in nurseries, alongside older, leafy, protective trees that with their shade made sure they grew well and didn't lack for moisture, which must be constant in the trees' infancy. Now they're planting them, placing them in previously dug holes, covering them with earth and mule manure on all sides, but especially around the stalk, so that they're firmly anchored and the neck is higher than the level of the hole, so that the roots won't drown, because they always come up to the surface, always looking for air up above to nourish the tree.

He'd been promoted. He was now foreman of the Mirasol Coffee Hacienda; he no longer lived the miserable life of a day laborer. They'd even given him a little house for his wife and children, and for that he was thankful. The new landlords, the plantation owners, had trouble finding hands and the government saw to it that anyone without an income or a deed to property (almost nobody had these) was obliged to hire out as a day

laborer. The same old story: people don't have any income, they go into debt, they find themselves obliged to pay. With what? Why, with their land. The big plantations live off the accumulation of land, which, in addition, provides them with cheap labor. When a *jíbaro*, a rustic, loses his land, he becomes a day laborer. Now, getting to be foreman is a piece of good luck, it's moving up to the best of all possible worlds. Otherwise, it's New York.

He talks about coffee. Gonzalo Lebrón always talked coffee, he understood coffee, coffee was all he'd ever done in his life. He was a peasant, and his parents and grandparents had been too, as far back as he could remember. He knows what to do to grow the best coffee in the world, a secret that neither the Brazilians nor the Colombians know. And, as if it were a legend, he learned it from the mouths of his elders, *jíbaros* who, like him, spoke nostalgically of the weather, of the rainstorms they could remember when they were the owners of the land.

So, growing coffee is like raising a child. At first the newly planted coffee requires a little rain to grow: you have to give it time to flower and avoid having the leaves eaten before the flowers bloom. And the same thing goes when the coffee tree is growing. It shouldn't rain much, else there won't be any pollination, and the flower will be left sterile. But when the fruit comes out, it needs lots of rain in order to make leaves grow and to fatten the fruit. The cycle goes back to the beginning, when the berries ripen. Once more, they need only a little rain, because this time the weight of the water would make the red berries fall prematurely and the sun would leave them all fermented in a thick white drool. That's why you've got to be on guard in September; the coffee's ready then and it has to be harvested before the rains come.

He is a good father. And a good foreman too. He gives them instructions. Never pick green berries, only those with a bright red color; a mixture of green with red gives the coffee a sour taste, like shoe polish; and you should never pull the fruit from the branch, it can lose its tip or be damaged; and you have to be careful to protect the buds, where the new blossoms will be born; in Brazil they're a bunch of savages, they shake them and that gets the flowering of the next crop all mixed up, sometimes it even kills it.

The planting goes on from March to May and the harvest from October to January. Between May and September nothing happens. Those are the dry months. Gonzalo Lebrón isn't one to trust his memory. He jots down in a notebook what each tree bears: one *almud*, two, three . . . Each *almud* is twenty-eight pounds of coffee berries, which, later on, after being passed through the screen, will end up being only five or six pounds ready to be opened, fermented, and dried. Once dry, the beans are stored in bags that have to be moved constantly, turned so that the heat won't damage them.

Gonzalo Lebrón knew all that; and he also knew that this harvest wasn't going to make it. And anyway, the San Felipe hurricane had swept everything away. In the future he'd have to grow oranges for New York to make up for the bad run of luck.

Meanwhile in between droughts and hurricanes—the Caribbean is a cross section of this obedient cycle—people's moods are shaped, and nationalities, and landscapes. Around the early 1800s, coffee arrived. It had previously passed through Martinque before being planted in Haiti and Santo Domingo. To put it simply, coffee doesn't grow all by itself, and its story, like that of many other things, before it became a nostalgic subject of conversation,

paralleled the lives of people, those of my grandparents and great-grandparents and of so many who one day would cheer themselves with the memory that they had really known how to grow coffee. At least the people from Lares did. It had been the best in the world. And the most expensive.

⟶ Chance brings people together for a while. Gonzalo Lebrón, just forty-two, would die toward the end of 1937 (the family already aware that his demise implied the loss of the house on Mirasol Hacienda), but before, on the feast day of nards and roses that Lares dedicates to the Virgin every year, his daughter, Dolores, would be crowned Queen of the Flowers of May. Lares declares her the most beautiful, and no one tires of looking at her. Dolores Lebrón, Lolita!

She was a sensible woman, and a stubborn one. She only made it as far as eighth grade, and was later trained as a seamstress, but she took the pen name Violeta del Valle. Everything is possible if you are young and daring. She taught herself to write her dreams into poetry which, at her age, was perhaps immediately mingled with family needs: her father's tuberculosis, the imminent danger of losing their house.

Among her admirers was a man whose name is now veiled in family secrets: Francisco Méndez, Don Paco, the engineer entrusted with government funds for the urbanization of the valley. In those precarious days, institutions like the PRRA (Puerto Rico Reconstruction Administration) could be very helpful in obtaining a moderately comfortable house and perhaps some land, which for the Lebrón family meant a lot.

⟶ During the summer of 1939 the land in the mountains must have been drier than ever. The same story was being re-

peated, over and over. Every afternoon, two or three clouds would come down from the mountain and station themselves over the slope of the town, and for several hours the skies seemed ready to burst open, as in good times. Lolita must have been one of the many young women who during the afternoons of the drought would come out with their basins to wait for the rain. She was nineteen. Photographs show her striking melancholy poses, slim, fragile, someone who could break easily. But they didn't show that, in addition to waiting for the rain, she was also waiting as something grew in her, in her own body. How else could you say it? "Expecting a child" is the preferred expression, but Lolita must have been experiencing that pregnancy as an organic thing, something that kept on growing in her in spite of herself. Did she want that child? Was she committed to this new role? Or did she simply not know how to avoid it; in 1939, the body of a poor woman still obeyed its own laws; there was no alternative but to "choose" motherhood . . . or infanticide.

In September it finally rained in Lares. The family still remember it as a great event. They still talk about how they all went out that afternoon with their eyes closed and their mouths open for the downpour to drown them. "And to set out basins, child. There wasn't a drop to be wasted." Lolita didn't go out into the yard that afternoon. She had to be careful those next months. My mother was born in San Juan at the end of the spring of 1940, and it was a repetition of a phenomenon that has fed the mini-tragedies of colonization; the engineer Paco Méndez wouldn't acknowledge her, though he did condescend to send her an occasional envelope with cash.

On March 18, 1941, Lolita's brother, Agustín Lebrón, takes her to the port, a scene central to the fate of two women:

my grandmother and my mother. As she goes on board the *Marine Tiger,* an officer inspects her papers. Lolita Lebrón. Date of birth: November 19, 1919. Born in Lares, daughter of Rafaela Sotomayor and Gonzalo Lebrón, both of Lares. Single. Destination: New York. She goes up the gangway as years later she will go up the steps of Congress, and I can imagine her looking for the highest spot on deck, from which to wave a last farewell to her brother, and for the last time to the coast of a country to which she would one day have to return to reclaim her daughter, to unite with her again.

⸺ All of those who were leaving sailed with a promise to return. Right there on the docks they entrusted their children and belongings to family members, assured they would soon be back for them. New York is harsh, everybody knows that. Sometimes, you know, there's no time even for English, you need to get ahead. And getting ahead means so many things: Latin rebelliousness, the optimism of a young people, and a lot of Anglo-Saxon triumphalism. Getting ahead, at all costs. The opposite is looking back. Back? Almost everybody has gone, the only ones left are grandparents and grandchildren. And the myths . . . Someone from Lares can be pro-Yankee, but if his town is mentioned he becomes transfigured, as if on those squares and in those churches left behind the truth would still be alive. Few think about coffee. Lares is nationality, and, no matter how far away, when Lares is mentioned to one of them he thinks about 1868, *el grito de Lares,* the Shout of Lares, with which Puerto Rico began its anticolonial struggle against Spain. If the processing plants and the port are in San Juan (facing north, their backs to the country), in Lares lives the spirit of the land. Usually they speak of the taking of Lares by the native-

born. The failures are seldom talked about, that of 1868 and the many that followed. But it makes no difference, the language is alive in Lares. And the words feed hope, or forgetfulness. The truth is that in 1920 Lares was still nothing but coffee. In the thirties it would be half coffee. And in the forties, around the time Lolita left, it was one of those towns that one might read about in some Latin American novel, a rather pitiful town, down to its dregs.

I remember a TV commercial from not so long ago: scenery followed scenery—not a single human being—at a fast pace, the all-enveloping eye of the camera brushing the brown continental earth like a gust of wind and leaving the viewer to wonder, with a sigh of longing, what land one was being called to. Classical music stirred in the background. I seemed to recognize some landmarks (was that El Morro?) but wasn't sure until the end, when the music blended in with the voiceover: "Puerto Rico. Discover a continent." I watched in amazement, thinking, just for a second, "My gosh, there is so much there I've never seen." But wait, a continent? This attribute gave Puerto Rico strength, legitimacy. A continent: strong, imposing, grand, existing. A continent: untamed, nature not yet penetrated.

The tourist trademarks of Puerto Rico.

Another commercial followed. This time there are big letters, right from the start: "Jamaica. Discover an island." A sensual black woman walks a dirt path, a basket of fruits balanced on her head, while a casual tourist passes by, looking at the woman's edenic smile. Another shot reveals a very old black man sitting in a plaza, smiling a peaceful smile at the visitor's tender gesture. And aquatic, turquoise Jamaica goes on and on, fruits, flowers, plants, pottery, brilliant silks, saltfish, yams, more flowers, more fish, and the reggae tunes.

And my grandmother's Puerto Rico? I remember learning more in school about the flaky snow, the rocky precipices of the Grand Canyon, than about the foamy open seacoast of my town, Barceloneta, or the outlines of the surrounding canefields. Perhaps the most vivid memory of childhood was hearing about a mayor of San Juan who ordered an airplane full of fresh American snow to be poured down on the bewildered, sweaty faces of the residents.

Trying to come to terms with its own myths, the tourist industry needs to give the island a legitimate attribute: a continent, a vastness, an illusion of magnificent landscape where people are absent. Put a Puerto Rican in the picture and you kill the ad, the appetite. You return the island to her lingering status as no-nation, an uncomfortable mirror for both Americas, somewhat shapeless, devoid of identity, of truth, something painfully deceitful that one would rather not look at.

The slogan "Discover an island" won't work for tourism's agenda in Puerto Rico. An island full of Puerto Ricans? The other Antilles can remain islands, the weak, ephemeral, and frugal played as exotica, because they are still foreign, not main characters, like the Puerto Ricans, in the North American saga of colonialism and its immediate product: immigration to the U.S.A. As long as we stay down there, dirt shines like a smile—it's part of exotica. But the moment we pretend to enact our own dreams by getting closer to the other America, appearing in TV commercials or living among them, their dream is our nightmare. Dirtiness is a problem of space. Mixture is promiscuity.

In 1683 Louis Hennepin painted a marvelous picture of Louisiana, a true New World paradise. Only the aborigines flawed the scenery, and so every effort would be made to keep them away. Of course there were the William Penns and the

John Lawsons, offering a more idyllic, Rousseauian view of the noble savage. But there is no doubt that both traditions survive in us, percolate their presence through the centuries, ultimately to impregnate a tourist ad in which an island that does not conform to their idea of progress must be disguised as the uninhabited, pristine continent of Louis Hennepin.

*Do you want to hurt yourself? There's no need to open my eyes or answer. It's Miss Boyd's shift. Every fifteen minutes she pokes her head through the door with the same question, the same pained face waiting for my answer.*

*"No."*

*For three days now I've been saying that same no every fifteen minutes. But I keep on thinking about the window. Later on, in our session, Dr. L. asks me the same question.*

*"Yes."*

*Self-esteem—me first—is the magic formula. But the only thing that makes me feel good in this hospital is seeing Miss Boyd's relaxed face when I say no. You first, Miss Boyd. I'm a Christian. Every fifteen minutes I lie to her. And every fifteen minutes I thank her for believing me. And I even believe myself.*

*You've got a visitor, the nurse told me as she was getting out the only change of clothes I'd brought with me and which was hanging in the closet. I'm sitting up against the bedstead, still wrapped in the sheets, and I pretend to be looking out the window. I'm not looking at anything. I've promised myself that there's no God who can get me out of bed today: I'm going to stay like this, looking out the window. But the nurse lays the slacks and blouse over my legs, telling me that the person who's just called from reception is my father and that he must be on his way up in the elevator at this very moment. It's true that I was expecting his visit. At Hutchings I learned from the Hindu psychiatrist that he'd been informed by the university that his daughter had had a crisis. I knew that sooner or later he'd come to see me, but after that I didn't think about him anymore. Or about my family. Because we were following different paths, and he already had the explanation, he'd had it ever since the night he helped me fill out the forms for the university in the kitchen. He asked me if I'd really made up my mind about going. He told me that when he was a student in Mayagüez his best friend had got so involved, so wrapped up in his studies, that one day he stopped coming to class, and when they went looking for him, after three days, they found him all covered with piss and shit, talking to the walls of his bedroom and writing equations in the air. It's not the same thing, of course, but maybe you ought to wait, not because I don't trust you, or because I'm selfish, you know that, but you're only fifteen. I'd thought everything through and I told him that I'd never piss on myself, he could be sure of that, and we both laughed and that was that. As he left the kitchen he turned and said, several times, that he was burned out, you know, the poor guy was*

*burned out. I'd heard the story before, the novel about the man whose brain dried up from studying so much. In 1984 this seemed more like a cliché than anything else.*

*And now, four years later, I was waiting for him in the Ping-Pong room, at the entrance to the section. He passed rapidly through the other door of the corridor, leaning heavily forward, the way he'd go to the bank or the post office two minutes before closing time. He must have come with the idea of taking me back to Puerto Rico with him. I suddenly thought that might be his intention, and I panicked. He must have felt the same way when he saw me, because he turned pale. Behind him my brother Fonsito and his wife came in and didn't say a word. I'm all right, I tried to say, to ease their shock. But instead I turned my back on them and began looking out the window. I felt sorry for them, having to take in a scene like that; but turning my back on them made me feel good, the farther away I got the better I felt. I was giving something back to them, I didn't know quite what, but I did know that it was all right. That they deserved it.*

*"Hello, Irene. Can't you say hi?"*

*They left us alone. I felt his hand on my head and I thought how little we'd been together.*

*"Tell me what happened. Was it that? Did you burn out?"*

*Questions without an answer again. I didn't know what to say. I put my arms around his body, and the pain was so great that my throat dried up, everything is a big failure in your family, there's nothing left for you to say, tell him, but I don't, I can barely breathe, and I hear myself saying words broken by stupid moans. (How can I tell him? We'd have to go back to the beginning. But to what beginning?)*

Dr. L. is short and when he sits in his chair his feet hang about six inches from the floor. In the three sessions we've had as doctor and patient, all we've done is play cat and mouse. The doctors always make me talk about my mother. I've lost count of the times I've talked, mechanically, about the same things. It's become easier for me to talk about my mother's tragedy than the disgust that's been taking over my body, the rotten smell that comes from inside me.

"Any hallucinations?"

"No."

"None at all?"

Well, yes, in Hutchings, but that wasn't me. A train with a newlywed couple passed right through the middle of my room. It was the pills, I know that. But the bride had on a long veil, as long as all the coaches together, and it reached up to my bed, brushed against my face, and I had to spit it out of my mouth, but I knew it was because of the pills. That's why I can't sleep, because as soon as a dream begins it changes into another, and another, one inside the other, until in the end the tiniest thing becomes the largest monster. (But at the station it hadn't been the pills. I'd barely opened my eyes but I could see the letters in red and white. AMTRAK. That morning I'd taken a taxi to the railroad station. All I had was twelve dollars and I gave it to the driver. Behind the building, facing the tracks, I sat down to wait for the first train to come. I didn't want to look at the timetable. It would be easier if I didn't know. I could hear the sound of the train getting louder in the distance. I closed my eyes. The sound and the speed grew inside me and on the tracks like a wild lullaby. I opened my eyes. The train was continuing at the same speed. It probably wasn't going to stop. I walked over to the edge of the

*platform. I calculated the distance, the rails, maybe the pain, and then the train had two headlights and a red stripe underneath, almost a face. Hey! That's not your train! Get away from the track! I looked back and saw him coming. He had on a blue uniform. The train went through at full speed and I almost fell. It was a train with only a few coaches. There was still time . . . it wasn't the same anymore. The man in uniform ordered me to stand back because a train might come all of a sudden and take me by surprise. I hated him. I stood there with a knot in my stomach, looking at the last coach of the train moving away.)*

"Dreams within dreams," he says, stifling a yawn. "They can't do you any good. I'll have them give you something so you can sleep. And that's all. But if you don't put on some weight, I'm going to have to prescribe a special diet for you."

*Eating and sleeping. Managing both things was already halfway to sanity. But what about the other half?*

*I wanted to ask him what was wrong with me and I kept looking for the phrase in English. What's wrong with me? No. What's the matter with me? No. What's happening with me? Maybe.*

"You're not sure?"

"Of what?"

"If you're hearing voices?"

*I'm no fool. If I say yes, I'm crazy, if I say no, I'm lying. And besides, they weren't voices, there was only one. I knew it. It wasn't as if it was somebody else's voice. It was my voice, the one I always used at play, to excuse myself, to talk to myself, to talk to other people, to God, and to put myself to sleep. Mine had been the perfect monologue, as if I had been carrying a portable confessional inside. But over the past few months things had changed, I began engaging in more dialogue, not only with myself but with objects, the most insignificant ones; a cobweb on the*

window, for example, would catch my eye and I would have to comment on the cobweb to the point of weariness. Sometimes I would talk in English, with an exaggerated accent; sometimes in inaudible whispers; on occasion I'd raise my voice to return to the usual monologue, to the thankful voice. The last few times I went to the library, I went to the fourth floor, to the PQ section where the Latin American and Spanish literature collection was shelved. I read haphazardly, and if I found some interesting phrase, I would memorize it, or try to, because it was very hot in those cubicles on the fourth floor, and that voice of mine would begin to babble, and it would be as if they'd put my head in an oven and it had exploded, like an eggplant you bake without per- forating the skin. Right then and there the dizziness would start in my head and move from my head down to my feet. They call that swooning, though it's not as sudden as fainting. That's why I didn't hurt myself.

What's happening to me? What's going on with me?

"Did your mother breast-feed you?"

Mama again!

"It's important to know."

"I don't know. But I doubt it." We ate a lot of Chef Boyar- dee at home and my favorite dessert was Gerber vanilla custard. Besides, my vision is dotted with little orange and white dots.

"When?"

"Sometimes."

"Now?"

"Not now."

"Do you feel like dying?"

"Sometimes."

"Now?"

"No."

*Doctor L. looks at his pocket watch.*

*"We'll continue tomorrow."*

*"But tell me, what's wrong with me?"*

*"That's why you're here," he says softly, "to find the answer."*

*"And how long is that going to take?"*

*"As long as necessary."*

*I wait for absolution. The recipe. How many Hail Marys? I've only been to a confessional twice, but I've seen them in lots of Mexican movies. In a dark corner of the cathedral the girl kneels at a tiny booth carved in wood and surrounded by angels and Christs. Inside, the father confessor usually looks into space with heavy eyes, and he talks to her of mercy.*

*She spends a lot of time there. In the day room.*

*"Aren't you going to bed?"*

*Miss Boyd brings the little glass of Benadryl and water. As if she'd guessed that I can't sleep again, she sits on the bed and asks me if I feel like talking.*

*"I'm going to ask the doctor to let me leave."*

*"But yesterday you liked being here."*

*"I'm going to fall behind in my classes, and besides . . ."*

*I've already talked too much. So much energy just to say one word. But I've got to get the strength from somewhere to continue.*

*". . . besides, I've got a lot of things to do."*

*Miss Boyd's hand feels too warm. Good night.*

*Dr. L.'s eyes have no sex. They're not those of a man or a woman. They smile but they don't seduce. Nor do they let themselves be seduced. We'll see. We'll see if I tell him the same thing I told Papa. I wanted to get back to my studies. Graduate. After*

*all, if I'd really wanted to kill myself, I would have done so already, right? The first seventy-two hours had grown into seven days. At the fourth session I got back to talking, about leaving. It seemed to me that the doctor was sympathetic to my arguments. My only desire was to go back to class, to study. It wouldn't be fair to prevent me from finishing my studies because of a simple crisis, which, after all, was only that, a simple crisis. The doctor didn't say a word, but two days after Papa left, Miss Boyd told me I'd been given my release.*

*In the room I tell Kelly I'm leaving. She looks at me without any emotion.*

*"I hope you don't come back," she says indifferently, as if from the very moment I told her about my leaving I'd become part of those out there, those on the other side of the window, those whom she was struggling with and whom I was now joining.*

*"And why should I come back?" I asked, although I foresaw the answer.*

*"Because all of them do. I've seen them." It never crossed my mind that she might be right. Kelly was speaking in a low voice, I could barely hear. Finally I fell asleep.*

*She was probably right. A few days back I'd wanted to die more than anything else and now all I could think of was leaving, studying, graduating. Before releasing me they had me sign some papers and gave me copies. On the page with the diagnosis "acute depression," the word "acute" had been scratched out and above it they'd written "severe." I leave with no more baggage than the blue hospital stockings and the Chuang Tʒu, its covers completely tattered now. I put the copy of my diagnosis between the pages of*

*the book and enter the elevator. Going down has been the only motion I'd managed to execute for a long time now. When would I go up again? And this elevator, would I return on the same one? Kelly's words haunted me. I wasn't frightened. You can always come back, I told myself. And leave again.*

*Tomorrow we can be Yankees.*

RUBÉN DARÍO, 1905

*We're Yankees now.*

RAMÓN CASTAÑER, 1898

SAN JUAN, 1950. On the morning of October 31, a green sedan with six men inside rolls into the palm-shaded cobblestone square before San Juan's Fortaleza, the residence of Governor Luis Muñoz Marín. It may seem a scene out of a Hollywood gangster movie, but it is not. The six young men inside have taken the path of no return. Their pistols, rifles, and machine guns will soon prove to be real, as real as their determination. The car finds its way around the three-hundred-year-old palace. Suddenly the doors open and the six men run for the entrance, yelling "Viva Puerto Rico Libre!" It is as if they were waiting for them. From the rooftops, guards pour fire down on the men. Of the six men four die, another is badly wounded, and the sixth is taken prisoner. They are Puerto Rican

nationalists. Soon violence and gunfire will erupt all over the island. Seventy nationalists seize the town of Jayuya; they attack the post office, the police station, and the selective service headquarters, killing four policemen. Something similar happens in Ponce, Mayagüez, Utuado, and other towns. Governor Muñoz Marín calls out the National Guard. The guardsmen hunt down the nationalists with bazookas, tanks, and planes. It is the worst uprising since the United States took over the island in 1898.

Next day, in Washington, it is President Harry S. Truman's turn.

Blair House was then a dangerous place. According to the newspapers, its severe four-story façade rose almost flush with the sidewalk along busy Pennsylvania Avenue. Its two entrances were only ten steps above street level. President Truman had been living here for two years already while the White House was being made over.

The Secret Service had precise instructions. Agents with submachine guns were posted behind both front doors, and uniformed White House guards stood at two sidewalk sentry booths and at posts along the curb. It happened anyway. A White House cop was pacing back and forth along the steps of Blair House while on the sidewalk, some feet away from him, a neat, dark man aimed a German P-38 semiautomatic pistol at him. It went off just as the cop jumped, reaching for his own revolver. The man kept on shooting. As the Secret Service men went into action, a second dark man appeared, yanked out a Luger, and began shooting at point-blank range. Two private guards went down, both of them shot. There were more shots. The first dark man was trying to reload, when he was hit. The second man fell dead with a bullet through his ears. A Secret Service man looked up, saw the president, who had just been

aroused from a nap, peering out an upstairs window in his underwear. He urged the president to step out of sight. Down below, guards searched the gunman, pulling out his shirt and carefully snapping the elastic band of his underwear to be certain it was not hooked to a hidden bomb mechanism. They asked his name. Oscar Collazo was his name. His dead companion was Griselio Torresola. They were Puerto Rican freedom fighters.

In Washington's Gallinger Hospital, the wounded Collazo told his story. He and Griselio Torresola had known each other for only two weeks before they agreed that it was their sacred duty to kill the president. And so they came to Washington and found themselves in front of Blair House, not knowing if Truman was actually in. Had they read the Washington papers they'd have known that they could have had a free shot at him when he left for Arlington that same day, but they hadn't bothered to read the papers. "Any well-dressed man who is willing to die himself can kill the president of the United States," Calvin Coolidge once said. When asked how he felt after the incident Truman answered, "The only thing you have to worry about is bad luck. I never have bad luck."

NEW YORK, MARCH 1, 1954. She'd chosen a green kerchief, tied it around her neck; it matched her hat, also green, though it was a slightly lighter shade. The photo shows the familiar expression of pain, that self-effacing, defiant pain which haunts me since I first saw her, in 1977, at my mother's funeral.

In another photograph, by the Capitol stairs, at the very moment when she was arrested, the details of her outfit can be seen: starched skirt and jacket, silver earrings, black patent-leather high-heeled shoes. All this given a glaring majesty by

the language of the press, and by the slight epic angles of the photographs. Had she perhaps dressed that way out of sheer vanity? Or to feel up to the level of such an undertaking? That would be like her.

It was raining in New York. Irving Flores, Rafael Cancel, and Andrés Figueroa must have been waiting for her in Penn Station. They would probably buy one-way tickets for the train to Washington, for they certainly meant to die. That was what they believed, or wanted to believe. Not because they were rushing blindly into it, as Griselio Torresola and Oscar Collazo had done. But because after Blair House death became the standard, the expectation that brings it all together. Death and love. And now, like Griselio, she too turns toward it.

In the afternoon, Lolita is climbing the steps of the Capitol with her three companions. Holding on to her gold-crested purse, which must have shown up sharply against the starched skirt, she advances, step by step. In the purse she carries a gun and a letter that she herself wrote in English. It is a cry of conflicting voices, humble and arrogant, that she hears and answers. But before we may know anything more of those voices, we must wait. Right now she has everything to lose and nothing to regret. Now the only thing that exists is the steps, the scenes of her life that must be passing before her eyes, before and after, obsessive, like a film now that she can't do anything else but go forward, climb those steps, one after another, and another— how many more? Hundreds, a thousand, the whole colonial past of America was there, its cruelties echoing at each step, unchanged, unforgotten: Mexico, Panama, Nicaragua, Cuba, Haiti . . . and, of course, Puerto Rico, one of Spain's first New World colonies, one of America's last.

In school, one of the great surprises was to read Europe's eighteenth-century philosophers, who wrote with that same condescension about the peripheral parts of the world, like those places where I come from, at the fringe, places born out of their imagination but which I could hardly visualize as my reality. It was a writing that maps and labels, describes, examines, and yearns to possess. Their crucial questions about Reason were so hopeless; Nature, Natural Man, their dearest subject, stumping out of primitive paradise, had nothing to do with our tormented souls, our landscape.

There was also this confidence of the traveler, the bystander who seemed so full of firsthand experiences, first-rate accounts. And if initially there had been a great curiosity about the New World discoveries, because they held valuable information about the past, about what Primeval Man once was and had lost—"In the beginning all the world was America," the lost innocence—it would soon progress into an infatuation with the future, a merciless effort to guarantee that man would never regress to that noble but nevertheless savage stage.

And yes, the model of the future was already there: Western, European Man. The rest are, naturally, inferior. And if they do rise above their handicapped condition, it is most likely because of an ability to imitate, emulate, in the manner of children . . . or parrots.

A partial world, right smack in the passage to the New World, the typical setting of so many Caribbean nations inhabited by castaways and refugee smugglers, dripping through as in a coffee strainer, waiting for sugar, but before sugar it was gold, and this, for the Tainos, went all the way from forced labor right up to their physical annihilation. By the middle of the sixteenth

century, Spanish investments found new avenues in the silver rush of the Andean and Mexican parts of the empire. Puerto Rico and the other Antilles somehow vanished from the picture, remaining largely cut off from the currents of trade of the West until the start of the nineteenth century, when Spain's strength was exhausted and its great colonies slipped away. The wars of independence in the Spanish colonies brought to the island the leftovers of the intolerant Spanish establishment fleeing from a new wave of native-born administrators and military men, themselves intolerant. In 1815, a weak and defensive Spain struggled in San Juan de Puerto Rico to undermine the possibility of any infectious separatist sentiment coming from the newly founded republics of Latin America by proclaiming the Cédula de Gracia, which softened the tariffs on imports and exports and permitted free trade; immigration was further boosted by the promise of land to each white immigrant, plus a bonus for each slave they brought along. The forgotten archipelago, especially Puerto Rico, would receive under the umbrella of sweetest sugar the remnants of a displaced violence. And curiously enough, they could become Spanish citizens. So, a new wave of immigrants came, white people, the Corsicans and the Catalans, and the Majorcans, fleeing the epidemics that finished off the vines and orange trees in the Balearic Islands. Via the Dutch islands came the New Christians—the converts, sixteenth-century Spain's most intimate obsession. And, preordained by the very structure of Spanish colonization, the blacks too came (no longer sporadically but by the shipload), *bozales* driven forcefully from the coasts of Africa and other Caribbean islands as hundreds of small sugar haciendas proliferated and legal coercion of the landless sanctioned the much-awaited production boost. And thus the story of sugar begins, capable at

once of securing hope and oblivion. Time after time a typical plantation system finds it difficult to emerge out of the smaller haciendas. Puerto Rican sugar ends up not being white enough, refined enough. Not good enough. But still, San Juan de Puerto Rico had lingered for three centuries with a few isolated sugar mills here and there, fated to exist under the shadow of big sister Cuba, never able to compete with sweet sister Saint-Domingue, the biggest and richest producer of sugar. Old San Juan had an earlier chance with the Revolution of Slaves in Saint-Domingue. Between 1789 and 1794 sugar production was paralyzed, prices went up—an ephemeral alteration. Because, in another fifty years, across the Gulf Stream, the America of the North would begin to produce maple syrup in Vermont and New Hampshire and grow sugarcane in Louisiana. There it is: not big enough, not small enough. Not lucky enough.

After the wars of independence in Latin America came the big drought of 1839–1841, then the end of slavery in 1873, then the American occupation of 1898, the haciendas outmoded by the well-organized grinding mills, the *hacendado* class moving away, selling out to the Americans, whole villages becoming pure workers' villages: company store, company housing, company loving, company dying, company all. And in the thirties and forties, the nationalist struggles of Pedro Albizu Campos— heir of José Martí—wresting concessions from Muñoz Marín and those who had been co-opted by the American dream. And so it goes . . . until Abuela Lolita goes to Washington, March 1, 1954.

Now she can't do anything else but carry on, climb those steps, one after the other, they have to get there, right to the very end. From up above, a guard noticed them coming, dressed as if

for a baptism. They did indeed look ceremonial in the photographs taken a few moments later. Are they coming to kill? No, sir. They're coming to die. They have everything to lose and nothing to regret. That's called sacrifice. Still, no one could tell what lay beyond those disheveled faces. No one could know.

It was one of those rainy March days, and the darkness of the sky must have made them uneasy about facing the inevitable. It was as ominous as it was appealing. They were climbing, staring straight into the Capitol dome, which as a focal point seems to rise from the stairs all the way to the entrance. At the top, a sort of ceremonial access to American democracy, the House of Representatives. And it was obvious that something must have crossed their minds telling them about their own unfulfilled dreams, five hundred years of unfulfillment. The white dome was above their heads, a maddening sight, yet they still moved at what must have seemed an unbearably slow pace. Halfway up, the men seemed to hesitate. Not Lolita, they say. She was quite at one with her own feelings, with her mission. "I'm alone," she said. And as she went on climbing, holding on to her purse, she seemed even more alone, a woman listening to an inner voice. There must have been that moment of indecision that's repeated in all tragedies: "This is the coup de grâce," Lolita says she heard as she went up the steps, startled perhaps by the resonance of the voice. (Later on she would hear other voices, but this Lolita was still talking to herself in order not to stumble.) Irving, Rafael, and Andrés follow her. She goes forward. At the entrance she greets the chamber doorkeeper in impeccable English. They look at each other, maybe she smiles at him with a last touch of coquetry. He asks if they have any cameras. No, they do not, they say. He motions them through the swinging doors, smiling, as the four take back

seats in the Ladies' Gallery, almost civil, almost ready to turn
into warriors at the utterance of the right word.

Beneath the semicircle of the Ladies' Gallery, 243 legisla-
tors who are debating the law that will permit the free entry of
Mexican farmworkers have just answered a quorum call. It's
2:35, and Speaker Joe Martin is counting the ayes on a rule to
provide two hours of debate on the bill. (Lolita's horoscope—
she's a Scorpio—for that day says: Encouraging rays for all
matters close to your heart. But you will have to work right up
to the end to obtain the greatest reward possible. Stick with it
and fight to the last.) Lolita stands for a while, staring down at
the representatives. Then she walks down the aisle, wraps her-
self in the Puerto Rican flag she has brought with her, and as she
reaches the front of the gallery, she holds her pistol with two
hands and hears herself shouting, "Freedom for Puerto Rico!"
and opens fire. And at that, all three men behind her whip out
automatic pistols and spray bullets throughout the chamber,
pausing only to reload.

In a matter of seconds it was all over.

Down below, according to the *New York Times,* they heard
what seemed at first a string of firecrackers, interjected by semi-
intelligible screams which to some sounded like "Viva Mexico!"

It was then that Representative Benjamin James of Penn-
sylvania shouted, "My God, this is real!" Bullets and ideals,
ideas turned into bullets. One bullet hit Tennessee's Cliff Davis
in the leg, another hit Maryland's George Fallon in the hip, and
a third pierced the thigh of Alabama's Kenneth Roberts. Ten-
nessee's Percy Priest rushed to Roberts's side and fashioned a
tourniquet from his necktie and fountain pen. Behind Speaker
Martin's desk, Representative George Long crumpled to avoid
bullets that pinged everywhere, showering bits of wood on

three California congressmen who were huddled under the
table. Speaker Martin will never forget how as he pressed back
with all his strength, hiding behind a column, a bullet intended
for him hit Ben Jensen of Iowa, who was standing directly
under the Ladies' Gallery. Jensen struggled through a door into
the Speaker's Lobby but couldn't go on and fell on his back in a
widening pool of blood. In the third row Michigan's Alvin
Bentley, a bullet in his chest, slumped to his seat and collapsed
into the well of the House.

⟶      The four Puerto Ricans are no more freedom fighters.
They are lunatics, according to Governor Luis Muñoz Marín,
crazy and savage people. But in Lolita's purse the police will
find a letter written in English: "Before God and the world, my
blood calls for the independence of Puerto Rico. My life I give
for the freedom of my country. This is a cry for victory in our
struggle for independence, which for more than half a century
has tried to conquer the land that belongs to Puerto Rico. I say
that the United States of America is betraying the sacred princi-
ples of mankind with its continuous subjugation of my country,
violating our right to be a free nation and a free people with its
barbarous torture of our apostle of independence, Dr. Pedro
Albizu Campos. I take responsibility for everything."

Boyd Crawford, staff administrator of the House Foreign
Relations Committee, was in the committee room across the
hall when he heard the firing. He went in and saw a small slen-
der woman, a trim brunette, screaming in Spanish. When
pressed with the question if they were tied to communists, she
answered in English: "I love freedom, I love my country."
Hearst papers carried stories describing the shooting as being
ordered by Guatemala. But Lolita had planned it to coincide

with the opening of the Tenth Inter-American Conference in Caracas, so people could begin to talk and say that Puerto Rico refused to die. Yet Secretary of State John Foster Dulles proposed to twenty Latin American countries a program for joint action against the "menace of international communism." A primary target was the "leftist" government of Guatemala. The days of the administration of Jacobo Arbenz were numbered.

That same day, when he hears the news, Pedro Albizu Campos, founder of the Puerto Rican Nationalist Movement, declares: "A Puerto Rican heroine of sublime beauty has pointed out once more for the history of nations that the Nation is a woman and that she cannot think of her mother as a slave. Nor is it possible to shelter the idea that the Nation is a slave. Lolita Lebrón, and the gentlemen of our race who accompanied her on that expedition of sublime heroism, have given notice to the United States . . ."

The Nation is the mother, and Lolita, who may have had trouble in being a mother before, now would not hesitate to die for that Nation.

On July 8, 1954, as the trial ended in Washington Federal District Court and Judge Alexander Holtzoff sentenced Lolita to the maximum term of fifty-seven years in prison, a reporter approached her and asked her about her children. "They need a mother," she told him, "that's true. But later on they will need to be free even more. When they grow up, they'll do the same thing I'm doing now."

On September 7, before federal judge Lawrence E. Walsh, stood seventeen Puerto Rican nationalists, accused of conspiracy; among them were the four already sentenced for the attack

on Congress that same year. By returning to this issue, the government would open one of the many Pandora's boxes of Puerto Rican politics. Who the militants were became crystal clear, and also who were the government collaborators, and who the infiltrators.

The whole trial must have been a difficult scene for Lolita. To a question from Prosecutor J. Edward Lumbard, Lolita replied: "I didn't come here to kill but to die." Her brother Gonzalo, a first-rank militant, ended up testifying against her as a witness for the people. Throughout that memorable trial, she will hardly lift her eyes up from her Bible; she will not see anything; she only listens to things which words can seldom convey. And now that the judge is about to pass sentence, the woman who does nothing but read the Bible asks to speak from the bench of the accused.

*NYACK, NEW YORK, 1991.* Conrad Lynn, one of the finest black civil lawyers of this country, talks to me about the touching aspects of Lolita's second trial, in which he represented her. He tells me how the federal prosecutor had wanted to prevent Lolita from giving her version of history and of her life but that Judge Walsh denied his motion, forcing him to listen for hours. It is strange to see a ninety-two-year-old man, a former communist, speak with tears in his eyes, as if it were all happening again, right in front of us.

"Rarely has it occurred to me to praise a judge, but Lawrence Walsh did a praiseworthy thing. He made Prosecutor Lumbard sit down. And Lolita told everything, her whole life in Puerto Rico and in this country. How she preferred to look for coins in fountains rather than accept public assistance from the oppressor nation. One day her child told her in English, 'Don't

worry, Mom, someday I'll turn myself into a bird and tuck you under my wing and we'll fly far, far away.' It was moving, even the members of the jury wept, never in my life have I heard a more eloquent speech. And it was her speech. Everybody was aware of that. And they listened to her in silence. Even Judge Walsh himself had to interrupt it momentarily in order to go to his chambers and dry his eyes. Finally the jury found her guilty, and on June 7, 1954, Judge Walsh sentenced her on all the charges, because, of course, as she told the story of her life, she also told in detail what she had done with the pistol on that first of March. And why she'd done it. After the sentencing I went to his chambers to thank him for having let her speak so long. But I also wanted to assure him that it hadn't been a trick. I had no control over my client. Nor had I made her rehearse or memorize it or anything like it. I had no idea myself what she was going to say. 'Mr. Lynn,' Judge Walsh said, 'I'm convinced that that's the way it was.' We looked at each other with anguish and for that reason I turned and left, almost without taking leave."

*The nurse on night duty is changing the dressings on my wrists and frowning.*

*"Why do you want to die?"*

*I imagine how on a morning, any morning, not knowing anything, I would have risen, drunk orange juice, not knowing why, combed my hair, put makeup on, etc., and neither I, nor the landlord, nor my father, nor the mailman would have known why. My sweat, my saliva, my menstrual blood would all be equally unbearable. Why? At any moment everything could have ceased to be.*

*"How could you have done this? You left too soon."*

*"Can I go to sleep now?"*

*I can't help my pleading tone.*

*"No," the man answers, "the M.D. has to come and take a look at you. I just called him on the phone. I can't understand why they released you. This time they won't."*

*He doesn't like the way the bandage looks and redoes it. The stitches close the two wounds, but blood shows. He cleans the stitches with tincture of iodine, lots of iodine, and it pours down my wrists and drips onto the metal of the table. He complains about other patients, especially about a young girl, also a student, whose arms are all chopped up with cuts that she's inflicted on herself over the years.*

*"I can't understand it. I can't understand it," he says. As I ask him what he can't understand he looks again at me and repeats the same words, as if talking to some creature that causes him great revulsion.*

*"Well, this doesn't look so good," he says, poking his finger into the flesh around the wounds. "Does that hurt?"*

*I didn't know how to tell him about feeling a tight swelling and a sharp flash of pain shooting from the wound up my arm. The skin looked wrinkled, it had turned purple.*

 *It's late now. I've spent the day in the emergency room of University Hospital lying on a gurney, thinking about the nurse's revulsion while waiting to be put in a room. I've been informed that I will be admitted again to the fourth floor, that Dr. L. no longer works at the hospital, that his place has been taken by a new bright doctor, Dr. O., a woman, and that beginning the next day I'll be her patient.*

 *"How did you get along with Dr. L.?"*
*"Fine."*

*"No one can explain why he released you." Dr. O. speaks slowly, fixing her eyes on me and then lowering them to my wrists. She keeps on staring.*

"I never would have released you. I think you'll do better with a woman psychiatrist. You'll see, it'll go well with us. But you mustn't expect to leave. I won't let you this time."

She has dark eyes, large, like Dr. L.'s. But there's no way to make eye contact with Dr. O. She's behind or ahead of any movement. Maybe she's right in her suspicions. Dr. L. had opened up too much, after all.

For a few days I had felt pain on the right side of my body that reached from my temple down to my big toe. I tell the M.D.

"You probably weren't sleeping well," he says. "How are the wrists doing? According to the nurse the wound has become infected." The M.D. takes the bandages off and smiles.

"It's nothing. Your skin's a little traumatized, that's all."

The nurse doesn't seem to agree with the diagnosis.

"No, there isn't even any damage of important tissue," the M.D. insists. "The veins are deeper than they look."

He is smiling. Is he making fun of the nurse or is he having fun at my expense—perhaps showing how anatomy can play a dirty trick on the soul? Hesitation marks, that's all. Everything else is imaginary. The two men laugh. The nurse and the M.D.

The corridor is one long pause. At the end is my room and, inside, tied to her bed, is Kelly. The smooth sheets are waiting for me. I go in without making any noise. I don't want to see her and I lie down on the covers without getting undressed. I'll be damned. I came back. Five days after I left, I came back. The wish to hibernate. That's all. My kingdom for a hole.

"You came back." Kelly's voice was as disembodied as always. I didn't answer her.

"I knew it."

~~~ *Dr. O. had asked me to take notes on my dreams and once more is growing nervous about my reading Melanie Klein. Every single therapist insists one should keep a diary. Nothing else but a diary . . . as if diaries hadn't been part of my misery. But I keep my three-by-five world of index cards, and my library notes. She insists that for now I mustn't read psychology books. She talks, jots things down in the file folder, taps on the glass of the table with the tip of her white pencil. It's always the same pencil. It's missing its eraser and, as it rubs against the glass, it squeaks. We spend a long time in silence. I would like to be in bed, to sink into it, wrap myself up several times in the blanket, and disappear into one of these dreams that never end, or end in another dream. The silence is unbearable. Sitting in her office, I hear myself speaking about being different, as if talking about a dream. Patience shows behind the doctor's impassive face. She's waiting, so I tell her about Mama's rocking chair; it's one of those wicker rockers that you see all the time in markets, but when I describe it I talk about the wooden legs that coil around like columns, or serpents. Dr. O. hasn't blinked once. I'm on the point of asking her if her eyes aren't burning.*

"*Did you sleep last night?*"

"*No.*"

I spent the whole night in the dark with my eyes fixed on an imaginary corner of the room, thinking about thousands of details lost in the 6,510 days of my life. I made that count half-asleep one morning on the toilet. I'd begun to fantasize about single words. They would pass in front of me, one after the other, as in a funeral cortege. Until not so long ago I was in the habit of clinging with all my strength to the present. To reality. A table wasn't anything. It was a thing. An object. I existed, the table didn't. But maybe objects would keep on being in the world where I would no longer be. The future, always the future. But also the

past. What is the past at eighteen? Images that have been hidden in my memory of all this time reappear. Last night, instead of thinking about my life, I imagined a soft red apple, recently bitten into, from which a white worm was peeking out, quivering. I got out of bed and went to the window. I wanted to get rid of the fruit, but it stayed up there, like the sky, hanging from nothing. And it didn't matter; no matter what I did, the most insignificant details would still be there, taking on a new glow, growing in size and even in weight, I could calculate weight with my eyes. It was unbearable and I didn't know how to free myself. The bed. I went back to bed and kept on seeing the worm, tugging at the worm until I got it all out, and dried it so it would stop being a monster and let me sleep, and dream.

"Why do you want to die?"

I was not sure. I was always somewhere else.

"You can be cured here if you let me help you. You need a good rest."

SAN JUAN, 1991. Luis Sotomayor, son of Elvira Soto, the sister of Rafaela, Lolita's mother: he takes some photographs from his wallet and shows them, first to William and Wanda and then to me. He pauses, raises his eyes, moves his head back, then backs up in order to see better. "Blessed be—here she is, bless the Lord, this one here's your mama, so beautiful, with Aunt Aurea. And this is one of my sons, Luigi. And there's Lolita too. Of course I knew her well. Lolita and I grew up together, child, in the Mirasol district in Lares, near Bartolo, and later on in New York, in Gonzalo's place, around 1946. And yes, your mother Gladys too—gosh, Gladys was born in the Barrio Obrero, on Calle Martino. The way time flies. I saw your mother being born. I was living with them because next door lived a guy who sold Rioja coffee. His name was Francisco. I lived and worked in Puerta de

Tierra, but when I heard that Lolita was in the Barrio Obrero—
because they first went to live on the Avenida Borinquén. But
then Don Paco told me that, you see, he'd got hold of a more
comfortable house with a garage because, since he worked at the
Cambalache Mills, he had to travel, so I got her that more com-
fortable house with a garage and Mama went to take care of it.
Lolita told me, come live with us here because we're all alone.
Then I quit the job I had in Puerta de Tierra and moved in with
them in Santurce. And next door lived the man who sold Rioja
coffee, and I went to work for him. And then I looked after
them, because she was living with Don Paco, understand? Don
Paco Méndez, your grandfather. Did you ever know Don Paco?

"Yes, they were living together. Well, no, they'd been liv-
ing together ever since they were in Castañer, you know. Then
Don Paco—uh, no, Lolita wrote me. She'd gotten my address
and I went there. Well, she . . . it was this: look, Luis, Paco
wants to talk to you. I ask her what day I can see him and she
tells me come on Friday, he'll be here on Friday. Then she told
me, no, he told me, Luis, get me . . . I'm going to leave you
some money, and if you can skip work Saturday or Sunday . . .
I say yes, I can miss any day there, no, there's no problem. So
you can rent a comfortable house, a big one with a garage, for
the car, Don Paco Méndez's car, you know . . . who had his
driver when he came to visit there, you see. Lolita was already
pregnant then, you understand. And Mama went to take care of
her. And you're, you're hanging around here, he told me. And I
said look, Don Paco, I'm going to try to get a job near here to be
closer to Lol—to Mama. And he told me, by God, I'd appreci-
ate that, Luis. He gave me the money for the rent and I got the
house, a great big house in the Barrio Obrero, on Calle Martino.
That's where Gladys was born. And he gave me money to buy

furniture and everything, you know. But they broke up in
time, you understand. Since she left . . . You know . . . boys al-
ways . . . since Don Paco was a man with money, you under-
stand, and he was a man who could get any woman he wanted,
anyone, you know, and his protection too, you understand.

"As I was telling William here, it was a midwife, a lady,
who attended Lolita with the birth. And that was when I went to
get her, when Lolita was already having pains that Mama, who
is taking care of her, you know, told me to go see that, uh, lady.
Well, I got there and the midwife tells me to go to her house and
tell to my daughter to send me the duck, *el pato*. I stood there
looking at her. And she tells me, you don't know what that is.
And I say, sure, it's a bird. It's not a bird, she tells me. You get
over there, because she knows what it is. Then she explains to
me when I got there. I didn't know that those ducks were what
women use for births, a urinal, you know, for their necessities.
Well, your mother Gladys was already getting big—still a little
one, probably a month old—and Lolita took off, took off for
America, you know. Why I don't know, I don't know, Irenita.
Because Lolita got it into her head to go there, because right
after moving to the house with the garage a little problem came
up and Lolita had a strong temper, let me tell you. He was an
agronomist, an engineer, because that was how Lolita tells me
the next day, look, Luis, I want you to go to the Cambalache
Mills—which was where Don Paco worked—and get some
money for me. But I told her, come on, Lolita, how? She tells
me, get going, get going and wait for him in his office, and if he
isn't there, wait for him and have him give you money for the
trip too. For my trip, you know, to get back to Santurce. Then I
asked her what's the matter, what . . . Luis, I'm leaving here,
I'm taking the baby. And I ask her, but how are you going? No,

I'm going back to Lares. I don't know which way. And since I was working, I said, well, then, I'll rent myself a room in the neighborhood . . .

"And Don Paco, well, I said to him, Don Paco, here's a letter that Lolita sent. Then he reads it and asks me what's wrong, what's wrong with her? I tell him, look, Don Paco, nothing that I know about. She told me that she'd decided to go back to Lares with the child and Mama. But what's going on with her? What? And I tell him, Don Paco, I don't know nothing. Well, he told me, take this money, around two hundred dollars. And this is for you—he gave me ten dollars for the trip and things. And I took it and got back and—Here's what he sent you, Lolita. Only two hundred? And I said, look, girl, like you told me: he would have had to have gone to the bank—or something like that, for now it'll have to be what he had on hand. And right off in a truck owned by Don Ramón, may he rest in peace, that goes to Santurce, you know, to sell charcoal and bananas and all that—that was when they moved and took off.

"Did you know him, Irenita? You didn't know Paco Méndez? I think I saw him again when Gladys Mirna, your mama, died and Lolita was brought from jail for the funeral. I spoke to him a little there.

"She came back from New York . . . let's see, I've got to jog my memory because a lot of years have passed, you know. She came back to see Gladys Mirna with Félix Junior, Felito, and they went to live nearby . . . No, wait a minute, no, that's not the way it was. Lolita came back and left Felito with Gladys Mirna and Rafaela in Puerto Rico. That's how it was, yes. And right soon then, a little while after what happened in Congress, you know, Felito drowned, in Dos Bocas Lake in Utuado. Grandma Rafaela never got to know that Lolita was in prison,

you see. She thought she'd gone to Cuba. She died without ever knowing. That was New Year's, 1959. I remember the date because it was a new year that night, the one when Castro, that bastard Castro, took over the government of Cuba . . . I was going to tell you: then she met a fellow who's a friend of mine, who still calls me up and asks about her, Anderson Pérez. And they got married. And when he found out, you know, that she was in the Party, they got divorced. As a matter of fact, he looked me up since she was agreeable to the divorce and I was the star witness. Because he had to pass himself off as an adulterer, of course. And then they got divorced. He was a good friend, Anderson. And he still is. You know, we were all living together then . . . How? Let's see . . . they'd been together a year, a long time. Understand? More or less that time. When I found out that Lolita and he'd gotten married, since they were living downtown and I was up here on the West Side, I went down there and told them that where I live there's a furnished room. Bear with me for a little bit . . . Yes, when I found out they were living way down there, because I like to have family all together, you see, I went down and told them, Lolita, up where I live, on the second floor, there's a furnished room for the two of you. And she says, yes, Luis, that way we'll be together again. She said, let's go up there, Anderson.

"But something that Anderson didn't like started up. Her going to Party affairs. And the meetings, you know, the speeches. The union business, and all that too. And that was when they had their falling out. Then she went to live on Fifth Avenue in Brooklyn, although she came back to the West Side later on, you know. Still, the guy loved her. He really loved her. The fellow almost took his life in his hands one day with a nationalist at a dance—that was in the Bronx—with one of those

big nationalists who was killed later on at Blair House, in Wash-
ington, when he went with that other fellow Collazo to kill the
president, you know. What was his name? Not the president,
no, the nationalist. Oh, yes, Torresola. I think he was from Utu-
ado, let's see . . . Damn it, the guy died, like I told you, because
one of the guards there at Blair House shot and killed him. Well,
it was there that the whole nationalist business got started. As I
was telling you, this guy gave Anderson a whack, punched him,
you know. Because he was a wild man, that guy Torresola. Red
all the way, you see, girl! What was it all about? Okay, okay,
Anderson said. Because you know the way those nationalists
think. That was how the divorce happened and it was then that
Lolita got involved in the damned Party and fell for this guy
Torresola. And then, and then . . ."

⟨⟨⟨ Luis Sotomayor is still searching for words to describe
what happened "then" to Lolita, after she got involved in the
"damned Party." Wanda and William are about to leave, they
have to run some errands, some forms to fill out for the retire-
ment check, but Luis is talking nonstop. "Thirty-five years ago!
Lolita must have been very lonely during that period. Listen,
she was going from one house to another . . . Lolita! Anderson
Pérez, her husband, didn't look kindly on Party matters, and
then she would go to live in Brooklyn, and afterward in the
apartment on West Ninety-eighth Street, and then to prison—
twenty-seven years . . . Come to think! Well, as I was telling
you, I was driving along in the taxi when I heard it on the radio,
and when I got home, I say to Irma, you haven't got the TV on?
What happened? she asks me, turn it on and see, and they kept
on giving news, the same news all the time, the same news, and
I tell Irma to get ready now because they're going to send the

FBI here to check up, to investigate. They kept coming by our place, they were always there, they were practically living there, the FBI. They were after me too. I just missed getting arrested, you know what the reason was? Well, that's a long story. The fact is that when Lolita got busted, I never knew how deep in the Party she was. All that, you see, all that was in the Bronx. And at the dance the nationalists put on to raise money, you know, there was a guy passing himself off as a nationalist but he was undercover for the FBI, you understand, and he took out his lighter every time he lit a cigarette, and since we were selling drinks, understand? Well, according to what they asked for there, a drink, a beer, it was two or three dollars, understand? And whatever the people paid for a drink, a beer, whatever, it was to put together some money for the lawyer for Lolita and the others—I can still remember his name. It was—or it is, if he hasn't died yet—Conrad Lynn. Well, that FBI guy, he was lighting his cigarette and taking people's picture, because what he had was a camera, and people found out of course and I told Gonzalo, Lolita's brother, okay, try to defend me and my wife Irma. I'm not a nationalist, do I look like one? Or Irma either, and this is going to spread out. And he tells me, don't worry, Luis, nothing's going to happen to you. Well, later on Irma and I got divorced, and she got married, and her husband died of tuberculosis, and she got married again, in Puerto Rico, and about a year ago that husband died. And I could have died too, if I'd stayed married to her, you know. So, what do you think happened? That the guy was an FBI snitch and he took advantage, took all those pictures of my place and the people there, because that's what it was, an investigation, girl. The FBI was at my place every Saturday and Sunday. And Gonzalo said, don't be afraid, I'm the one who'll do the talking here, and that's the

way it was as you know. Gonzalo just rattled on . . . And this picture is one of my sons, Luigi. And look, this other boy, on the thirteenth of this month, the thirteenth of May, he's going to be forty-nine. He's my oldest and I haven't seen him for forty-seven years. I went to the States, you know. He'll be forty-nine on May thirteenth."

"Look, children, excuse me, I'm leaving."

"Are you leaving, Wanda?"

"Yes, come along, William. We've got to run some errands and I just want to say good-bye to Irenita."

"You know, I liked going to Palmas Altas because your mother always made *panapen* with codfish for me. Don't you agree, Wanda?"

"Oh, yes, I told Gladys that I liked *panapen* and codfish and she told me, don't worry, come whenever you want and I'll have some for you. Oh, Irenita, we dropped by one day and she had some, can you believe it? She was crazy about having us over there, you know, to spend the whole day with us. You were just a little thing . . ."

"Look, Wanda, what happened to the check?"

"Well, Luis, they gave me a date, the thirteenth of May."

"The thirteenth of May? Look, that's what I was just telling Irenita about, that on the thirteenth of May my son turns forty-nine, that I haven't seen him—"

"And I have to fill out a sheet for the retirement check so they can send me all the back checks."

"They'll send you the whole thing, yes, yes . . ."

"Yes, you see, because the company went out of business. They shut down Baxton, the pharmaceutical company, you see."

"Yes, they moved to a country . . . some republic out there. Where, Wanda?"

"Costa Rica."

"You see, Irenita, they turned our work over to people in Costa Rica because they pay less there, you understand . . ."

"So okay, children, we'll be seeing you."

William comes over to the table, thumbs through my notebook, and I realize that he, too, wants to ask questions.

"So what are you writing, a book? A novel? A novel about what?"

They took Kelly away today. She was being transferred to another hospital. A chubby little woman loaded down with packages stumbled into the room. Afterward I learned it was her mother. Kelly received her coldly, without getting out of bed. (I already knew why: since morning we'd been talking about the new hospital and the people she expected to meet. "It's the closest thing to Hutchings," Kelly had said. There was a monotonous tone to her voice, and even though she didn't say so, she must have felt very bad about being taken to a place like that.) The woman dropped the packages onto the bed. Kelly kept on talking. When there was a pause, the woman went over to her, took her head, and kissed it tenderly. She stroked Kelly's head, showed her the packages with the gifts she'd brought, and then kissed her on the head again, this time noisily. Kelly was struggling to get away.

"You're looking very good," she said. "You've put on a little weight."

Then the woman picked up one of the packages and took out a little white hat that had a small red plastic bird on it with silk ribbons around its neck.

Kelly wasn't paying any attention to her. And it wasn't true that she'd put on weight, because she'd gotten thinner since I arrived at the hospital. I noticed this as I observed her from my bed, her body looking more and more like the folds of her bed covers. On one occasion, convinced that she'd gotten up to go to breakfast, I went to the dining room looking for her, and they told me she hadn't been out of bed all morning. She was losing weight at an accelerated pace. Just by looking at her I saw that she was quite close to death, but if we chatted, no, she seemed a self-proclaimed throwaway like me and, what's even more curious, with precise words, "clear and distinct," as the philosophers say, capable of expressing the death she carried in her soul.

They were taking her to a "loony bin," and it would be even more difficult for her to leave there, because her case was getting complicated. She'd been in University Hospital for months and hated the food more and more. Even the empty plates made her nauseous. According to the doctors, hers was a chronic case. Maybe she needed electroshock. Maybe that was why she was going to another hospital.

Kelly hadn't spoken since the little scene with the hat and the bird. She looked outside at the steaming roofs across the way. She'd lost interest in talking anymore, or doing anything, but her mother came up from behind and put the little hat on her. And she held a little hand mirror in front of her so she could see how pretty it looked on her. She was quite cute, though the hat, with its colors and hanging ribbon, made her all the more reedlike. When she

saw herself, she smiled. It must have been the first time in a long time that she looked at herself in a mirror. But her eyes stayed gray and sad. She took off her hat, and before she returned it to her mother, sat looking at the little plastic bird tenderly.

"See how you like it? You always wanted a hat with a hummingbird."

Her mother seemed happy. Kelly kept on looking at the little bird. Suddenly she gave a tug, pulled the bird off the hat, and tossed it into the wastebasket. And, dragging her body, she crossed the room and shut herself in the bathroom. Her mother was devastated. She picked the bird up out of the trash and, sitting on the bed, tried to repair the hat. Kelly came out of the bathroom in panties and bra. She must have been crying because her eyes were quite red. And that little whitish body, specked with freckles, was like that of a child of seven mounted on the skeleton of a woman of twenty-four. It didn't take her long to dress, to hang clothes on her bones. With her back to us, she was combing her hair in the window glass, as if even that bothered her, running the comb through with increasing ferocity. Then she turned and spoke to her mother, with the same ferocity. She told her that it was useless, that she mustn't have any illusions, because she wasn't going to eat here or anywhere else. Because she wasn't hungry. She would never be. Again her mother said that she really looked better, much better.

At lunch Kelly's place was empty, and as on so many occasions no one missed her. Just yesterday Miss Boyd had passed by with the cart and two portions of everything for Kelly. When I got back to my room I went into the bathroom and found a card with the picture of a unicorn: "You've got to get better. Love, Kelly."

She liked unicorns. Once, playing with a plush unicorn that

was hanging on her bed, she wondered aloud what unicorns tasted like.

"They must be very sweet, I'm sure that this one tastes very sweet," she said, raising one of its legs to her mouth. "I'd try that. I wouldn't mind that," she mumbled.

How lucky! A room of your own. Miss Boyd peeks in through the door and gives me a wink of complicity. She's got the tape deck and a cassette with the sound of the sea and waterfalls. Relaxation time: the best cure for the phantoms of insomnia. Miss Boyd leads us to the therapy room. The instructions are to lie on the floor, close your eyes, breathe deeply and slowly. She closes the windows, turns out the lights, and for almost half an hour I let myself be rocked by the sea. It's the closest rhythm to breathing, with phrases that are repeated like foamy waves breaking on the sands of the beach, tickling my feet. Someone has fallen asleep and is snoring lightly. You can hear the gulls. The waves come and go, recede. Miss Boyd's voice too. "Breathe deeply and slowly," she says, "float, let yourselves be carried along . . ."

A garland of hearts in the hallway, hearts everywhere. They've even fastened some cardboard hearts to the television set. It's Saint Valentine's Day. The person who makes the most perfect heart wins. "Wins what?" asks Sam, the fellow who says he's studying law. "Just wins, that's all," says Miss Boyd.

In my room there are so many hearts on the floor already that all that's left is for them to start beating, as in a Cortázar story. I can't sleep. Use the tape of the sea and the birds, it's to make you sleep, silly, don't talk like that. Because I do talk to myself like that. If you go to sleep, you'll feel better tomorrow. Enough, I mustn't talk to myself like that. Think about the sea, and birds, concentrate, the way Miss Boyd says.

Miss Boyd has put a red carnation for me on the can of Del Monte fruit salad, and it's about to fall off the table. What a strange dream. Fighting cocks with combs like the ones I used to see as a child when we'd go to visit aunts and uncles in Lares. One red and one white. Their owners stuffed them with raw meat, shaved them, smoothed their crests, massaged them, checked them over, and, after running their tongues over their heads, threw them into the ring. The people were shouting, and with every peck blood spurted and the bets got bigger. The roosters pecked at each other, they blocked off their enemy with their wings, and if they couldn't, they clinched and went back to pecking, seeking out their opponent's eyes. The red rooster took out an eye of the white one and kept on pecking until he exposed his heart and stained him red. The winner's owner was jumping for joy. I was weeping over the death of mine.

It was true, I had the room all to myself, a room with blank walls, and the difference from other times didn't upset me, I didn't feel any urgency to fill it up.

The nurse stuck her head in the door again and turned out the lights.

Tonight would be another tedious night watch for her, as she peered time and again through a peephole. I suppose I looked even smaller. A speck of dust in the eye.

As a child, Mama used to think that the beautiful woman she saw in photographs, the woman she would later see in the newspapers, would come to get her someday. And she waited for her. In 1948, Lolita returned to Puerto Rico with her second child, a six-year-old boy. She came back a militant. New York had transformed her.

She wasn't the woman Gladys Mirna had expected, or that's what I'd like to believe since it's all a great mystery when the family speaks to me about that first encounter between mother and daughter. And as for Lolita, I always get the same answer—"It's best not to talk about that"—as if I were reopening an old wound.

She wouldn't wait long before returning to New York. And as before, Gladys Mirna would be left waiting. All through her childhood she'd wait for her. And after the attack

on Congress, she'd be waiting for her—on the pages of all the newspapers and in all the pictures.

She would return, yes, thirty years later, but surrounded by guards, and not to get her daughter but to bury her.

⟜ Is it a diarist's compulsion, this endless going back to the question of beginnings? Maybe not, but if I were to trust Papa's version, everything has a beginning and an end. For him it all began and ended with a dance. He already had a date, but he saw her coming down the slope with soft steps and his eyes couldn't believe what they were seeing. It was the first time anyone walked like that in town, you know. Where'd she been? Where was she coming down from? From heaven, my girl. And without saying anything more, because he already knew the little he had to know, he swore he'd take her to the dance. That's how it all was, shaped in his own mind, after his likeness.

It was raining in the mountains. The downpour was ruining the new shoes he'd bought especially for that ball. Yet he stood there like a boob—and let me tell you, child, soaked from head to toe—and at a loss for words. The woman of the soft steps came along, looking at him with unusual curiosity, and then, yes, he knew what to do, then he resorted to what he knew instinctively, the old strategy of power (avoiding the dangerous use of words), and he let her pass by and stood right there watching her go down the slope from up above.

They made a date that same night as they left the dance.

"What happened then?"

"Nothing. We both left the dance and took different routes . . . and we finally met on the outskirts of the village under the elm tree that grew between the marsh and the river plain."

"And what else happened afterward, Papa?"

"Why, everything, girl."

He was seventeen. She was fifteen. A month later they would be married.

According to the Lebrón uncles, she was pretty, and she knew she was. The photographs show her smiling. An almost happy adolescent is recorded among the few pictures left of her in the family album. She is hanging from the balcony with her legs open, and yes, she had the habit of opening a few buttons of her white polyester blouse. It was hot, you know. (I mentally try to reconstruct her appearance from my own memories, side by side with the present. In the picture she is wearing that same blouse on her way to school and sucking a lemon.)

It seems that they were spying on her. One morning she was hurrying across the square, not suspecting that Uncle Agustín was watching her from the Café Revolución. "You should have seen the way we kissed right there."

That afternoon the uncles were waiting for her at the door of the house with the news. She was going again to Newark, to Aunt Aurea. The next day she came down to breakfast, but first she went into the kitchen and, as if she'd torn her childhood out from inside her, she shouted that she would never go to Newark, that she was in love with the son of the pastor of Bartolo, and, besides, she'd gone to bed with him.

That night the Lebrón brothers were already knocking on Pastor Vilar's door. He came out to open up for them himself. He'd just finished the six o'clock service and still had his robe on. The brothers stood there, framed in the doorway. It's not known whether it was to calm them down or whether he already suspected the reason for their visit, but Pastor Vilar invited them in and, as if they were already part of the family, put a bottle of sherry on the table.

The brothers Lebrón are not easy people to get along with. They'd come to talk about his son.

"Which son?"

The silence that followed spoke for them.

The Spanish minister, a convert in body and soul, knew that it was no good pretending to be surprised, and although he repeated the invitation to sherry, he sent for his son, who'd been following the scene from the other room, not daring to enter.

Then they got down to business. Casually, the old Spanish question of honor was laid on the table, like a winning hand at cards, and the Lebrón brothers said it wasn't a matter of what was to be said but what was to be done—the whole works or nothing. Grandfather Vilar understood, and they spoke of the only way in which to repair a family's good name (because in the case of a woman, her inheritance is her honor), and the pastor agreed to everything, but he set one condition. It would be a Protestant wedding. And in his church. Fine. All that was needed now was the permission of Don Paco Méndez, her father.

So next day they crossed over the mountains down to the coastal plain in the north in a trip by car that took five hours. When they arrived at Barceloneta, they went straight to the Plazuelas Sugar Mill, and near the canefield, found Don Paco sitting in a car and signing invoices, attended by assistants who were running back and forth.

"He was an elegant man, your grandfather, aristocratic, you know. He always wore a jacket and a hat."

Uncle Julio and Uncle Agustín were the ones who stepped forward to speak, Papa and Grandfather Vilar waiting behind. Don Paco Méndez seemed to receive the news of his fifteen-year-old daughter's wedding rather calmly.

"In February, eh?"

"Yes, in February."

He raised his eyes, and there, in the rear, he met those of his future son-in-law. He tipped his hat, like an English gentleman, and without another word said that it seemed fine with him, and that was all.

 At first they shared Father Vilar's house. Everyone had resolved the conflict in his own way, the Lebróns with the myth of honor, the Vilars with the myth of family, and the young couple, for a time, with the myth of love. Because, if one is to believe Papa, they would make love suddenly, in the most acrobatic positions, as if they wanted to peep over the brink of some abyss and pull the secrets of the flesh out of it in order to be more alive.

Until they were left without any secrets.

That first Christmas he got home late and said that the girl with the long hair was just a friend, that's all. But she, who'd seen them embrace in the square, left the house and went off into the woods to lose herself near the pond. (When a woman is in love, she can imagine herself completely lost, but sometimes things go beyond the expected and then there isn't much sense in talking about meeting up again. You get to the point where there's no way you can go back. Then the card to play is death; playing suicide is the trump card of adolescent love's other face. Poets say so, and so do afternoon soap operas on TV. In a book on suicide the author Romilly Fedden speaks of a young Polish woman who suffered from unrequited love and who over a period of five months swallowed four teaspoons, three knives, nineteen coins, twenty nails, a bronze cross, a hundred and one hairpins, a stone, three pieces of glass, and two rosary beads.)

When she hadn't returned by midnight, Papa and some friends went out with torches to look for her. They found her sitting on a log on the shore of the pond, and when she saw them coming she only made a gesture of disdain. But he'd found her and she let herself be led back to the house. It happened more than once. He would commit "some indiscretion," get home late, and she would get lost and they would have to go into the woods, cut through brush, wade through swamps, and go up and down the banks of the pond to find her. One night, still in that first year, he'd gone on a spree with the long-haired girl, dancing the *plena*, you know. At one moment he turns around and sees her, she's standing in the doorway of the store, barefoot . . . Was she following him? He doesn't know. There she is, standing, watching them dance, and everybody's waiting for the music in the juke box to stop to see what's going to happen. And just as the music stops, he sees her come in, and he goes over to her so she won't keep on coming, but she punches him in the chest and gives the other woman a terrible stomp on the foot, turns around, and goes out the way she'd come. That couldn't be the whole punishment, he knows that, and that's why he's not surprised when a while later someone comes running to tell him that his wife is standing on the edge of Castañer Canyon and seems on the point of jumping in, if she hasn't done so already.

⁓ She's still only fifteen. The balcony at the rear of the house in Bartolo faces a gully that ends in the canyon. In a scene that has a touch of the macabre and a lot of melodrama when Papa tells it, he's watching her and waiting, she's teetering on the very edge of the balcony, facing the gully and looking at him. She swings again, keeps looking at him with that absent look. Finally he says that's enough already, this is all a game,

but be careful, it could backfire. Suddenly the two of them are swinging on the balcony. They make an effort to see who can go farther, and he lets go. He wins.

"I knew the bamboo trees would slow me down."

She came running, all teary, terrified by what might have happened. They made up. They would start all over again, one more time. But she always went back to the same thing, the first date under the elm. In exchange for peace she demanded that first submission. And he, who couldn't bear repetitions, also went back to the same thing. Because, if she needed for him to come and get her, all he needed then was for her to let him be, free to give his life away, if he wanted.

⎯⎯ The feeling of emptiness was mutual. But they both lived it and expressed it in their own way. Soon she began to look for herself in the mirrors of motherhood. Each new pregnancy— my brothers Fonsito, Cheito, Miguel—must have been another way of filling hollow places, old and new. Papa's answer was to run away. Emotionally speaking, since he still stayed at home but would leave at dawn and only return at nightfall. In the village they called him the Rooster, not so much because he was bold, but because he was a womanizer. (He tells me this with a retrospective guilt, and he has to be believed; men like Papa prefer hypocritical sincerity to compassion.) Like someone who knows the rules of the game, he solved the matter by seizing on the advantages his culture gave him. And even now, when I bombard him with questions and he has to relive the years with Mama, he doesn't know why, but he returns to the cliff scene, and once more sees her go down, looks at her from up above, with the perspective of those who can choose and almost always survive.

"Why didn't you leave?"

"She wouldn't let me."

Maybe he didn't know one could choose. Being unfaithful upset him and he must have lived through it as something unavoidable. The other women? He chased them, that's true, but they only lasted as long as it took for him to get them. He always promised himself this one will be the last, but the very fact of making promises obliged him to break them. And to make more promises. "You see, then, there was no way out with your mother." He was condemned to live a split life. Besides, to choose is to deprive yourself, and he would never deprive himself of anything. This presupposed that love stayed out of his life. On the one side his girlfriends; on the other, Mama's possessive love. That's the way it always was. "Besides, she wouldn't let me leave, she was a tigress, you know. What else can you expect?"

But no matter what Papa says, she did leave him once. Having gone many days without speaking to her husband, she announced she was leaving them all, for a while at least, and moving to Santo Domingo. Grandmother Irene stared at her astounded, and her father-in-law voiced loud Spanish cries, swearing this trip would be the end of her marriage and her children. Mama left anyhow, convinced that this was what her husband deserved, a lesson not to be forgotten. She never gave it much thought, or so people tell me, nor imagined herself alone, without her two boys, in a foreign country, promoting a car magazine. But she probably gave thought to the lover she had once had in her husband and to the husband who was once her lover, and both men and the string of women who brought them together took up all the space in her mind. I imagine that she

held on to this invisible thread of people for a while, but that as she walked the streets of La Romana it loosened till she realized she had lost them somewhere along the way. Everything else about that fated trip is a big family secret. It is rumored that she walked the streets for days after being fired, that she became mute, that she heard voices, and that she tried to escape the voices by covering herself with a man's body, and that now and then she poked her head out, to breathe . . . This is what I think happened.

⸺ Six years had passed since their wedding. Once, as he approached the house, he saw one of his girlfriends talking to Mama on the balcony.

"What was her name?"

"Oh, if I could only remember."

They were talking and gesturing vehemently. Mama especially. And he didn't have the courage to go in, so he decided to go back to town. The two women went out looking for him. After several hours they found him strolling along the piers. He saw them coming and realized how much alike they looked. They all looked like Mama (on one occasion she told him so and began to cry). At least they weren't blue-eyed blondes, right? Mama was the first to speak. This young lady had come to demand that he marry her. If not, she would tell her father that she'd been dishonored. Mama ended up telling the young lady that the best thing would be to ask Fonso himself and let him choose.

"That tone is still a mystery to me, you know? It was the only time I saw her calm. She stressed the 'young lady' bit, and the other one didn't catch on. Your mother could be cruel when she wanted to."

He went out with other women, took them to bars, beer
joints, or simply to watch the sunset on the beach. He must have
always prepared himself twice: for the girlfriend of the moment
and for Mama. That meant he must have known beforehand
how to get out of the entanglement. But he'd already become
weary of excuses for love.

"Come on, was that love?"

"Maybe."

But on that day, because he was tired, or because of the
empty jiggers of rum in his pants pockets, he decided that it was
their problem and not his and he told them so. They should de-
cide and leave him in peace. And he went off. Now let the
women solve the problem.

When he got home that night she was waiting for him on
the balcony with one-way tickets to Newark. They would start
all over again. And in case he had any doubts, she'd taken a
whole bottle of Equanil and they had to take her to the hospital.

For Papa, leaving meant losing the last six months
needed to finish his degree in chemical engineering. But he
did it, maybe because it was the price he had to pay to ease his
conscience.

"She must have been unfaithful to me too. You don't know
how much she lied."

He doesn't say it to torture himself, but guilt, like pain,
had become a condition of his life. She told him that the tickets
for Newark had been given to them by Paco Méndez. But it
wasn't true. "She always tried to make it seem that her father
was there looking out for her. But he wasn't. Your mother lied
constantly. 'Paco Méndez wrote me, Paco Méndez sent me
greetings by so-and-so, Paco Méndez sent me money.' Her birth
certificate read 'Gladys Mirna Lebrón Soto,' but when she had

to get her Social Security card in order to get married, she moved heaven and earth to get it changed to 'Gladys Mirna Méndez Lebrón.'" Papa didn't know how she did it, but she did. Paco Méndez was a myth. Lolita was another myth.

⟶ Luis Sotomayor helped him find work in an electronic-tube factory. They'd only been in Newark a year when the game of the locked door began. He would always come home late. Outside the snow, and inside the cold, the rejection. She tells him that he's not coming into the house today. He breaks down the door. She's waiting for him inside, all wound up, ready to gouge out his eyes. For a split second they're both criminals because they both can imagine the destruction of the other in their rage. And as soon as he comes in, she leaps on him. They struggle, they shove, with every shake the immediate reason for what's happening gets foggier, until little by little, startled by the very violence, hate lessens. Sitting down, each in a chair as far away from the other as possible, they look into space, perplexed. They'd probably go silently to bed, fall asleep or make love without saying a single word, in order to be able to believe the illusion that they were starting all over again.

⟶ In Newark he got involved in card games. He'd bet sums he didn't have. Only the jack of hearts was lucky for him. He began to lose and the notes began to arrive, due dates, and finally threats. He calculated the money he had. One day, when he couldn't calculate anymore, she gave him the word that she was pregnant. Nothing. They searched through all the pockets of old clothes and what they found was enough for the taxi and the tickets. They put on their overcoats from the Salvation Army and, without a word to anyone, left for the airport. That's

how they returned to San Juan early one April morning in 1969 after six or seven years of "starting all over."

Her belly was growing and, according to Mercedes, who'd gone to take care of her, the same as she'd taken care of Lolita before, she'd cry every time she looked at herself in the mirror. That pregnancy was an accident. The bonds had been loosened after eight years. In addition, she was bumping into everything, belly first, as if she wanted to get rid of the child. She had bruises from her navel to her waist. When she got it in her mind that it might be a girl, she finally accepted it. If only. And she'd touch her belly. She'd walk through the streets of the village and look at herself in shop windows. At the age of twenty-eight she was still pretty in spite of the fact that she was going to give birth for the fourth time.

He was thirty and still wandering about, trying to get out from under his wife's belly, for the fourth time; and he was just as useless as before. According to Aunt Mercedes, during the last months of this pregnancy they scarcely saw each other, and when they did they didn't talk. Mercedes had traveled down from Newark to San Juan to help her in the last month, and what she remembers most is that when the pains began, there was no-body at home. Or in the neighborhood. They didn't have a tele-phone or a car. The two women walked down the street looking for someone to help them. Mama was weeping. At every de-serted corner she would stop to insult him. He must have known that her water would break at any moment. Mercedes had told him so.

They decided to go back to the house. Aunt Mercedes would act as midwife. When they'd got everything ready, they saw him coming. Mama didn't want to look at him. She didn't

want to talk to him, either, and Mercedes had to act as go-between. She didn't want to see him ever again. He could go straight to hell. And Mercedes should pass that on to him, in spite of the fact that she hated saying things like that. Her rage was coming out, but not the child. Then they had to take her to the hospital. Mercedes reminded her how easy her other births had been. There was no reason why it should be any different now. But she opened her eyes, looked at them, looked at him, and nothing. Maybe to get revenge on Fonso, so he'd keep on sweating heavily in a corner of the room, or maybe because she thought it was going to be another boy and she was sick of boys. The surgeon came in with the nurses and announced that they were going to open her up. Too much time had passed already.

"So the joke's over."

At the end of a long scream I was born and for a few days it looked as though everything was really beginning all over again. She found what she was looking for. In the end, another dream. A new toy, a mirror to see herself in.

At times I'd like to think that that birth was the anchor that slowed her down, but again, perhaps it was the sudden wind that finally cast her off.

Madame K. is the old lady with blue eyes and gray hair, much too long for a woman of seventy-eight. She wears a brooch of black pearls. This woman, with whom I like to chat so much, confides to me that in her youth she'd been a pianist and a dancer, although she doesn't remember in which order. She also tells me that she'd been in Auschwitz, where they killed her husband. For some time now someone has been stealing from her. She doesn't know who it is, nor does she know if it's the same person. Her family doesn't pay any attention to her, she says, because they don't believe her. Of everything they've taken away, what she misses most is the piano. Being without a piano has been her downfall, and she never tires of saying so.

She seems quite confused. Miss Boyd says that Madame K. comes from a good family, is intelligent, but that she'd begun to get the names of her children mixed up and that she's starting to

lose her mind. *The most obvious solution would have been to put her in a home, but her children decided that for the moment they'd leave her here. In the meantime, Madame K. takes her angelic smile up and down the hallway along with her black pearl brooch.*

Today I spent the whole time looking for my black moccasins. They're my only pair of shoes. In the dining room I ask the nurse about Madame K. I don't ask about the others. I'm interested only in reading and, from time to time, strolling with Madame K. and listening to her measured voice. In this place, where everybody goes around in bathrobes, barefoot, I always go about dressed and wearing shoes. Ever ready. That's why I miss my black moccasins. I haven't seen Madame K. all day. The nurse says that she must be sleeping, but suddenly I see her coming. Wearing my black moccasins, of course. Her feet are tiny, mine are eight and a half. The hallway is endless and Madame K. has to hold on to the chairs so as not to fall. She knows by now that I know that she's got my black moccasins on, but she doesn't look at me, she's pretending she doesn't see me, and the only thing she wants is to reach the dining room and sit down at the table, because she's tired.

At night, after the nurse turns off the light, I shut myself in the bathroom to read, and in that way discover new ways to get out of myself. Yesterday they brought me I and Thou, *by Martin Buber. The title attracts me. Last night I opened the book for the first time and read a page. This morning I couldn't resist and read another, and then another. I must have found something in the book, because suddenly my life began to parade before me in scenes as I read. In a certain sense I read looking for what I don't find in the sessions with Dr. O. When I get desperate and don't know how to arrive at something that I need to be true, and not*

simply a hollow explanation of myself, or when something more than myself is at issue, I open books and read the underlined parts to myself. My life-preserver epigrams. Sometimes it's exasperating. It's like clothing your life with borrowed phrases. And I punish myself by demanding that I always begin again from scratch.

I ask myself: What can I do to start over again? The more I think about it, the more I approach the theme of my roommate Kelly's open window. Only a few years ago I was a child. Now I am a nobody. I have nothing. I've reached the most perfect state of dispossession. Last year Papa was late in sending me money. Like Proust's character, I'm trying to go back to the day when I can find the starting point of memories in my memory. I'm motionless in my white bed, aiming my eyes at an unrelieved ceiling and waiting passively for something to happen. What?

Night comes and goes. In the meantime, the proximity of death, which night always carries along and which disappears with the first sounds of dawn in the hallway, keeps me awake in expectation in the dark. I go to the bathroom several times to see what time it is. When it's three o'clock I can't take it anymore and I go out to walk. The nurse brings me back to my room and gives me two pills. I ask her to let me sleep with the lights on. Somewhere I've read that sleeping too much is a sign of depression and not being able to sleep a sign of anxiety. In depression the controlling factor is the past, in anxiety, the future with its unknowns. What about boredom? I'm sleepy, and still that damned present time, that clock in the bathroom that I keep going in to look at, and which keeps me awake. The time on that clock always surprises me, in some imprecise way it derails my thoughts, as just before I can perceive an idea clearly it disappears and another comes along, and when I go to the bathroom I get the

proof that the time that's passed has only been minutes, though it seems that hours have gone by.

— It's up to me to kill time. First the breasts, which don't arouse anything, anesthetized, cold. I think about the machine for slicing roasts, two cuts, no, better one, and the sound against the wax paper, no blood, only a very fine glass powder on the white cone of flesh that's turned blue. I continue, my hands continue on inside my yellow bathrobe, down to the panties and under the crisp, thick fuzz hiding an opening, over it, like quicksand, I sink into the maelstrom of earth and water.

Then the same feeling returns, that of seeing my double. I'm outside, in some corner of the ceiling, and I can see her drinking from her body as if she were drinking from a huge bottle of milk. I bring my hand to the surface, rest outside while I think about the black sea urchin that sleeps between my legs, moves its spines sometimes as if it needed water and was trying to take to the road and go back to the sea but can't. Every day I pull out a few of its feet. It's going along, losing its life. One day it will dry up completely. Then just the touch of my hand will make it crumble, turn to sand.

— The room is white, the light is white. I decide to put Kelly's unicorn on the mirror of the dressing table. Back in bed, I don't like it. Its presence is bringing life to the room. I don't want anything that reminds me of the world outside. A man's land.

I feel the same way when somebody turns on the radio in the recreation room, that the world is moving on, that people are writing letters, singing, dancing, sending postcards, that millions of unicorns exist, that everything is happening and I'm losing everything.

I get up and I put the postcard in the drawer. The bathroom clock says four in the morning. It will soon be dawn. Before turning out the light, I look the room over. There's nobody but me. Relieved by the blank walls and the approaching end of night, I go to bed. Where would I rather be? The question comes to me from one of my books. Anywhere. As long as it's out of this world, anywhere. I close my eyes. The last coach of a train moves away into the distance. I fall asleep.

1975. I watch Mama stop at the door to my room. She's coming to say good morning. I'm playing marbles, or I pretend to be playing, which she doesn't notice, although I follow every one of her movements. She strolls along the balcony, goes back and forth in the hall until she finally makes a decision and opens the door. There's nothing abnormal about that behavior. From a distance she looks nervous, that's all. Close up she's somebody else. She lifts me up with the dissolved eyes of someone who's not there. Her artificial lashes stamp that disconcerted look on her.

"Will you love me when I'm not here anymore?"

It came after a long silence. The perfume that was even more intense in those days wrapped her in a cloud of fragrance. My eyes were filling with tears and she, with the same care that

she was accustomed to take in front of her makeup mirror, stroked them, and stood there looking at my tears for a long time, as if my suffering reminded her of something.

There were days when everything went well with her. If there was love. Then she could ask me anything at all. "Of course I'll always love you, Mama!" I was waiting for the holidays. At Christmastime the house would be full of people: cousins, friends. But those days must have been few. It's hard for me to remember them. The family holiday is a distant world of people and voices, even though I lived through it only yesterday. But other times have stayed with me, the days when Mama and Papa would look at each other coldly or simply not see each other. I was their only girl, after three boys. I was the last to arrive. And since we hadn't been separated from the time she carried me in her until her death, I would be her witness daughter.

 The nights were nothing but a hide-and-seek game with the dark and all the monsters it concealed, and each one of the monsters wanted the same damned thing, to take me away from my family. There, against my parents' bedroom door, I would feel that they were looking for me, groping about with their hands, and to save myself I would begin to cry wholeheartedly and run wildly about the house. But the house would then become small, so small, and its corners were not sharp but dull, and they chased me into the center and there was no place for me to hide. Several times I would hurl my body against the wall, terrified that they were about to seize me. I would end up crying disconsolately with my back to the door of my parents' bedroom. If they weren't sleeping, if they were talking, I would let myself be lulled by their voices and begin to fall asleep or just forget about myself if they didn't come to help me. I'd hear whispering, and

that would be the sign that all was well. Sometimes Mama would wake up, lift me from the floor, and give me a bottle of milk.

But later something similar would start to happen around daybreak, always in the bathtub; it was the fear that it might be my parents and not me whom they would take away.

If I couldn't sleep, I would try my brothers' bedroom. They seemed to spend all their time in bed, and there was always one who'd let me join him. Fonsito, the oldest, if I brought him cheese and crackers from the kitchen; or Miguelito, the youngest, if I tickled his back and counted to a hundred. With Cheito, the middle one, it was different. When he was back from the university on weekends he'd make a little place for me on his pillow. One night he dreamt he was a boxer and woke me up with a big punch.

But the safest room was my parents'. My childhood consisted entirely of figuring out how to sneak in without Mama noticing. My impression was that she didn't want me in their bed at night. Papa, on the other hand, was more open. We would take baths together. He would talk to me about his work and his business as if we were old friends. One day a new refrigerator was delivered, and its huge empty cardboard box, which I found on the balcony, seemed to offer the perfect solution. That whole afternoon I worked at cutting, pasting, folding corners, until I made what nearly resembled a bed my size. I covered it with sheets and cushions and dragged it into my parents' room. When Papa got home from work I announced the completion of a project. I showed them my little cardboard bed. In one corner of it, Figaro, my white mouse, was sleeping, wrapped in one of Papa's red silk handkerchiefs. He started to laugh and congratulated me. He said that it was all right by him. Mama, on the other hand, didn't say a word to me. She walked

back and forth in the kitchen. She fed me almost without look-
ing at me. Nor did she sing me any songs, as she was accus-
tomed to when we were alone. That night I was allowed to stay
there, sleeping in my cardboard bed. But two days later, I woke
up back in my old bed, surrounded, sadly, by the walls of my
bedroom; and there, beside me, was Figaro, back in his usual
bed on the night table. Mama! I shouted, and I grabbed the
mouse and ran over for them to let me back into my cardboard
bed. But Mama had closed their door and locked it.

From time to time, if it was getting late and Papa didn't
come home, Mama would put me in the car and together we'd
go to get him. Almost always we'd find him in some bar in town
or at the beach with friends. She'd be angry. But she'd get over
it in the car. Still, in the morning she would always go through
his closet. The sign that something's going on is for her to attack
his clothes with the scissors. Later on she'll have to go buy Papa
new shirts and pants.

On other nights, instead of going looking for him, she
waits for him at home. She probably doesn't know where he is.
Those are the worst nights. She puts me to bed early and pre-
pares herself. I prepare myself too. I hide in the closet that opens
onto the parlor and from time to time I stick my nose out to see
if there's any movement in the hall. She's put on her favorite
nightgown, the light blue one; she's made up her face, and her
perfume fills the house with fragrance. Sooner or later he'll ar-
rive and then it will be up to me to run and wake up my brothers,
because if the usual thing happens, there's nothing else to do.

Finally the car can be heard arriving. Papa slowly opens
the door. He knows by heart what's going to take place: stand-

ing in the center of the hallway, Mama is waiting for him with her arms folded. He must have faith in his skills because he comes in smiling and, without giving her a chance, plants a kiss on her and tries to undress her, the way they do in the movies. Papa always does the same thing. He hugs or lets himself be hugged.

Not yet, though. I'm still in the closet, waiting for the great moment. Almost in suspense, Mama's freed herself from the onslaught and is now confronting him, all coiled up tight, like an animal taking measure of its prey and getting ready to attack. He tries to calm her down. He tries to make peace with outstretched arms. I can tell—from experience—that he's got more than one drink in him, because he's nicer than usual. All that play and sympathy must make her even crazier. She can't stand it and she attacks, screaming. He tries to get her off him now. They struggle, pant, shove, tied together by twenty years of deceit and reconciliations. That's when I have to run out and wake my brothers. When she sees us coming she faints. Cheito kneels down, Miguel begs her. I speak in her ear, "Mama, Mamita . . ." And I know that she's unable to respond because I can hear her weeping to herself, as if in resignation.

1976. One summer afternoon I saw her take the machete from Don Toño, the gardener, and hide it under the car seat. Then she braided my hair very prettily and around dusk we left for town in the car. She parked in front of the main entrance to a house where there was a small sign saying PENTECOSTAL CHURCH OF JEHOVAH. She lit a cigarette and got out of the car.

"Luli!" she shouted.

An older couple appeared on the balcony, and when she saw them Mama took the machete out of the car and showed it to them threateningly. My hands were sweating. Every time I felt something imminent and unforeseen on Mama's part, my hands would sweat. Something similar must have been happening to the old couple. They were pale, the man especially, and he straightened his tie obsessively.

"My dear pastor, you tell your daughter that if she doesn't stop chasing my husband I'm going to kill her with this machete. I've got a family, four children and a husband, and I'm not going to let anybody break it up, least of all some shitty blonde. Okay?"

On the way back home the machete was still on her lap. Before getting out she put it under the seat again. In case she needed it in the future.

Sitting in a corner with my finger in my mouth and the warm baby bottle between my feet, I'm witness to another of those habits that for her, perhaps, are a way to give structure to the days and to the growing restlessness that's coming over her. Now makeup is all there is. She's in front of the mirror testing colors, blending them as if with this things come together: the smile, the doll's face, and the peculiar shine, like silk flowers. I wonder if making up and putting on wigs was a custom of the seventies or simply her way of protecting herself from all the women she carried inside her: the daughter, the wife, the mother, and, toward the end of her life, the Puerto Rican nationalist. Lolita had bet everything on one single card. Mama, I think, must have thought she could live all those lives her mother had postponed. Somebody else might have been able to do it (or maybe she herself under other circumstances), but

Mama was just unlucky. She had her fate all prepared. "Just
don't get blacklisted by repetition." On many nights she'd take
the rocker from the balcony and carry it into the yard, under the
palm trees. She'd spend hours there, like a statue, a cigarette in
one hand and a glass of anisette in the other. Mama didn't drink.
The same bottle would last in the cupboard for years. (It finally
appeared in the kitchen sink, empty, on the day of the wake.)
Sometimes I think that the anisette, the cigarette, the makeup,
the eyelashes, and the wigs were a kind of game. Playing with
death, maybe. But I don't know whether the point was to kill
herself or to tell herself that she wasn't dead yet. That there was
time to change. To be somebody else. I liked watching her. By
the time she'd put the cigarette out against the palm tree, I knew
that things weren't going well with her. Then, instead of com-
ing back into the house, she'd go into the canefield and mingle
with the stalks of sugarcane, which were tall now, ready for har-
vest. I'd follow her from the dining room window until she was
lost to me in the midst of the echoes of thousands of *coquí* frogs.
I couldn't sleep. I'd wait for the canefield and the *coquís* to send
her back to me, and when I saw her returning, I thanked God
for having given her back to me alive once more.

1976. It was my seventh birthday, and on that day Mama came
into my room with a package.

"It's from your Grandma Lolita."

And she laid it on the bed. I'd heard that name before but
I couldn't remember when. Now I found out that I had a grand-
mother with that name, different from Grandma Irene, Papa's
mother. I opened the box and inside there was a little yellow
dress, hand-embroidered, with three ruffles on the skirt. I'd
never seen Mama's face more glowing. She was in her glory. She

was talking to herself. She took the dress out of the box and, standing in front of the mirror, held it against her body, pulling it down and adjusting the folds and the waist as if it were really for her. Maybe it was the gift she had always hoped for and which now, thirty years later, was reaching her in the mail, care of her daughter.

⁓ While I was waiting for Papa to come and pick me up from school, a boy threw a stone at me that hit my left ear. That day Mama had fixed my hair into one of those bullfighter's bows that I hated because it showed how big my ears were, especially the left one, which, in spite of my efforts, twisted frontwards. At home my brothers called me Dumbo. The boy at school was hiding behind a tree and every so often he'd stick out his head and shout: "Nyeah-nyeah, your grandmother's in jail. Nyeah-nyeah, your grandmother's crazy, she killed a man with a gun. Nyeah-nyeah . . ." I picked up the stone from the ground and kept it.

Ever since that day the questions started. It couldn't have been Grandma Irene. She was a nurse, she lived in San Juan, and when I went to her house I'd go to sleep against her stomach. It must have been the other one, the one who lived far away. It must have been that one.

When Papa arrived, I showed him, whimpering, the stone I was holding so tightly that it had punctured my skin and made it bleed. The boy was still behind the tree, I could still see him peeking out. I pointed him out to Papa and repeated what he'd said about my grandmother. I never saw Papa so pale. And what followed was something I had seen before, but in a Cantinflas movie. Because it was just like it: Papa chasing the boy and the boy getting away from him, and the two of them whirling around the tree and surprised people wondering what was going on.

A few days later I was called into the principal's office and I was on the point of hiding out in the bathroom. I wasn't afraid of her, but I didn't know whether she was good or bad. She would inspect the hallways every morning. And from time to time she'd appear unexpectedly in one of the classrooms and fasten her eagle eyes on us. Still looking at us, she'd jot things down in a notebook. She too wore an Afro, and always dressed in slacks and a jacket, and she walked with her bird look, hunched over a little, like the policeman across the street. There was a rumor among the children that she was a man disguised as a woman.

Full of premonitions, I knocked on the door. I'd never been in her office before and couldn't imagine why she'd sent for me. The principal opened the door herself and with a smile and in a tone of voice that seemed tender to me, she invited me into her inner office and offered me a seat. No, she wanted to tell me how happy she'd been when she'd found out I'd won first prize at the science fair. She was proud of me and wanted to congratulate me. It was the first time I'd seen her smile for so long a time. Sitting in the office opposite her, seeing her smile, and hearing all that praise soon gave me back my confidence and I began to talk about the seismograph I planned to build for the fair in March. I was about to describe my new project to her in detail when she got up to get something from the library, and when she came back she was carrying a book. The first thing I noticed was that it was a book with a black binding, like missals and Bibles. It took me a while to realize that she'd brought it to show me, and when she saw my confusion she laid it on the desk and then I was able to read the title, with my grandmother's name in it: *Lolita Lebrón: La Prisionera.*

I'll never know whether she planned it or whether it had

just occurred to her suddenly. When she saw my confusion, she took the book, almost the way a person picks up a piece of crystal, and, standing up ever so calmly, she came over and placed it in my hand. As if obeying a command, I opened it to where the bookmark was, and on that page there was a picture of two women. I recognized Mama, a few years younger; the other was an older woman, a little heavier and quite a bit sadder than Mama, and they both had moles in the same place next to their mouths.

Sitting down at the desk again, the principal waited for me.

"Your mother and your grandmother," she told me, fastening her eyes on me. "I'm giving it to you."

Just before I left, she commented that Mama had told her about the incident with the stone, but that I shouldn't let it bother me.

"Look, that foolish boy's already got the punishment he deserves. As for your grandmother, I want to tell you that I admire and love her. You should feel very proud."

A ray of sunlight poured in through the window and landed exactly on one of her earrings. Years later, in a book of religious paintings, I would see that same light again, although not as intense as the light that struck the face of the principal that morning. Her eyes had grown large. I'd never seen anyone look at me with so much affection. Mama perhaps, when I'd bring home a hundred in Missy Rivera's dictations. The principal was beautiful, after all. We said good-bye, and before closing the door, she kissed me.

"I'm dying to see your seismograph, Irene. In March, isn't it?"

And that was how the grandmother of the yellow dress turned into the grandmother of the book with black covers.

For Christmas that year the Lebróns and the Vilars came to our house from all over the island. There must have been around forty people, and even though the house was big and comfortable, they had to set up tents in order to put up so many people. We were celebrating something more than Christmas. My brother Cheito, who'd been in the hospital after a car accident, had been discharged; but what was most important, Papa and Mama were back together again after a long separation during which Papa must have slept at the office (although the Lulis of that period most likely were with him). I remember that Christmas celebration more than any other. I'd be queen of the festivities, and of course my cousins would be there, and family reunions like that didn't happen every day. But I also remember it because it was the last Christmas for my family.

We played until we almost collapsed from sleepiness in some corner; we hid under beds, in closets, while the adults drank or played dominoes with a lot of shouting, and no one knew whether it was over the dominoes or whether they'd stopped playing and were arguing politics. My other cousins thought politics was the most boring thing on earth. For me, ever since the principal had given me the book about grandmother, politics became something intimately tied to the family secret. My cousin Elena wanted to play—marbles, I think. I wanted to know what they were saying. I remember that it was hard for me to understand much because they were shouting and using difficult words, words that I'd heard Mama use at meetings of the Independentista Party.

Which side should I take? Some uncles, for example, were for the Popular Party. They were calling themselves the center now, though they really were, or had been, nationalists, like Grandmother Lolita. But since the idea of an independent

Puerto Rico had no chance, they preferred to play the Popular
Party card in order to stop the Republicans from winning. For
the Independentistas, that ambiguity was unacceptable, cow-
ardly even. The Populars (Papa was one of them) defended
themselves, saying that ideologically it might be ambiguous,
but given "conditions" it was the only effective way out. They
said all this in shouts, and the funny thing is that through it all
they continued playing dominoes, and every so often someone
would pick up a piece and smack it down onto the table with a
tremendous thump and you couldn't tell whether it was because
of the game or the argument.

1977. In her last years, Mama decided to join the Independen-
tista Party. Those meetings were gatherings that took place at
night in a two-story house on the road to the Seboruco ceme-
tery. A neighborhood like the one Oscar Lewis describes. And,
just like in his books, to get to that meetinghouse you had to
climb some rickety wooden stairs painted a gaudy yellow. That
last year I attended almost all the meetings.

Is it a childhood memory or does it come from all the
reading I've done? I ask that because they're really the first
intellectual and erotic scenes of my life. On the walls hung
photos of Che Guevara, Pedro Albizu Campos, Karl Marx,
La Pasionaria, Lolita. During those days she'd read Oscar
Lewis's *La Vida*, and then she would read to me from *The Chil-
dren of Sánchez* (two books that ended up piled against the wall
in Papa's bedroom). She'd read those and other books vora-
ciously, and she even took notes of thoughts or ideas that she
would read later at meetings.

Sitting on the floor with some of the toys she brings along
so I won't be bored, I enjoy watching her in the center of every-

thing, speaking passionately every time she has the floor. At those meetings—it was the last years of the seventies—I heard the word "colonialism" for the first time. Later on I would hear it more and more at home. In the end, a lot of those who went to the meeting would come to see her at home; sometimes they spoke out loud, and sometimes in whispers, and they drank and smoked a lot.

I think Papa and Mama were living apart those months. Mama has finished braiding my hair and has gotten dressed up in very elegant clothes. It is evening, and we are driving to a destination she refuses to reveal to me. She says it will all take very little time. Afterward I can have ice cream. The car crosses the gates of the Club de Leones and there is music all over the parking lot. Mama says to wait in the car, but I follow her shadow, enter the ballroom, and see her walk toward my father, who is sitting at a table next to a woman with long black hair, almost longer than Mama's. I can't see her face but I can see my father's startled face when Mama reaches for the woman's hair and pulls her, chair and all, to the floor. The orchestra barely fits in the stage and the dancers are packed tight amidst the instruments, speakers, tables, my parents. Papa is holding Mama by the shoulders, he says it's all his fault, leave the girl in peace. But she just stares at the hair spilled across the floor and over her own high-heeled shoes. Without a word she comes back to me.

I'm on the beach at Cerro Gordo, enjoying the sea and also the clouds that pass, one after the other, toward the right, where the grapevines are and where Mama and that man have parked the car. It must be the middle of the afternoon, I'm

hungry, and they're still in the car. A yellow Volkswagen. Lately Mama's been picking me up after school and we go to the Caracoles beach together. Sometimes to Cerro Gordo, a small beach hidden like a half-moon between greenish dunes where cattle graze. For quite a while I've been thinking it's taking them a long time to come back. I get up and go to look for them. There are some bushes. I stop. My throat feels dry, the same as when I'd wake up all alone in my room. The car isn't anywhere in sight. There's nobody there. I remember it well, but to tell it now it sounds as if it were a dream. First there's a single figure that's really two that have come together in a violent struggle and they chase each other and one is changed into the other. All of a sudden it's one single figure. I don't know if I understand, but I turn around, quickly pick some grapes hanging from the bushes around me, and take off on the run to the sand castle I'd built a few hours before with the pail Mama gave me, and, without thinking, I sit on the castle, devouring the grapes, swallowing them without chewing, the way I do with the carrots I hate so much. And I forget.

—— Another day. We go to Vega Alta to visit a man. He's not the one from the Volkswagen. At Party meetings he was the one who sat beside her, and back at the house they'd chat for hours. I don't remember the house, only the living room, and that there was a window that opened onto a yard. On many afternoons that year they'd shut themselves in the bedroom and have me wait in the living room. I would have rather stayed in the car, but I didn't feel like telling them so. Instead, I'd amuse myself at the window watching some children playing ball in the yard below.

It must be January. I sneak up to her room with the pretext of asking for her hairbrush, but it's really to spy on her. She's standing in front of the closet mirror, looking all worn out. Her movements are slower than usual and when she smiles she twists her face in a way I don't understand. Maybe she doesn't like what she sees in the mirror. She's grown heavier— flabbier and whiter. She's no longer the beautiful, proud, and erect woman of before, or so she thinks. Sitting on the edge of the bed, she keeps on looking at herself in the mirror. Then I discover that she's holding two cotton cups. I'd seen them in a dresser drawer but only lately had I found out what they were for. She covers her breasts with the cups, holds them down with her bra; then she gets dressed in black and walks with the fear of someone who doesn't know what her feet will come across in the dark mud of the mangrove swamp.

One afternoon, again at the beach, I watch her vanish into a wave's white crest. I cry out for her to come back and she does, though I know she has almost drowned. The wind is blowing as never before, or that's how I remember it, and in the midst of it all she lies in the sand and I try to imagine what it must be like wiping the sand off Mama's lips, traveling to distant places, hidden secrets, a lost city, a mist with the shape of a woman whom I may embody . . . I could not hold back the tears and begged her to say something, to please talk to me, and her mouth opened in spite of herself and out of it came, in a rasping voice that surprised us both, "Everything will be all right." Mama's words floated above, "Everything will be all right," and though they held a promise I knew it wasn't going to be.

~~~~ A few years back they'd discovered a tumor in her uterus. "They cleaned me out," she often told her friend Soraya. "I'm not the same person." I didn't know what that meant. There were days in which she'd spend hours in the rocking chair, deep in thought. Blotches appeared on her skin. Her blood clotted. She said she had tachycardia and attributed it to her father's genes. The medicine cabinet in the bathroom was full of pills. She must have written a lot to Lolita during that period, and she may even have confided some of her immense sadness to her. I know that Lolita would write her long letters from prison, asking her to have faith, to pray to the Virgin Mary.

Between the prayers and the Valium, I saw her gradually disappearing, in the same way that, from my bed, I would see the light of the fireflies twirling in the darkness die out until I could no longer discern it in the night. And now I ask myself, why? How can it be that at the age of thirty-six a beautiful and intelligent woman, with the vitality of the latitude in which she'd been born, fades away like this and no one notices?

"Everything in that woman's life was so brief," I hear Soraya telling me. "So you think her life was cut short?" For her, my mother was from the beginning a woman under some sort of blackout, with parts of her life scattered here and there. One part is still fourteen and lives in Lares with uncles and cousins. It's 1954 and the police surround the home. In vain one uncle tells them that they have nothing to do with Puerto Rican nationalists, even if the most talked-about now is his sister. The police go into the house and ask to see the daughter. When was the last time she saw her mother? The girl says she only met her once, when she was eight, and that her mother had brought along a brother and left him there with her. She had wanted to go along, but . . . And as she apologizes

to the policemen for being an orphan, they come closer, and ask more questions.

Another part is still fourteen and carries a cage full of rabbits that belongs to her uncle Agustín. She is still wondering about her brother, about how it would have been to spend all those years in New York with her mother, when she hears the loud voices, the cries, and the news of her brother's drowning. She drops the cage and runs to the lake, and between the hearing and the seeing, she hears no more. She opens her mouth but no words come out. Months pass before she regains her full voice. Then, when her relatives think they've lost her to madness, she speaks and says she's marrying the son of that minister down the hill. She has just turned fifteen, and leaves the house clutched to her husband like a bloody prey.

Another part is eighteen and has two baby boys. Everyone is happy. No one suspects that if love has given back life to the girl, it has not the soul.

And there is a last, isolated part. She is thirty-five and there is not much time left. To each infidelity of her husband's she answers with another. This goes on until she has barely anything left to give in exchange. In each casual encounter she's left a piece of her flesh, and that means there is less of her, no matter the layers of makeup.

*What have I done with my life? It sounded like a question in a soap opera, but the voice was indefinite, one among the many that I had begun to hear at moments when I didn't know where to begin. My life . . . I felt it getting away from me the moment the automatic doors of the hospital opened and I walked out into the freezing March wind that parched my lips and dampened my eyes. It was the first time I'd been out in two weeks, and I had only an hour's pass. Making my way up the hill, crossing the campus, getting to the Hall of Languages, climbing five flights, giving the doctor's note to my religion professor, explaining things to him, saying good-bye. I crossed the parking lot of the hospital building; ambulances were clearing passage with their sirens and for a while I had to concentrate to find the way to the Crouse College building, which was visible in the distance, up above the other buildings on campus. I was*

*afraid and wanted to go back, return to my room, get into bed, and never go out again. Maybe that's why I didn't see him, only heard the faint hum of the little motor, and when I tried to get out of the way it was too late. I fell to the ground, not knowing who had run me down. A jab of pain in my right foot rose up to my left breast, and the paper I was on my way to hand in that morning was strewn all over the pavement. The little man in the wheelchair continued on his way at full speed. He crossed the street and disappeared behind a building. The son of a bitch had run me over and hadn't even turned around to see if I was hurt. I gathered up my papers, as the car horns became more and more insistent. The note from Dr. O. for the professor had landed next to a crack in the pavement. There was her signature. I tried to grab the sheet of paper, but the wind was carrying it uphill. The paper rose by itself, dipping, floating in circles, dipping, gaining altitude. I chased it, insulting the little man in the wheelchair. Nobody made the slightest effort to help me. Everyone looked the other way.*

*The midget who sold paper whistles on the corner of Marshall and Crouse had changed location. Now he was two blocks down, at the end of the slope. When people passed by, he would lift the whistle slowly to his mouth and blow. The tube of the whistle would uncurl like a snake's tongue.*

*The doctors are waiting for me with paper and pencil.*

*"Please don't make things up" . . . "These people are waiting for your answer" . . . "You don't have to answer if you don't want to" . . . "It would be better if you tell me, why do you think you're here?" . . .*

*Tell them it's Cuomo's fault. Tell them anything. Reagan. Coffee. Wonder Bread. Deer.*

*"You don't have to answer if you don't want to" . . . "Tell*

*me about your mother, what can you say about her?"* . . . *"Can you say something?"* . . . *"Yes?"* . . . *"We're only trying to help you"* . . . *"Is there someone telling you not to talk?"* . . . *"You have a right to feel disturbed."*

*Why do they need seven people for a psychological evaluation? This room has a problem with its design. They forgot to put in windows. Besides, how ridiculous it is to make me sit in a chair, just me, in the middle of the room. They all cross their legs the same way. I'd like to ask Dr. O. if they could dim the light in the room. It's too bright. I shouldn't have gone to the evaluation. Dr. O. wants me to tell her more, I know. They were looking at me like I was a freak. They were taking notes. The woman who was asking the questions sat opposite me and spoke as if she knew all about my life. The room was cold. The light was blinding. No, I shouldn't have left my room.*

*"I hate this." (Too late, I said it.)*

*"You could have chosen not to come. To say no, remember? You can always say no."*

⸺ *I should look into her eyes. It's the one way that I'll be able to concentrate and get away from this cursed voice of mine.*

*"You don't have to see them again if you don't want to. We'll continue the individual sessions . . ."*

*". . . and today we won't talk about the destructive side of your personality which bothers you so much. We won't talk about relationships, or about your baby, or your mother, all right?"*

*"Madame K. is leaving tomorrow."*

*"Where to?"*

*"To the home."*

*"She's going to Israel, to her home?"*

"*No, no, to a home. Her children are coming to pick her up tomorrow.*"

"*Is she going to her son's house?*"

"*You don't understand. She's not going to her children's home, she's going to a home, an old folks' home.*"

The program 60 Minutes *is full of little old people. But more than the old people I remember a mattress. In that home on the program they showed an empty bed and an attendant sweeping the floor beneath it. The old lady in the room had just died and the sheets on the bed held the shape of her last position.*

"*Does it make you sad?*"

"*I think so.*"

"*Why?*"

———  *Madame K. goes back and forth in the hallway, and that boy Sam follows her contentedly. I, too, have decided to follow her. I would have liked to give her a postcard or something but I don't think she's aware. Nothing exists for her except those days in the hallway and, every so often, my shoes. She'll return to her room and mend her coat again. Her children will come to take her away. She's mending again. Maybe if she gets happy and thinks everything is going to be all right, she'll talk to me. No. It's a black velvet collar and threads of all colors stand out on it. It would seem that she's been darning for many years. Since Auschwitz, maybe. Four decades is too much. She's not going to look at me. Nor is she going out to meet her children. She's going to keep on sewing until they come, like someone who won't let herself be noticed.*

And now the scene that has been fixed in my memory forever. The fright is still vivid as I remember the turban in a puddle, the long hair wrapping her, the lips giving her features a bitter grimace, in what must have been the first encounter with the horror, as if at the last minute she'd tried to shake off death. These are the last images I have of my mother.

After my brother Cheito's wedding at the church in San Justo, which would be the last festivities in her life, Mama left the party, barely saying good-bye to Uncle Miguel after he accompanied us all the way from the church to the car. Somebody had told her that Papa was dancing with a beautiful young woman, way too much. But she, indulging in the biggest déjà vu

of her life—a swan's death cycle which included all the real and imaginary injuries—could only retrace her steps in the dance hall, as she was looking at him and at the charming young lady probably with the same unusual curiosity of the past. "Unusual" is the word Papa had used to describe their first night, when he saw her coming down the slope with soft steps—"From heaven, my girl!"

My brother Cheito's wedding was anything but heaven for Mama.

"So long," Papa said, getting in behind the wheel. Uncle Miguel didn't take his eyes off Mama. "Drive carefully," he said. "Take it easy," he stressed. Papa, with his usual optimism, declared that everything was going to be all right; he started the engine and we took off in the Mazda. We were returning home on the twenty-seventh of February 1977.

I don't know if they said anything to each other. Mama stayed in the same position, maintaining the same silence with which she'd gotten in, and I, who'd seen Uncle Miguel's worried face, was keeping watch in the backseat, sort of preparing myself for what was to come. In the shadows of the car all I could see of her was the gold purse. She was clutching it with both hands. Papa was looking straight ahead; he was still looking ahead when we went through the main gate, and that's how he was during the whole trip. Straight ahead.

As if there was still time to stop everything, I looked back, I looked for the church where my brother had just gotten married and I saw Uncle Miguel still standing there with the undecided expression of someone who knows that something is going to happen. Was he imagining it?

I've got to look after her, I said to myself, and I took her arm, firmly, as if to tell her I wouldn't abandon her. She turned

around; she had the look of someone who was very tired. I let go, but from my seat in back I kept on watching her. Her eyes were enlarged, empty.

"Go to sleep," she ordered.

It was the last thing she ever said to me.

━━ I can see a girl dressed in white, a red ribbon at her waist, patent-leather shoes, her hair loose, her brow wrinkled from trying to hold back her weeping so much. She leaps into the front seat, which her mother had occupied seconds before, goes out the open door at the very instant the car slams on its brakes. She's going in search of the one who's escaped, with the hope of finding her sitting in the road perhaps, weeping but straightening out her dress. The girl covers the distance to the black bundle that's lying on the pavement. She gets there, trips over a gold high-heeled sandal. From her mother's forehead the wrinkles have spread to the cheeks and lips, to the tense brow that is now one single eyelid that tightens horribly over her eyes. Then she calls to her. The mother doesn't answer. The girl tries to move closer but a strange tingling immobilizes her. Something is climbing and sparking up her thighs, gets into her belly, tears it. She's nailed to the road. She sees the turban floating in the ditch, the broken hand mirror, the gold purse, the high-heeled sandal. Next to her right foot, against the white patent leather of her own shoe, she sees a strip of artificial eyelash. She hears a voice calling her name and for a moment she thinks it's morning and they're waking her up for school. Closer by, she hears the sound of a horn, manages to get off the highway. Her father lifts the woman's fallen body.

"Your mother doesn't know what she's doing," he complains. The girl in white quickly stuffs the mirror in the turban,

and the turban in the purse. She runs after her father to the car, remembers the eyelash and goes back, but she can't find it again. Her mother is inside the car, leaning against the door. She changes her position, notices the eyelid with lashes, strokes her forehead, settles her mother on her lap, and her horror is so great that she can't even cry.

This is how it was then: we were coming along the road from San Justo before getting on the expressway and she took her right hand out of her purse and put it on her knee. A bump made her lean forward. She stayed that way. The car continued on. As we entered the curve leading to the expressway, we leaned a little. Papa kept on looking straight ahead. I was still as if fastened to her in order not to let her out of my sight. But the curve seemed endless, or that's how it seemed to me. When I saw her grab the door handle, I tried to look into her eyes, and when I saw them I didn't wait any longer. I grabbed her arm. I dug my fingers into her shoulder to make her know that for nothing in the world would I let her leave. She pushed. When the door opened, a deafening wind came in. I was tugging. No! No! I was tugging in my direction with all my strength, all my body, as if obliging her to choose. Finally, I didn't feel any more resistance and I was left with a piece of black lace in my hands, and I hated her. She'd done what she wanted to do. She'd left me.

On the way to the hospital, with her head resting on my lap, I called to her several times in a very low voice so as not to startle her in case she woke up. First I said Mama, then her name, but she wasn't answering. In some way I understood that she had fallen into a dream from which it's hard to wake up. Still, she must have heard something, because at one moment the fainted look left her and she opened her lips a little. Words

didn't come out; they were quivering on her lips, as if she were gargling. (Sometimes I go back to that scene with Mama and wonder what she must have been trying to tell me. It's an unknown, perhaps the enigma of my life. It's painful writing about things like this, and Grandmother Lolita must be right; but even though it's overwhelming, there's something about words that makes them seem like souls. It brings us closer. So that I'm Irene and she's Gladys Mirna. Irene writes and talks about her and sometimes she answers her—with the ventriloquist voice of fiction, of course. The book will end and we'll go away, she, where to I don't know, and I . . . I don't know that either.)

I would have liked to have stayed alongside Mama until the last moment, but they didn't let me. Next to her the machine that's keeping her alive is purring. It's the only thing really alive. Everything else: nothing. The visitors speak in low voices, someone strokes her shaved head, no one says anything. They're afraid of disturbing her sleep. On the screen a line goes up and down, sinks to the bottom of the graph, reappears, repeats the same hazy trip for several hours, and then . . . nothing. Nothing. Nothing. The alarm sounds, the nurse runs out into the hall; in the room the alarm keeps on sounding. Nothing. The doctors come, Papa arrives, Cheito arrives. It can't be. No, no . . .

### POLICE REPORT

At 1:30 A.M. on February 27 (Sunday) the couple Ildefonso Vilar and Gladys Mirna Méndez Lebrón, accompanied by their daughter, age eight, were coming from the wedding reception of their son José, age 19. As they were traveling on Highway

848, coming from San Justo, right by the Trujillo Alto expressway, the door of the 1974 Mazda, registration 65-K-669, suddenly opened and Gladys, the wife, was thrown from the car to the pavement, receiving a hard blow on the head, and was taken to the Río Piedras Medical Center by her husband. They left her there and made a report to the policeman on duty, Officer Castro. The Institute of Forensic Medicine at the Río Piedras Medical Center determined that she had suffered a blow on the head that brought on a severe concussion of the brain. . . . Gladys, the wife, died yesterday, Tuesday, at 1:40 P.M.

"Tell me how it happened," the policeman asks me while he leans over some papers on the desk.

"My brother Cheito got married and after the wedding . . ."

"What happened after the wedding?"

"Papa, Mama, and I were in the car on the way home."

"What else?"

"Mama fell out of the car."

The policeman puts a sheet of carbon paper between the two pages. I tell him that he's stained his fingers black and he smiles; I look for Papa's eyes and I realize that he's not looking at me.

"How did your mother fall out? Try to remember clearly what happened."

"Like I already told you, sir, my mother was sleeping up against the car door and all of a sudden the door opened."

"All of a sudden?"

He stares into my eyes. My answer mustn't have been convincing.

"Yes, all of a sudden. We were bouncing along that San Justo street that's full of potholes, understand? At the curve the door opened. It wasn't closed all the way, that's the reason why."

"And nobody pushed her?"

"Didn't I tell you that she fell!"

"And she didn't open the door either?"

"She was sleeping along the way!"

"I see, I see."

A door opens, a man looks in and asks to speak with Papa alone.

———— In 1977 Lolita would have another vision. Father Hughes is her confessor and informant, the one who brings her news of the world outside, which interests her less and less. But that March 1 is the anniversary of the attack on Congress, and Lolita has had a vision that filled her with ominous certainties. Father Hughes arrives at noon, downcast, thinking of how he will have to pass on the sad news. She's ahead of him, disconsolate.

"Tatita! Tatita's left me!"

Symmetries, coincidences.

Lolita tells me these things about my mother with her eyes closed. She says that she saw a funeral and that at the funeral there was a crowd and they were all faces she recognized. Then she knew that it was because of Tatita.

"She's died on me . . ." Father Hughes must have been quite startled by that reaction on the part of Dolores, as he called her (only her mother, Rafaela, called her that—Dolores, Lolita Dolores . . . ).

At the death of her son, others knew it first. She didn't expect it. The most terrible part was the way they told her the

news. The policeman who was taking her to court on the day of her sentencing asked her if she already knew about it. Knew about what? Haven't you seen the papers, Lolita? No. She didn't read the newspapers.

⟶ A few hours after the father confessor's visit, four men and two women from the FBI would arrive. They're coming to escort her to another place, although they won't tell her where. It doesn't matter. She knows. That's why she's not surprised when they tell her to take only what's absolutely necessary. She has five minutes to dress. She hasn't finished buttoning up her black dress when one of the policewomen blindfolds her eyes. Lolita recites the Twenty-third Psalm, her psalm, to herself: *though I walk through the valley of the shadow . . .*

"That very day I was finishing twenty-three years of prison, and, of course, with blindfolded eyes it's hard to walk straight."

She'll probably have to feel her way as she walks so as not to bump into things. It doesn't matter. She knows the layout of the cell by heart, every wall, every corner, she knows how to get to the bars, reach the hallway, she's been doing it for twenty-three years.

⟶ Before, nights had simply been darkness, the time when it was necessary to sleep or, if unfortunately awake, to prevent the monsters from taking over. But now there was calm silence, almost a pause, and it was easy to believe nothing had happened.

I opened my eyes and in the distance on the horizon the copper-colored sun of dawn was rising. For the first time sunrise saddened me so much. I prayed to God (whom I'd just

begun to know on weekends at the home of my Episcopalian cousins) to take away that dream, please, and shorten the day, if possible. But it isn't easy to negotiate with God. The sun's already rising above the flamboyans, coming from the blue horizon, going toward the black future. The car in which we were traveling continued on toward where there'd been a road and where now there was a crowd. We were approaching home. I knew it not only because I knew the road, but the smell of sea was beginning. I put my head out the car window and saw that we were getting close. Full of that very special hope given by everything that smells of home, I fell back onto the rear seat, praying that none of it was true. It was a joke, another trick of Mama's, who'd surely be waiting for me on the balcony. Everything was going to be all right, and I began to fantasize, because as a child I did it quite often, that we'd still go to the beach, play at being sirens, bathing beauties, and I would ask her to forgive me for all my bad manners and for never having wanted to eat squash or codfish with *panapen*, her two specialties. Oh, and I wouldn't stain my school blouse with *quenepas* again. Those impossible stains that annoyed her so much. Yes, from that morning on everything would start all over again.

Uncle José's somber face appeared in the rearview mirror. I moved over in the seat to see Aunt Betsy, who was riding beside him, too, and I saw a teardrop falling from her eyes, a little drop that kept getting larger. My chest hurt; I had to make a great effort to control myself and not cry, because it would have meant accepting the hopeless and I was still hopeful.

The car stopped. I put my head out the window again but I couldn't recognize my house. Palmas Altas had suddenly changed. For four days people had been gathering on the corners with placards and they filled the street, which was narrow

and couldn't hold so many people. We had to make the last stretch on foot, pulled along by Uncle José, who, with shouts and shoves and displeasure, opened a path for us through the crowd.

In the distance a line of men in uniform could be seen approaching, and a woman was in the middle of them, enclosed, in the precise center. They must have been policemen, because they wore riot suits and were waving their clubs over the heads of the people who were holding out their hands—not to protect themselves from the clubs, but to touch the woman who was coming along between them.

"Lolita, Lolita."

It was a chorus of schoolchildren. They must have been prepared quite a bit ahead of time, because they were dressed for a holiday and they sang with a devotional tone, as in church. With every line they bowed their heads.

"Lolita, Lolita."

The police barricade was already near the house when I heard a shout beside me and I saw Uncle Gonzalo, Lolita's oldest brother, who was crossing with his arms out as if to embrace her. But at that moment another man, somebody unknown, came out of the crowd with a revolver and confronted him.

"You son-of-a-bitch traitor! How dare you!" he said, aiming at his head. Uncle Gonzalo stood stock-still, terrified, waiting for someone to come to his defense, but nobody did anything. Two policemen leaped on the stranger, disarming him at the very moment when he was getting ready to fire.

"Lolita, Lolita."

The children continued singing, everybody was struggling to get closer. In the end, the shouting was so loud, the people

pushing so much, that the police had to draw back and abandon the barricade. The woman immediately left her encirclement and, speaking to the crowd that was shouting and shoving madly, she asked them to be calm, for the sake of their country.

That was how I first got to know my grandmother Lolita. I'd only seen some hazy photo of her face, but I couldn't imagine what she was like. She was surrounded by thousands of people, yet she was alone. Ever since she'd gone up the steps to Congress on March the first, 1954, she'd been alone and now she was coming back to see, for the last time, her daughter who'd died in an accident just days before, another March first, and then she would go back to prison and go on being alone. She'd turned fifty-eight in November. She was wearing black, her skin was opaque, worn, and in her hand she carried a rosary, also black, and the tears fell in large drops onto the beads and ran down her fingers.

She was my grandmother. They looked at her, enthralled. They worshiped her. I was looking at her too, but from much farther away. They tried to touch her. Two policewomen held her by the arms, and, against the protests of the crowd, they led her into the house.

It was and it wasn't my house. They'd removed the living room furniture and they'd put the coffin in its place, and in it was Mama, wearing a canary yellow dress. Kneeling beside her, among the blossoms that were yellow too, was Lolita. In one hand the rosary, in the other the flag of the Lares revolution. I went over to the coffin, determined to wake my mother up. I still harbored a faint hope in spite of the crowd and Lolita's prayers and tears. I touched her. With the forefinger of my left hand I drew a line from her forehead to the top of her nose until

I ran into something like hardened modeling clay. Her nose gave way under the pressure of my finger and I withdrew my hand, almost with fright. Then I saw that they'd touched up the beauty spot with eye shadow. I went back to thinking that it was probably one of Mama's little jokes. Who would ever have thought to paint the beauty spot with eye shadow but her? Next to me someone was commenting on what a good job that woman Soraya had done on her at the morgue. She'd even found out the size of the artificial lashes. Number eight. She must have known her well.

It was probably at that time that I became resigned to the fact that Mama had died and this was a farewell. That it would be a long time before I got to see her again. I looked at her for a long time and my eyes were filled with yellow . . . But as my uncles and aunts said, everything would be all right. Later on, while they were putting the lid on the casket, I started laying out the schedule for the next few days and reviewing Mama's instructions on how to cook rice without it getting soggy. Cooking and helping around the house would be up to me until she came back, because Mama's body may have been there, but she wasn't.

And I remember quite clearly that I felt, almost perversely, a fresh sense of beginning.

The bells were tolling. The village bells of any small town always toll for the dead, but I, just a child, thought that they were tolling only for Mama, that the whole crowd who came pushing through the canefield, going alongside the river and around the square with the Fountain of Colors, had come only for Mama. As they passed Mount Carmel Church, the bells rang even louder and they must have been calling the people,

because they were coming out of the streets and drawing near, first from curiosity, but they ended up joining the procession. And then, at the tail end of the funeral cortege, someone arranged a stand, and songs started to mingle with the shouts and the horns of the cars following the hearse.

"Who got married?" a woman shouted from the sidewalk.

"Lolita, Lolita," the ones in front chanted in a chorus.

We entered the Seboruco cemetery with the sun on high, with shouting, shoving. Behind me two women were talking.

"Somebody died, somebody must have died."

"Who?"

"I don't know, but somebody famous."

They were coming from all sides, who knows from where, with Thermos bottles in their hands, folding chairs, and parasols. They overflowed the cemetery, but they kept coming on foot, along the road blocked by police stanchions, which everybody was leaping over, having fun, as if it were an obstacle course. At the cemetery gates a man had climbed up onto a lamppost with a banner that said FREE LOLITA. He was swaying as he tied it on. The people below encouraged him:

"Climb, kid, climb!" the same as at name-day parties.

Missy Sánchez, my third-grade teacher, was leading me by the hand, but we must have been trapped or have fallen into a pit, because it seems I fainted on top of a grave. I have a memory of having seen something in front of me that was like the smoke rings over an ashtray or a cup of coffee and of feeling all wrapped up in that fog, which was becoming a thick grayness. It's the only thing I can remember. And also Missy Sánchez shaking me to wake me up. Where was I? What was that sound? It was my stomach. The only thing I'd had to eat since the evening before was a rather tart orange that had stuck at the

mouth of my stomach. (Ever since then, hunger or a lack of hunger has been a theme in my life, a kind of intestinal dialectic that obeys its own laws.) Saint Joseph and the Virgin Mary were looking down on me from atop a black marble mausoleum, but they were blind, their eyes were blank or turned off, like the statues on those monumental tombs that sometime later I would see in the cemeteries of Spain. We went down, slipping past graves and people, to rejoin the procession that now almost completely encircled the figure of my grandmother, wrapped in the flag of Lares.

Someone comes over to offer condolences. She answers:

"There's no victory without pain."

Suddenly Lolita takes off the flag and drapes it around some children who have come over to greet her. The children kiss her hands, their parents weep, friends too. A very old woman comes forward bashfully, almost certainly to kiss her. Lolita faces her and tells her:

"I want you to be strong so I can draw strength from you."

The old woman bursts out crying disconsolately. A photographer struggles to get closer; the people block his way, they all need air to breathe, Lolita is sweating. The photographer kneels and focuses his camera from the ground. She spots him and tells him that pictures don't count, only actions.

"We're fulfilling a sacred duty."

A man comes over to the photographer, takes him by the arm, lifts him up.

"This is a funeral. Go away."

Now they're approaching the open grave. Over the heads of the people, the casket wrapped in flags is lowered. Then someone stumbles and the flags fall onto the heads of the people, they fight over them, or maybe they're simply struggling to

get out from under them. A man with very blue eyes, one of the ones who used to come to the house to talk to Mama—"Rubén Berrios," someone says—gives the final farewell. He keeps looking at the grave, talks about Mama, about Puerto Rico. The sad, patriotic words were meant to be a challenge to the loneliness of the homeland and of death. But beside him my brother Miguel is biting his nails; Fonsito, the eldest, bites his lips; Cheito hugs his wife, Papa hugs himself; Aunt Aurea, who reared her, leans dangerously over the grave. Then I saw how Mama was disappearing, all of her, into the bottom of the pit, and how they were covering her with earth until she was completely under.

We leave and when we get to the gate Lolita tells the photographers that now they may take all the pictures they want. It's a matter of historic moment. She faces the camera with a challenging expression. Amidst all that grief and confusion, Lolita never lost sight of the fact that her personal tragedy was a moment in the collective epic. She was going back to sacrifice herself, she was going back to being alone: the only one motionless in the midst of so much milling around, posing for history. The choruses were returning too, louder and louder, and the banners, and the shoving. Five bailiffs and a phalanx of police pushed through to take her away, but they didn't dare. They were under siege by thousands of angry people who were chanting Lolita's name until they were out of breath.

There is a moment of hesitation on both sides. She goes forward, crosses the cemetery all by herself to the police car, but before she gets in she turns and asks the people to observe mourning for her daughter. Then, without saying another word, she gets into the car and doesn't look back.

She was going away, as if she'd just fulfilled another great duty, and all alone.

A very thin man was finishing tamping down the earth over the grave, stamping on it with his black boots, and then he finished with the back side of the spade, as if he'd just planted a tree. As we left the cemetery we turned to look at the man up on the lamppost; he no longer had the banner, but he was still swaying.

For a child of eight, death must have been one of those unfinished stories that imagination completes by adding the most fitting ending. I knew that people and animals die. Not long before, my dog Lassie had died. But death wasn't an end, it was a farewell. Mama was staying behind in the Seboruco cemetery and I was going home. To take care of her things. To speak about it with today's intelligence, a lot of Mama's things remained with me, the house, the clothes, the makeup (though for a long time I wouldn't know whether as a sign of life or of death, nor would I know the difference). Over the following years her image would be erased. They say it's always that way with the dead, but that every so often they reappear, come up to the surface for a while, like those underground rivers.

"The suitcase act." Look, maybe she'll pay attention to you. Tell her not to shake the bed anymore. Not shake what? The damned bed. I wish they'd take her away to the home once and for all. Madame K. is unmaking her bed again. When she gets through she'll make it up once more. The nurse on this end of the corridor looks in through the door and repeats what I'd already heard in the hallway. Madame K. takes me by the arm and makes me sit down. She takes a suitcase out of the closet and opens it. There are shoes and stockings, shawls, thick cotton undershirts. Madame K. makes me nervous. She's emptying that suitcase out, piece by piece. Music notebooks, crumpled sheets of paper with an ancient smell. What about the glasses in the plastic case? What about the ragged black jacket?

*They don't look like a woman's things. Maybe they belong to her husband, from Auschwitz. I'd like to ask her, but for some days now Madame K. hasn't spoken to me in English. When she asks me to go with her somewhere she speaks a language I don't understand, or she just follows me until she manages to convince me to follow her. Nothing could make me feel more stupid. Some loose black-and-white photographs have fallen out of the suitcase, and some yellowing papers with pen-and-ink landscapes. She empties the suitcase and puts the things back in as they were, and before closing it she remembers that she's forgotten something. She puts her hand in among the things and searches desperately until she brings out some dark glasses with little pearls on them and offers them to me. I say no, they're very pretty, she should put them back. But she insists. What language are we talking? The "suitcase act" is over. In the other bed in the room, Madame K.'s roommate covers her head with the blanket.*

*In the hallway I give the glasses to Miss Boyd. She thinks she's going to Israel. Where? To Israel. That's what she says the few times she speaks English.*

*I see her come into my room again. I close my eyes so as not to see her take my shoes. Let her take them. I don't care. Where are they taking her? She doesn't seem to have any roots, she wasn't from here or from there. Her whole life must have been put in that black suitcase. Where had Madame K. gotten the strength to go on?*

*Among psychiatrists, psychologists, and social workers there is the game of looking: seeing who can be the most intense. It's the same game we used to play as girls in school, sitting face-to-face, staring at each other to see who could hold her look the longest without laughing or blinking. After jump rope and*

hopscotch, this game was the most fun, and one of the most educa-
tional, as I would come to understand later. The story of the per-
son who stares and is stared at (the insensitive ones dominate).

The patient who's just arrived in the ward spends the first
day looking at everything except other people. After several half-
hour sessions with the psychiatrist (we all get a half-hour a day),
he or she takes on that insistent doctor's stare, which gives the
same look to a table as to a person, since everything is equally
suspicious.

⟿ Dr. O. explains to me that the reason for the half-hour ses-
sion is clinical. She confronts me with all that I keep judging
without realizing: mother, father, aunt, table, pencil, each ac-
cording to the day's hurt. I understand and yet I can't help sens-
ing that in this industry of convalescent souls, time belongs to
the "curers," compassionate people, guardians of good behavior.
You have to like yourself in order to function, Dr. O. says in a soft
voice. You have to like yourself in order to be effective. I tell her
that I have been reading Carl Jung and Martin Buber. She looks
at me suspiciously, the way my little school friends did when we
played the game of not blinking, not laughing, seriously. That
might be counterproductive, Irene, understand? . . .

⟿ Miss Boyd says I look pale. She's pushing a cart with med-
ical equipment, fidgeting with her rubber gloves, assuring me that
afterward she'll open the window to let fresh air into the room. But
only for a few minutes. She winks. She's coming to take some
blood from me to see if I'm pregnant. I know I am. My body
knows it too. The body knows everything. You're going to feel a
cold jab, but don't jump. She lays the file folder on my skirt, ad-
justs the white rubber glove, puts her hand in, and I, in order to

think about something else, read the notes in the file and find out that it's still March, the anniversary of so many things. Are you sad? No. Bored, maybe.

Sometimes (as in my case) being hospitalized is a great comfort. The empty monastery walls and the silence invite rest. A big siesta, a no-man's-land. With the exception of Dr. O., who tries to burrow into my life, the hospital, perhaps like jail for other people, offers me days and nights where I can focus my attention on things of no value. I wonder if Mama could have been saved by something like this, an empty place, a "peaceful house."

Cells: Somewhere I read that there is no need to describe a cell, because a cell calls for nothing, and that is exactly what a cell must be. Nothing.

Dr. O. tells me that according to the pelvic exam I haven't got much time to decide.

Decide what? It's not the first time. Only months before, I'd seen the same changes in my body, except that I hadn't taken the time to think about or imagine what was growing inside me. Lying on the gurney, I feel the nurse take my arm and softly tell me the news again so as not to startle me, while through some cracks in the ceiling Carly Simon can be heard singing ". . . itsy-bitsy spider, went up the waterspout, . . . rain . . . out came the sun . . . ," but I can't follow the words because the song gets mixed in with the sound of something a fat doctor, panting with emphysema, is pushing between my legs. That's it, quick. You'll be fine soon. There was nothing to add. In the parking lot I couldn't hold back the tears. I don't know whether I was mourning for something or whether with that spectacular quiver of my body I was feeling a completely new fright. Now I'm waiting. I don't

*quite know why. Since the results came back, Dr. O. has treated me as if I were two patients. It doesn't upset me.*

*Sometimes I even feel as if it has given me some unknown strength to face her, at least. Back in my room, when the lights go out, I touch my belly and feel the invasion in my stomach. I am moved by a rancor that I don't understand, and I let myself be a hospital griper, hoping that someone, something will arrive from outside: something that will change my life and let me be completely different. Wipe the slate clean and start all over.*

During that first year after Mama died, I was in a kind of exile. I would wake up in the homes of almost all my uncles, I changed schools four times, and when I got back to Palmas Altas, I changed mothers. A nine-year-old seldom thinks about the past. In my case, Mama had "gone abroad" to see a famous doctor because she had an incurable illness. That also happened in a Cantinflas film, and maybe it would happen again. It did, but in a different way. Mama began to appear in my dreams, announced by a windstorm. She would arrive loaded down with baggage and all disheveled. She would appear just like that, as a surprise, without warning, without giving me time to get the house in order. Because I knew how much she cared about order, I would wake up in a frenzy, scared that she wouldn't find her things and she'd

think we had forgotten her already. A year and a half later, I'd almost ceased dreaming about her.

⟶ The first thing Blanquita did was to empty my drawers and dump all their contents onto the floor.

"A present for every drawer you put in order."

She was blond, she had beautiful hair, and in the morning she'd wind it into a bun that she would undo at night and the hair would fall down over her shoulders like a movie star's. She dressed like the women in *Cosmopolitan*. She wore a whole gamut of fabrics: silks, linens, muslins, rayons, woolens, cashmeres. Mama preferred polyester. They say she knew how to dress well, although to bleach everything was her obsession. She loved tight blouses and faded slacks and hated plastic buttons. Whenever she could she'd replace them with ones made of colored glass or sequins. Mama put sequins on everything.

Blanquita was a different breed.

Was she?

Before, going shopping meant a visit to the village market, to the Arab's hardware store, Nilda's clothing shop, Luis Pérez's shoe store. Everything was right there, on a single block of Calle Giorgetti between the Plaza del Carmen and the Manatí River. I knew that between Guaynabo and Hato Rey, at the end of Highway 22, there was that other world of shop windows and large stores, but I wouldn't have known how to get there.

Blanquita knew how to get there. One day she spoke seriously to Papa about my wardrobe. The state of my shoes was also deplorable, and they had to buy me some brassieres, since my little breasts were already showing through the white school blouse.

That was how, for the first time in my life, I went to the mall, that huge square chunk of concrete at the Plaza Las Américas.

"Let's go along the shady side of the parking lot so you won't get your clothes all sweaty."

Blanquita had yellow eyes, like the salamander who lived on the balcony at home, small and bright.

"Oh, damn, look how tanned you've got. If you keep on staying out in the sun they'll be calling you *negrita*."

She had small ears which stuck tight to the sides of her head—she really didn't seem to have any ears at all—while mine could be seen a mile away, even with your eyes closed.

"Your mother must have put you to bed with your ears folded over."

She had a small, turned-up nose, as if sculpted by hand, and some freckles dotted her pink skin. Only a few. There was never too much of anything with Blanquita.

The Velasco store: "If it's from Velasco . . ." That was what all the ads on television said. Air-conditioning, the smell of new clothes, the hiss of the automatic doors as they opened: I'd just entered the real world, which, till then, I'd only seen on television. If it's from Velasco . . .

In the women's shop, people came and went, making their way in and out of the dressing rooms. Brassieres. Go ahead, try this one on. And this other one. One for each day of the week. White, blue, yellow, cream, to match your clothes. They've got everything here. I'd never thought that, so close to my town, Palmas Altas, there could have been anything like that. Let's see, Irene, try this one on. With twenty changes of clothing, I pushed open the door to the dressing room; in reality I

was entering a magical world of mirrors that multiplied one another and multiplied me, from the front, from both sides, bathed in a white, dazzling light, the same as in fairy tales. When you try on the bathing suit, leave your panties on. Behind the curtain I began to get undressed. Ready? After the voice, the curtain parted. Not yet. Still in front of the mirror. Still naked and peeking, with resignation, from the fold in the curtain. I want to see how the dresses fit you. I could see her in the mirrors. From where I observed her, from any of the angles, she was always beautiful. Hurry up, Irene, the shoes are going to take a long time. She opened the curtain and the mirrors showed, simultaneously, the naked girl and the woman. She stood looking at me attentively. I was looking at myself too: a skinny girl, a bony girl, a hairy girl, like her father, with straight brown hair, with large dark eyes, like her mother, with a rather long nose, with ears . . . well, she had ears. Nothing was so obvious. We didn't look alike, my new mother and I. The mirrors magnified the differences even more: the white light accentuated my dark skin, giving it that look of a greasy fritter.

Mama was a different breed.

Was she?

"Everything fits you, Irene. You're as skinny as a rail."

She closed the curtain again and I took advantage of it to look at my body from all sides. It wasn't all that bad, if I had my ears trimmed, if I had my nose softened, and if I had those soap-dish shoulder blades of mine rounded off. Maybe if I put on a little weight . . . I wanted to change, even if it would only be to put an end to my doubts, to silence the contradictory voices that were visiting me in my dreams now.

Now she's waiting impatiently by the cashier. She pays.

Outside, we go up to one of those electric stairways. The people, too, are different at the mall. They talk differently. They're Venezuelans! Just imagine, she says, they come on cruises to buy shoes! I couldn't understand how someone would come from so far away just to buy shoes. And while we were gliding higher up, the scene of shop windows was spreading out, but the people were getting smaller, even though I wasn't moving, and not breathing. Then I could see another of the many faces of the magical city, the store that opened onto the inside gallery of the building, which in reality was another shop with show windows on each side and which, in turn, opened into another shop, and that one into another. One store inside another, like Chinese boxes and labyrinths. All this could be seen from the stairs that go up. That lift you up. Almost at the top now, I felt dizzy. Suddenly the stairs stopped moving but the mall kept on turning. I tried to grab onto Blanquita's skirt. Don't be such a hick, use the railing, you're wrinkling my clothes. The floor didn't move and I stumbled, and the person behind me stumbled too, and one behind fell on top of us. Blanquita was going on ahead, in a hurry.

Where could Blanquita have disappeared to? Into the shop called La Favorita. Were you lost? The man in the necktie with little pictures of dogs invites me to sit down and tells me to take off my moccasins. They argue: Jumping Jacks aren't being worn anymore. They're bad for the arch. She knows shoes. The man accepts that Jumping Jacks have gone out of style, but it wasn't because of the arch business. Take off your socks. Another clerk comes over with a device that looks like a foot and has a ruler inside. Are they going to operate on me? I instinctively hide my feet under the chair. Please, miss, your right foot. Well, I don't care if they do operate on them. I never liked them anyway, too big, nothing but fat toes, and with calluses besides.

I close my eyes and stick out my foot. Seven and a half, says the man with the dog necktie. Nine years old and seven and a half already, Blanquita says. You could sleep standing up. The man comes to my aid: She's tall, and large feet are elegant. And he looks at me sympathetically. The assistant appears with a gold high-heeled sandal. Would the lady like to try it on? Yes, of course. Blanquita, who's wearing blue sandals, lifts one foot and rests it on the thigh of the man with the puppy-dog tie. Yves Saint Laurent, the clerk comments. A fine shoe. She nods in agreement. She has small, thin, discreet feet, her nails are well cared for ("Glazed Rose"). Five and a half or six, the man in the tie shouts. Five and a half, his assistant replies, and reappears with the box in his hand. Blanquita places her foot in front of the floor mirrors, turns around, goes back and forth, sits down. They're arrogant feet, feet that dance and laugh with pleasure. The man in the tie with the dogs follows her, hypnotized, waiting for the word. I don't like them. They're too showy, even a touch vulgar. Bring the girl three pairs of moccasins. Let's go, Irene. She heads for the cashier.

The man with the dogs has given me a raspberry lollipop. Sitting on the bench, while Blanquita pays, I'm enthralled by the gold sandals she's just rejected. Where had I seen sandals like that before?

"Let's go, Irene. Hurry up!"

On the escalator I couldn't get the image of my callused foot on the metal measuring board out of my head. It was hopeless. I would have to walk on them for the rest of my life.

Outside, Papa was waiting for us with the motor running. On the way home, and with my nose up against the rear window, I kept thinking about my callused feet, and, not knowing why, I amused myself with the tracks of other car wheels on the

road, all on the point of being erased under ours, which were now rolling toward Palmas Altas. It was my way of killing time on long trips. We must have been close to arriving, the flatness of the coastal plain could be seen. On my left, the termites in the trees went by, and we left the baseball field behind, the one that's in the middle of the curves leading to the Playtex factory, passing afterward by the old abandoned Plazuelas sugar mill. Papa took the curve fast, and the car gave a skid that frightened me. Blanquita and Papa continued on in silence, as if nothing had happened. Actually, nothing had happened. I went back to sticking my nose up against the glass to look at the road and the countryside. It was a beautiful sunset and Papa's car kept on going forward.

One day Papa told me that Uncle José and Aunt Betsy were leaving with their children to teach at a school in New Hampshire and would I like to go with them. What do you think, Irene? A school right smack in the middle of the woods. So? All I had to hear was that there were deer there, little Bambis, their skin sprinkled with snowflakes, and that very day I was packing my bags. Like Cantinflas's children, I, too, was about to take a trip.

The afternoon before leaving I went to the cemetery because I didn't want to go without seeing Mama's new headstone. The workers at the Seboruco cemetery had taken a year and three months because the large mausoleums came first. I looked at it all with sorrow, although not believing too much that Mama could live beneath that piece of white marble. They'd put her name on it in gold letters. GLADYS MIRNA MÉNDEZ DE VILAR. Underneath, were Papa's and my brothers'. And

last of all was mine: MIRNA IRENE. It was upsetting to see that the other graves had lots of flowers while Mama's had none, just a ragged flag like the one on that ship that had run aground on the Barceloneta coast. I was beginning to want to leave, but you're supposed to weep for the dead, all the more so if it's your mother. So, I stood there, morbidly talking to myself, until I finally felt affliction and tears came.

———— That January 1979, it was snowing in Hanover, New Hampshire. It was my first snow. The plane had to circle for a while, until the runway could be cleared and we could finally land. On the other side of the river from White River Junction was New Hampshire, Papa's promised land. A taxi took us through the snow for a stretch that got longer and longer and deeper and deeper into the night; the roads got narrower and narrower and the curves went up and down in the dark. Then we turned onto a dirt road where an arrow pointed in, toward the night. Suddenly I thought of Frankenstein and got the shivers. Papa was riding along very happily, humming his favorite tune about an old horse getting lost in the distance. Blanquita was dozing. The taxi entered a sharp curve, then slowed down, and finally came to a stop: BOYNTON SCHOOL. We'd arrived.

———— Boynton School, Orford, New Hampshire: a pedagogical experiment conceived for twenty-four students who would live in a kind of kibbutz, like the pioneer utopias of New England. Entering Boynton meant leaving history once and for all: Palmas Altas, Barceloneta, Puerto Rico, the family crypt. It was entering the world of churches, fellowship with nature, and sometimes with other men and women who joined together

with the declared intention, by contract, of never doing harm to each other or to nature. For me, in addition, Boynton School would come to be the timid discovery of my own sensuality and, perhaps, desire. What more could a girl of nine aspire to?

At the top of the steps someone opened the door for us. At the rear of a parlor, high up on the wall, a wooden crucifix was hanging, and underneath, on a school blackboard, I could make out words and figures written in colored chalk. From the back of the room a giant was approaching, twice as tall as Papa. They recognized each other, embraced, said how much they'd missed each other. His hands were so large that I thought of Frankenstein again, but those hands were stroking Papa's head, and he had such a warm, fraternal expression that I immediately lost my fear. Then they separated and the giant came toward me, smiling. He got so close that I could feel his breath, could barely see all of him, but I noticed that he had the wide-set blue eyes of a television actor. Then he took me and picked me up in his arms. From up above I could see the double row of desks and students, who were laughing, as they always do at new arrivals and dumbbells. They were almost all boys. They were almost all older than I. The man's wool jacket irritated my face. And he smelled of new-mown hay. Finally he put me back down on the floor and, holding my hand, said to me in a ceremonious way: "Welcome, Irene."

I felt my ears burning. Then I was introduced to my schoolmates, one by one. I was looking for someone like me, they were all big, they were almost all boys. Finally a certain Didi held out her hand. And behind her was my cousin Elena.

"How is a battle won?" Mr. Boynton had asked Papa one day. It was at the Episcopal high school in San Justo. Papa was fifteen and Mr. Boynton was his history teacher—as well as his ideal of the perfect man. Twenty-five years later Papa would still repeat the question and get all worked up as he listed the series of important strategies, a kind of Episcopalian Zen that he'd learned from his history teacher.

"Well, you win by fighting," Papa had answered.

"No, Ildefonso. By feinting."

Ever since, Papa was obsessed by that man in the black jacket, that man with a touch of the dandy and a lot of the missionary about him, who, after class, would take him to the running track and teach him boxing techniques. Especially feinting. The same technique that Floyd Patterson, the world champion, would adopt in his early fights. Mr. Boynton had fought with Marciano and would have gone a long way if it hadn't been for the fact that one night, because of that powder they sprinkle on the ring, he slipped and permanently injured his ankle.

Feinting meant not necessarily hitting your opponent, but playing with your arms. Throwing a right only to have it die in the air, halfway there, and then to come up with a left hook that would also disappear before reaching its destination. The technique consisted of hundreds of sleights of hand, of combinations that he knew as if he had a dictionary of them, because it isn't easy to feint, it consists of always keeping your eyes open, even when counterpunching, even if your opponent's fists land directly on your eyes. In order to teach him the technique of open eyes he had him walk through the bushes that grew on the school grounds. He made him go ahead without blinking, no matter what the obstacle or threat.

Papa didn't have many things clear in his mind, but there

was one thing he was sure of: he wanted to be an engineer. When the time came to say good-bye at the main door of the school in San Justo, Mr. Boynton spoke to him about the hundreds of acres in New Hampshire that he'd inherited from his parents and grandparents. So, my friend, if you get to be an agricultural engineer someday, they're waiting for you there.

⟶ Mr. Boynton is accustomed to studying at the same table as we do every day from seven-thirty to eleven in the morning, from two to four-thirty in the afternoon, and from eight to ten in the evening. His doings are passed on in bits and pieces. The boys know a lot more about him, since he shares the dormitory with them and sometimes talks to them about his life. He knows eleven languages. At the age of twenty he was a boxer, then a sea captain, traveling all over the world. I never dared ask him about his life, but one day during a study period I wanted to find out who the Medici were, and when I went to ask him I saw that he was reading a book full of little doodles. He looked at me over his glasses, and when he saw my surprise at the little pictures he told me they were "ideograms of a Chinese dialect."

They say he comes from a wealthy family that left him land stretching far off into the distance. What no one says, but everyone believes, is that he lives the life of a monk. And maybe that's what he's always wanted to be. He walks with his hands in the pockets of his black jacket, looking at the ground, as if he were studying the tips of his toes.

How do you cut down a tree? One morning he came with a saw and told us how Billy's father had died. We should memorize two things: one, you should only cut down a tree that has a red cross marked on the trunk, and, two, you should always cut with another person. Never alone.

～   Mr. Boynton wakes me up at four in the morning because it's time for me to learn how to milk Louise. Yesterday, in the same barn, I'd seen him practicing boxing, hitting a black oil-cloth bag that hangs down from the hayloft. I'd gone over to Louise's stall and watched him, happy to know that we were getting to be friends. Mr. Boynton had boxing gloves on and was punching the black oilcloth bag, first with his left hand, then with his right, always looking for an opening between his gloves as he talked to himself in a strange language. One of those days I'd drum up the courage and instead of asking him about the Medici I'd ask him about his other lives, about Captain Boynton, about champion Boynton . . . Whatever the mask, the rumors always returned to the same thing: he's a monk, pure and simple.

In the stall, with the same impenetrable face with which he does everything, he takes my hands and guides them onto Louise's teats. My only emotion is the feel of his hands on mine as he pulls. As it hits the metal pail, the warm milk sprays and sprinkles my skin. Louise turns around with a look of reproach. Sometimes I feel she's trying to lash me with her tail. The pail is filling up, and Mr. Boynton smiles with satisfaction, but to me it's a betrayal. Extracting poor Louise's milk like that. I'm sure she resents me. But Mr. Boynton's hands are still tight on mine, they're huge, and as rough as Louise's teats. And I know that everything is going to be all right. For in Mr. Boynton's school, God is proletarian and everybody, Louise included, must give something of his or hers in exchange for something belonging to the others. That's how it was from the beginning.

Until Sussy arrived.

My grandmother Lolita Lebrón (center), Rafael Cancel Miranda
(behind her), and Andrés Figueroa Cordero (in the center of
the cluster to the right) being taken into custody by police outside
the Capitol, shortly after the shooting at the House of Representatives
on March 1, 1954, in which five congressmen were wounded.

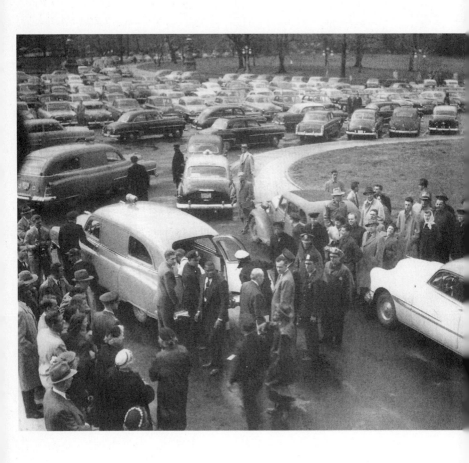

A view of the crowd outside the Capitol soon after the shooting.

The inside of the House chamber; the crosses signify bullet holes.

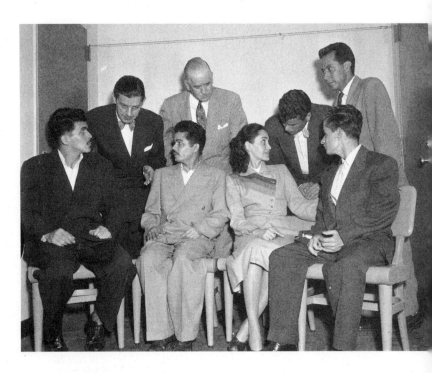

(From left, seated) Rafael Cancel Miranda, Andrés Figueroa Cordero, Lolita, and Irving Flores Rodríguez, consulting with their attorneys, (from left, standing) Myron G. Ehrlich, F. Joseph Donohue, Ben Noble, and Hogu Pérez, in federal court, June 16, 1954. The four Puerto Rican Nationalists had just been found guilty of five counts of assault for the March 1954 shooting.

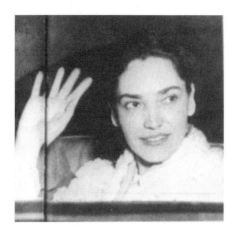

Lolita on her way to federal court
in New York City, May 1954.

The guns used in the
shooting, spread out on a
Puerto Rican flag. In the
center foreground is a
.38 caliber automatic; the
others are German Lugers.
AP/WIDE WORLD PHOTOS

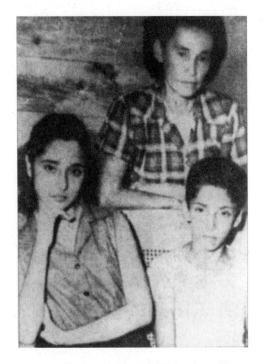

My mother, at age 14, with her brother Félix
and their aunt Mercedes Soto in March 1954,
shortly after the shooting.

*(clockwise)* My mother: in 1959; in 1964;
in 1969, shortly after my birth; and in 1976–77,
just before her death.

My parents, in Newark, New Jersey, sometime in the 1960s.

My parents with the son and daughter
of friends, in Newark, New Jersey, in 1966.

My father with (from left to right) my brothers Fonso,
Cheito (holding two of our cousins), and Miguel, sometime in 1967–68.

My grandfather José María Vilar with Miguel, in 1963.

My father with me on his lap.
Behind us are Miguel (sitting) and Cheito (standing).

My parents and brother Fonso (third from left)
at Fonso's birthday party, in 1974.

Lolita and my mother,
on a visit to Lolita in jail, in 1976.

*Left*: At my
mother's funeral, on
March 3, 1977: (from left)
a cousin, Lolita, me,
and another cousin.
*CLARIDAD*

*Below*: Lolita (center)
at my mother's funeral.
*EL NUEVO DÍA*

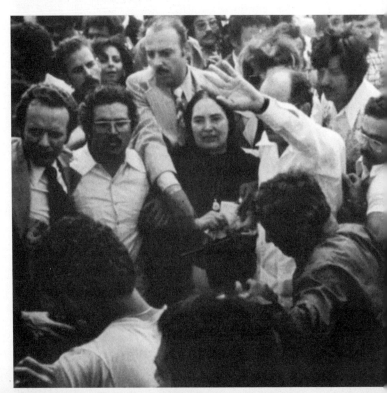

Saturdays are always happy days. We travel down along the other side of the river to Dartmouth. Mr. Boynton takes off the blue plastic cover that protects the yellow bus and we get in. I can see him in the rearview mirror and know that he's counting us, one by one. As soon as he's sure no one is missing, he starts up. It's a roomy bus, like everything in Orford, and you can stretch your legs out on the seat next to you. A few seats ahead of me my cousin Elena is riding. I wait for her to take out Mrs. Holt's book, which she carries in her purse, and finally finish it. Some nights, if she's in a good mood, she'll narrate a chapter for me in detail. But for days now I've been waiting for the end, which doesn't come. What's happened is that she's fallen madly in love with a certain Kevin, whom she only saw once and at a distance, and every night she dreams about him. Last night she dreamed that they were coming to play basketball against our team and that the jeep Kevin was riding in turned over and crushed him. And Elena did nothing but cry until dawn. Didi is riding a little farther back and I can hear Tommy, who's the same age, telling her in Spanish that he loves her but won't she please shave her legs. They're children of Episcopal priests from Puerto Rico. They take me everywhere because I'm the school's mascot. The other mascot is Danny, who's a year older than I and does nothing but sneeze. The gossip is that when it's very cold he wets his bed. On another seat, and all alone, Billy, the genius, is riding. Until a little while ago his parents used to live in a house full of raisins and almonds on the other side of the woods. But everything changed when Billy's father was crushed by the tree. He was using one of those electric saws that cut faster than you think, and when he least expected it the tree began to fall and didn't give him any time. He

tried to look up, but everything—leaves, trunk, all the years of the tree—came down on top of him. Billy is a good student. Some nights we get to practice German together. He picks his nose a lot and when he talks he sprays my whole face. He says he's sorry and I tell him, *"Nicht Problem, nicht Problem,"* and we laugh.

The bus goes along slowly, and to the left and the right the countryside stretches out like a gigantic plain. America the immense. Which direction is the sea? It must be a long way off, because there isn't the smell of salt anywhere.

We've passed the house that Ms. Keith and Mr. Jack are building themselves. It's a two-story house made of logs placed one on top of another. A real log cabin, Mr. Boynton said the day we went to place the first logs. They're Quakers, my aunt and uncle said, and for a long time I thought they belonged to the family of the man on the oatmeal box. Ms. Keith is our art teacher and Mr. Jack is in charge of work period. At this point the bus is going faster; now we're on the main road; the triangular houses along the way are like mini-castles, and nothing, nothing is moving in those yards. In a little while we'll cross the river; the metal bridge will creak. When the big supermarket where Aunt Betsy does the shopping for the school comes into view, we will have arrived, and then Mr. Boynton will seek out the shade of a tree and park the bus. There I'll see the first college students of my life. They walk around with their backpacks and books. Up the hill are the bookstores and shops. I remember it as a recurring scene. We'll have time to cover the campus of Dartmouth College after we finish the laundry. Then I'll go up to the bell tower and wait for the chimes. Mr. Boynton will come out of the library chatting with a professor friend, and if, as at other times,

we happen to run into each other again (that's what I hope), we'll go along to the swimming pool in the gymnasium, and once more he'll tell me that one day I'll be a student at this college, or one like it.

On Sundays, wearing our best clothes, we got into the bus and went to the Episcopal church. We were always received with the same enthusiasm and with a certain curiosity. I don't know why, but that curiosity seemed to be renewed each time. To the congregation we must have been the "others." Children of all colors and accents, something like the passengers on Noah's Ark. The missionary fantasy of rescue that invaded the church and its Puritan Sunday to shake up that other America a little, the fortunate one, the orderly one, the unmovable one. After services we would go downstairs to the recreation room and there they'd serve us strange little cakes, but the tastiest I'd ever eaten in my life. That was the best part of the services, thinking about the miniature cakes that awaited me below, the muffins. Of course, there were also tarts filled with fruit of an incandescent color, apple, cherry, and plum. In one corner of the room the children were playing with puzzles and little cars made out of numbers and letters. Everything was pedagogical in the Episcopal church; the people smiled, spoke in soft voices, talked to each other. In general, they were tall, they wore dark clothing, although some wore a brooch with the design of some animal or a brightly colored flower. I lived waiting for those Sundays, it's true, but I never got to feel completely at home in that church. There was something, some unknown dimension I could never get used to. Maybe because it didn't belong to me, because in spite of my aunt and uncle and cousins and Mr. Boynton, I was still the one who came from somewhere else.

~~~~ Muffins and chocolates. An old couple lived next to the barn and Mr. Boynton had forbidden us from using our sleds on the small hillock where her husband had erected a white wooden cross. (She was convinced that she would die soon and she wanted to be buried up there on that hill, facing east.) The husband had worked for Mr. Boynton's parents, and when he decided to found the school, he chose to build it around the old couple's house, to have them inside and not out. In the afternoon, the wife would make chocolates in their garden. I remember the first time I went into her house, whether in fear or expectation I'm not sure, but I'd pushed open the little front gate, and since the door was half-open, I went into the kitchen and let myself be enveloped in the smell of cookie dough that filled the whole house. The woman was sewing, by hand, a huge blanket that already covered half the floor of the room.

"It's a quilt," she said.

She could barely speak; she looked ill.

"It's going to be the biggest of them all."

She was sewing cloth squares of different colors and joining them together in an endless procession until they formed a checkerboard. Clocks of all sizes hung on the walls, wooden frames, cubes with miniatures, and any number of small mirrors. Souvenirs: every corner of the room was the memory of something; postcards, old photos. (Suddenly I can see myself in Palmas Altas, four or five years old, up on a chair, using a sock that Mama gave me to clean the only living room picture, a mill in the middle of a field planted with yellow daisies.) The woman asked me if I saw any children playing on the hill where the white cross was. No, I hadn't. We never play there, we're not allowed to. Through the classroom windows we could see the cross planted at the top of the hill and that cross looked like a

seagull or an eagle drying its wings in the wind. It was the other America.

⟶ My town had a river too. You could see it from Vega Baja if you were coming from the east. As you come into Barceloneta, the river comes in with you, going through the town itself and continuing on, due north, through Angostura and Palmas Altas, until it meets La Boca, and a little farther on, the sea. That river in Barceloneta was no great shakes, but more like the sum of the sins of its people and its landscape. The young people necked on its banks, and every so often some devil who'd discovered them would drive them off with their clothes in their hands. Miss Candelaria, who ran the candy stand, would always threaten not to sell us anything if we insisted on fooling around by the gully. We'd hear her shouting the same warnings when we left the shop with her corn cakes—that the river was the downfall of youth and that one fine day God would punish us all by drowning us in its muddy waters.

From time to time the river would overflow into a good part of the town, which inevitably renewed the great subject of discussion: When were they going to channel that "damned river"? Those most affected, like the shoemaker by the waterfront, for example, wanted them to dry it up once and for all. It was brackish water and wasn't good for anything in any case.

On the steps going down to the river, behind the abandoned dock, lived Baldy, the crazy young man who considered himself a prophet. It seems that he'd taken an overdose of LSD and was never the same afterward. In the afternoon after school, we'd go to watch him take his ritual bath in the river. He would take off the sheet that covered his body and slowly sink into the water, naked. Baldy was rather tall, and slim, and he must have

been seventeen, the same age as my oldest brother. Doña Julia would bring food for him and sometimes would shave his head. After his bath, Baldy would rub baby oil all over his body and lie down to sleep. On the other side of the river, the coastal valley seemed to go on endlessly, and up against the horizon, spread out and seeming to have been built into the landscape since time immemorial, some cows were grazing.

I stared at the door through which I'd come into the school a year and a half before. What had I been expecting? What was there behind that door? I really don't know. I was almost eleven years old, and for a long time, suitcases had been my way of life. Lugging suitcases, opening and closing doors.

For some days now, word's been going around school that a new student is coming. She's sixteen and she's from Maryland, I heard. It was still cold in New Hampshire in April. That morning there was a knock on the door and Billy went to open it. There was Sussy, with a broad-brimmed hat, a pink paper flower pinned to her breast, very blond curls that reached down to her shoulders. I was about to welcome her, but I remained seated. She was carrying a bag in each hand, and when they told her that Mr. Boynton was probably out in the barn, she sat down on one of them to wait. She watched us out of the corner of her eye. We were watching her, too. She had a mole right beside her mouth, and a set of imposing breasts that rose up through her blouse. The boys were open-mouthed, literally.

Then Aunt Betsy arrived, and while they were waiting for Mr. Boynton, she introduced Sussy to the class. Every single boy got up to offer to carry her bags. Except for Tommy, but only because Didi had put her arm around his neck. Sussy

walked between the desks, greeting each one, and when she got
to me she stopped for a moment. I think she was surprised to see
a little girl among so many adolescent boys. She smiled and
went on. She had honey-colored eyes sprinkled with little yel-
low dots.

From the time she came in that door, everything in the
school began to vibrate differently. Hearts dominated now, and
Sussy's beat with great force. She'd brought something new to
the school, a rhythm and an abundance that we'd been missing.
According to my cousin Pablo, they called her "the Marilyn
from Maryland."

Mr. Boynton is refereeing a soccer game and it's my job
to retrieve the ball, which almost always ends up in the bushes.
In the bushes I see them. The voices seem to be coming from far
away, but there's a girl I once saw in church and who visited the
school from time to time. Her blouse is off. She has a boy's head
in her hands, she hugs him, brings his head to her breasts, and
strokes it. He mutters things I can't hear, bites her on the nip-
ples, which are swollen and red, damp. She insists, rocks him
like a baby. I really would have stayed there, nice and quiet, if it
hadn't been for Mr. Boynton's growing impatience when I didn't
bring the ball back right away.

Another time it was my turn to clean the stables during
work period. Annoyed (it was no fun gathering up the dung
from Jim and John, the horses, and Louise and May, the cows),
I decided to go up to the hayloft, where I used to have fun pole-
vaulting. Shovel in hand, I would run until I had enough speed,
stick the shovel in, and give a leap, with the hope of landing in
the hay. That day I thought I heard a laugh and, through the
ladder that led to the storeroom, I saw a pair of pants go by,

which I think fell onto a mound of hay. I heard laughing again. The laughs were two now. I climbed the ladder without making a sound and hid behind a bin, the way my cousins and I used to hide in the bathroom to read pornographic magazines. The two—a boy and a girl—were half-naked and they were chasing each other. They would roll on the floor, get up, and roll again. At that point, through the door of the storehouse that opens into the sheep pen, another boy entered. He quickly took off his pants and, giving a shout, leaped onto the girl. Now the three of them were laughing, louder and louder, and as they rolled on the floor, the boys were howling. They were clinging to the girl's breasts like barnacles. Then one boy tried to take off her panties, the only thing she had on; she defended herself by trying to pull down his shorts and tried to do the same thing with the other boy.

My heart was beating faster and faster. I was beginning to sweat, my stomach ached, my knees were weak. The ladder. I was barely able to get down the ladder, and I don't know how I managed to get back to the stable and finish my job, which was to clean it up. The smell of shit was unbearable, and on top of it all, I couldn't stop thinking about that girl, about the thick lipstick on her mouth.

— Mr. Boynton's hands. One night I was awakened by a monotonous weeping, a weeping as persistent as the rain that had been running down my window for some days. The sound of slamming doors and steps running down the hallways. Since I couldn't sleep anymore, I went to the stable to see what that weeping was, as it was now an almost mournful moan. Mr. Boynton was in one of the stalls and he had a lantern in his hand, lighting up the head of a trembling sheep. He was talking to her;

then he stroked her to calm her down. For a moment the ewe stopped bleating and you could hear the rain on the roof again. Mr. Boynton went to hang up the lantern, but the bleating started again and this time it was stronger, and the shaking too. The sheep could barely lift her head from the straw in a useless attempt to stand up. A gelatinous pink bundle was peeking out from between her hind legs. Mr. Boynton finished wetting his hands in a yellow liquid, and then he kneeled down and began talking to the ewe again. Murmurs, winks, caresses, all the while he was sticking his hands between the legs where the bundle had become stuck. His hand had gone way inside and I couldn't see it anymore . . . The sheep was barely breathing, it could scarcely moan. But the bleats were more and more irregular until finally Mr. Boynton's arm reappeared, and in his hand he held a little lamb with closed eyes who immediately struggled to stand. But the mother was finally quiet and seemed to have fallen asleep. Mr. Boynton shook her, almost shouted at her, "Come on, wake up, you've got a son to feed." He rubbed the little lamb against the drowsy lump. Finally he made her stand on four feet, almost carrying her in his arms. Then the mother smelled the baby, began to lick its legs, and little by little quieted it down and let it nurse. Mr. Boynton took off his jacket, laid it out on the straw, and lay down next to the sheep. I left the barn without making a sound, knowing that I'd seen a baby sheep born and that it had been his hands that had gone to get it there inside. When I got to my bed, dawn was breaking.

There was nothing that hadn't passed through Mr. Boynton's hands: the wooden cross, Louise's teats . . . The mother sheep was no longer moaning, her little lamb must have still been suckling. (In the hospital, I would spend many nights thinking about Mr. Boynton's strong hands, easy in their caress.

When my will flags, when nothing is going right, it's nice to think of hands like those. My talks with Dr. O. should have begun there, with things like that. Would have saved a lot of time, she and I.)

~~~~  In June, the school was in its usual rhythm, and then came the day when Jane arrived. It was quite hot in Orford that day and we were playing basketball when a car stopped right next to the court and a huge woman got out; she kept putting on (or taking off) her shoes and stumbling, all the while holding out her hand to Mr. Boynton. Then when Mr. Boynton opened the rear door, Jane appeared. First her face, then her hands, arms, and, finally, a cascade of red hair that must have reached down to her waist and which the wind was scattering in all directions.

One day—just like that—Sussy ceased being the source of desire. The boys no longer looked at her, hypnotized, as in the beginning.

Jane took us by surprise. We hadn't expected her, not even Mr. Boynton had. It seems that her mother found out about the school through the father of one of the boys and since she was having problems at home, she decided overnight to bring her to Orford. Mr. Boynton had always felt that there was an imbalance between the number of males and females and he was pleased. Now, instead of four to twenty, we would be five to twenty.

With the arrival of Jane, the rhythm of the school really began to miss a beat. She must have been thirteen and, unlike Sussy, she was small, thin, and silent. She always seemed somehow far away. And the boys didn't lust after her the way they'd lusted after Sussy—they fell in love with her, some of them

madly. At first, Jane went about downcast; she didn't know any-
one and she didn't even have enough clothes. I offered her some
turquoise slacks that I'd always disliked because they empha-
sized my behind. To tell the truth, love arrived with Jane, and
misunderstanding too. She would spend hours in my aunt and
uncle's apartment. Uncle José would keep a close watch over
her—he practically adopted her—and I know that Aunt Betsy
also looked after her. She was quiet, reserved; yet she seemed to
have an effect on everybody's life. She followed Mr. Boynton
everywhere. One day, when Mr. Boynton made a goal in one of
the games, she took advantage of it to throw her arms around
his neck and kiss him. All that affection from a new arrival must
have surprised Mr. Boynton, but he gave her a few loving pats
on the head and everything went on as before. That first month
Jane wore nothing but my turquoise slacks. At night we'd study
in the classroom for two or three hours. Jane was wearing my
blue slacks and they were quite tight on her—they'd become
her second skin—but they only seemed to make her more beau-
tiful than ever. I couldn't bear it and I buried my nose in my
book, telling myself that I would never have had the courage to
wear slacks like that, not even if I knew how. Sussy was sitting
in a corner of the room, her big eyes as melancholy as Louise's.
I stick my nose in the book and read and, thanks to that, I man-
age to get out from under Jane's spell. Someday I'll be like her,
like the other kids who laugh and dream, like an adolescent in an
English novel.

Finally I found my lifesaver. One day, in the back of the li-
brary, I came upon *The Lives of the Saints,* and from then on
everything was different.

"Today makes five days that I haven't bathed, seven that I
haven't eaten breakfast, ten that I've been wearing the same

clothes, and eight since I took the mattress off my cot and slept without sheets or blankets on the hard wooden boards . . ."

The diary has since gotten lost during one of my many moves, but the sacrifices of those days, the entries, are still in my memory. I passed the time reading the lives of famous people, saints I admired, to whom I'd go for advice, to whom I'd open up, sometimes scandalously, telling them stories I would then jot down in the diary, the lost diary. In the meantime I wanted nothing to do with my body; I wouldn't even look at my feet. The body that I'd compared with Blanquita's one day in a dressing room at Velasco's was becoming more and more part of the landscape, as the mystics say; it was smelling more and more like manure. Everything passed through the stables in Orford. I wasn't devout, I was only a girl searching for the key to something in books, even though I didn't know quite what: nostalgic, a mini–Madame Bovary with no object in mind and, to top it off, from the Caribbean. I'd found those cobweb-covered books on the top shelf in the library, up against the wall. And the fact that they were in Spanish, the only language I really knew, was enough to bring on my enthusiasm.

"They're the lives of the saints," Mr. Boynton told me, smiling, when I asked his permission to read them. He couldn't imagine what interest a girl would have in the lives of those martyrs.

Mr. Plant scrawls on the blackboard in biology class, and while pollywogs are born and frogs blink and chrysalises are transformed, I surreptitiously read the *Lives*. Secretly, as if it were something forbidden, I get into those worlds outside of time. I could even see their faces, Saint Andrew's, who had been Epiphanius's teacher and later Patriarch of Constantinople and who one day, as a final act of surrender to God, decided to be-

come a beggar and wander about, crazy it would seem, with his dogs, naked and homeless. The lives of Theophilus and Mary, who came from very rich families and also chose the lower life as an offering to God, he becoming an actor, she a prostitute. That of Saba, who for twenty years pretended to be deaf and dumb and mad. Abba Pitiroum had a revelation once. An angel told him that if he wanted to be a real saint he should go to the convent of Tabessini and look for the nun with the halo around her head. Without wasting a minute, Pitiroum went to the convent, but he couldn't find any sister with a bright halo around her head. And when he asked if all those who lived there were present, they answered yes, except for the madwoman who lived outside the cloister, in the kitchen. When they pointed her out to him, he saw the bright halo, and, throwing himself at her feet, he asked for her blessing.

"It's been two weeks today that I've been sleeping on the hard wooden planks without a blanket, twelve days that I haven't eaten breakfast . . ." Mr. Boynton opens the door of the main student room at five-thirty in the morning and, as always, crosses himself before the crucifix hanging at the end of the room. That hand helps me forget my morning hunger.

Every chance I got I would run into the woods, and there among the trees and leaves I'd lift up my eyes and feel that there was no distance between the sky and me. I had the feeling that nothing on earth could destroy me. It was almost impossible to tell anyone about it or to describe what sometimes filled me with doubt. I would weep, but from too much feeling. It was the first and maybe the only time when living wasn't a punishment. It must have been something like the thing people call happiness. It was the influence of the thirteenth-century Spanish books I

was reading in Mr. Plant's class. But it wasn't the thirteenth century anymore, and not even Orford would have tolerated those excesses. And other people weren't long in reminding me of that fact.

~~~~    Blood! One morning I got up to go to the bathroom and I saw the blood and I had the great surprise of my life. According to Aunt Betsy I'd just entered the ranks of "young ladies," a little prematurely. It seemed like a joke. From that day on, the angels and the enchanted woods began to fade. One day I put the mattress back on my bed and changed my clothes. Menstruation had come to the saint. Now to compete with Jane.

But I wouldn't have any time. Uncle José had taken a job at an Episcopal church in Baltimore and, of course, I would have to leave too, go back to Puerto Rico—live with my family again, with my father and Blanquita. It was the summer of 1981. I'd soon turn twelve, and Mr. Boynton, the man I admired most in the world, seventy-four.

~~~~    On one of the last Saturdays when I went to Dartmouth in Mr. Boynton's yellow bus, a car pulled out of one of the roads going into the woods and passed us. On its roof, a little toward the back, a deer was tied down. The animal didn't have Bambi's smile or the curious eyes, or the clownish nose, or the skin sprinkled with snowflakes, but the glassy, bulging eyes of the dead fish that cover the beaches of Barceloneta near the water-treatment plant. A red pompon was tied to its rear end, like a stamp of death. I felt no need to hide anything then, so I cried without stopping all the rest of the trip, for the poor deer and for myself.

How could a little girl realize that what Papa and the rest called "education" was really a caricature of the people who would circulate through her life from then on: stepmothers, teachers, girlfriends, all inviting her to be someone else. In less than five years' time she would go through an experimental school in New Hampshire, to a nuns' school in Spain, and from there, passing through Puerto Rico, to an American university. Then she, too, would get to want to be somebody.

*We're finally a family. Our mother is Ana Mani ("Mani" for the doctor's diagnosis: manic depression). She never tires of telling us what she's suffering from, or that she has a husband she doesn't love but continues living with because he leaves her in peace ("in peace" means "he leaves me alone").*

*She's been walking up and down the corridors of University Hospital for a week. We meet coming out of group therapy sessions and Ana gives us back the desire to live. Life is all rosy according to her. We admire the ease with which Ana Mani can pass from idiocy to intelligence. The day they brought her in, in the throes of one of her many attacks, we assumed she was famous, or at least well known, because the nurses were pained to see Ana with her eyes rolling, looking stupid, and they kept on comparing*

her with "the other Ana," whom they knew to be gentle, intelligent, with exquisite taste. She spent the whole day sitting on a table in the recreation room, not moving, staring at her hands and feet and whimpering, in a lethargy that became all the more painful to watch as her tongue hung out of her mouth, covered with saliva. I went over to see if I could help her. "She's fifty," the nurse told me. I couldn't understand why she was telling me that.

"My name is Irene," I said. But she didn't look up. At that moment the nurse came back with pills, but every time they offered her one, she lowered her head and trembled, refusing them. Her long tongue, like that of a thirsty horse, hung out of her mouth. The nurse stroked her head tenderly. There was a kind of truce, and that distracted her; she wasn't ready when the nurse grabbed her and tried to force her mouth open. Ana resisted, struggled. She doesn't want them to touch her mouth, she doesn't like the pills, she shrieks and resists like a cornered animal, and she tries to get away, but the other woman is too strong; she shoves the pills into her mouth, under her tongue, and she closes it with a firm hand. Ana has lost. She looks around with wild eyes. She looks at us.

Little by little she realizes where she is; little by little the woman whom the nurses remember as full of life returns, the Ana of always. I move close to her again without knowing what I'm going to say. Now I'm the idiot and when she sees me she laughs raucously.

The ease with which Ana has been cured seems nearly miraculous, and for a while it tends to increase the doctors' prestige. But according to her, the key is the pills. Her whole problem is chemical. In the unit we're almost all between the ages of nineteen and twenty-something, and Ana Mani wants to know why we're wasting our youth shut up here, unlike her, victim of a

*chemical foul-up inside her. She circulates throughout the floor with a plastic-bristled brush, looking for the people who must need their hair brushed out; there are times when she brushes the hair of everybody on the floor. You've got to know how to take care of yourselves, she says. She's right, thinks Tim the bulemic anorexic, who is almost recovered after a half-year of therapy. She's wrong, everybody's wrong here, says Sam, who admires her but sometimes doesn't know what to do about all that smiling and all that optimism.*

*Jenny arrived in her room, which she isn't required to share with anyone. She's my age and very nice. She came to the hospital because she's just had a daughter and doesn't know what to do. She must have wanted to raise the child, but she doesn't know how, and neither her boyfriend nor her father takes her seriously. Her father, it seems, kept telling her she needed medical help and finally she believed him. Jenny eats Snickers bars, which she buys on passes. The nurses have forbidden it, but Ana Mani tells her, "Go ahead." Whenever she sees Jenny looking sad, to make her feel at home she urges her to eat some Snickers bars. "Go ahead."*

*Around Ana Mani you always find both the saddest and the happiest people, poor Ana's two faces. The patients come to see her, to ask her advice, and sometimes just to see if they can still cry. She listens to them, caresses them. Sam must have had a bad night, or fantasized more than usual. After breakfast, instead of starting his customary obsessive walk, which usually lasts until lunchtime (and makes the nurses restless), Sam comes over and asks her what she would think of him if he decided to kill his parents. Nothing gruesome, he'd only poison them. Ana answers that*

*that would be okay, but maybe he was bored and just had nothing
else to do. Why don't you play some Ping-Pong or Scrabble?
Later on, as always, Sam will come to see me and speak grate-
fully of Ana Mani.*

⟶ *Sam goes over to the girl with the scars on her arm (the one
the orderly had mentioned to me the second time I was there).*

*"I'm into girls with scarred faces, birthmarks, eyepatches . . ."*

*"Stop it!" Ana Mani says.*

*"Or a tattoo. I'd be happy with a girl with a tattoo on her."*

*"Stop it!" Ana Mani says again and takes him by the shoulder.*

*"Did you take your medication today?"*

*The girl with the scars wants to go on with the game and starts
unbuttoning her blouse.*

*"Sweetheart, what are you doing?" Ana Mani says and
buttons it back up for her.*

*"I have an eyepatch right here, hey, look, it's here . . ."*

*Sam leans over the table to see.*

*"Sweetheart, stop that!"*

*"Here it is." And she gives him a glimpse of her navel. She is
very serious as she shows it, and Sam looks at her disconcertedly.*

⟶ *Yesterday a very pretty young girl, the kind who looks at
the floor when she talks, said in group therapy that sounds both-
ered her. Even the sound of silence made a sound and she couldn't
sleep or eat or make love with her boyfriend, who would bawl her
out for her manias. She spoke and couldn't stop shaking her legs.
Ana Mani interrupted her to ask what her mother was like. There
was a great silence, full of expectation. Dr. X. stroked his mus-
tache, Dr. O. was taking notes. We were all waiting to hear what*

*she was going to say. But the girl began to look at the floor and move her legs without stopping. Dr. X. told her that she didn't have to say anything if she didn't want to. Ana Mani got up with a threatening look and said that wasn't fair, that we'd all contributed that day and that "the young lady" should make an effort. Dr. X. went back to stroking his mustache, but this time he was a little annoyed and reminded her that he and Dr. O. were the moderators there. Then all hell broke loose. The Ana Mani of day one reappeared and the happy face became the idiotic face and the lethargy immediately took over, and in a while she was drooling and her tongue was hanging out. We left in defeat. In the hallway the girl with the sounds went over to Ana Mani to apologize and told her that she'd never really known her mother. Relieved at having finally been able to say it, she stood waiting for some comment. But Ana was just salivating like a thirsty dog.*

*Dr. O. asks me in a session what I like about Ana.*

*"Her laugh."*

*According to the doctor, part of my problem is that I don't establish boundaries. When I leave the hospital I'll know how to say no. For her that's being somebody.*

---

    *One night Ana placed me before a mirror and used all of her makeup on my face. I didn't say anything because when I was a little girl I'd always liked it when Mama made up my face. I closed my eyes and let Ana Mani draw around my eyelids and my eyes while she whistled like the men in my town and interrupted herself to make some obscene comment about the nurses. There! Open your eyes, Irene! I wanted to remain in that peaceful memory, not thinking or seeing anything. But I could hear her breathing, and when I finally opened my eyes I wanted to cry, not so*

much over what I saw, a touch of crimson, some blue eye shadow, but over what I was discovering (or not discovering) about myself as I looked at myself. I don't know how long I'd been looking for the graceless face of all those days, the face of the last month, which Ana Mani was reanimating now with a touch of crimson that took me so long to wash off.

The most beautiful fantasies, as well as the most terrible ones, depend on the people who inspire them. At the age of nine, Irene's ideal was to be like Blanquita. She was attracted by her way of life, what she did and what she seemed to be. At twelve she wanted everything that she thought Jane wanted. And, of course, she wanted to be like Jane—the girl who seemed to be so out of it all. At thirteen, in Spain, she would meet Mariluz and learn much from her . . . From a very early age I was a traveling child, and for a long time I would go on like that, in love with teachers and girl-friends. Like one of those characters in the Spanish picaresque novel: educated en route, so to speak, the missing one, the adapted or adopted one . . .

Palmas Altas. It was and it wasn't my old home. Blan-
quita had removed the only painting in the house—a water mill
against a background sown with daisies—from the living room
wall and replaced it with a photograph of herself in an oversized
frame. From the center of the picture, Blanquita's eyes watched
over the entrance to the living room, peered to one side at that
imaginary point where some afternoon an unexpected visitor
might arrive. And she would always be gathering up her strap-
less dress, discreetly, covering the line of her breasts, where, by
some inexplicable bit of carelessness on the part of the photog-
rapher, the hint of a nipple could be seen. The furniture was
now of glass and burgundy velvet, and the porcelain was
Lladro, and in the corners there were huge plants with branches
and leaves that reached up to the ceiling, and which it was my
duty to water twice a week.

One day, a visitor arrived at that house in Palmas Altas
who paid no attention at all to the picture. He came from Spain,
and his name was Pascual. He was my father's uncle, the
brother of my grandfather José María Vilar. I didn't know that
we had uncles in Spain, though I did know that Grandfather
Vilar had come from a town named Artana, somewhere in Va-
lencia. But that was all. Suddenly we had more family, people
with the same last name and the same eyes who sat at the table,
drank wine with sardines, olives, olive oil, conversed in shouts
at mealtime, mingling Castilian and Valencian words. Tancastes
la porta? Porta la clau.

Everything was new with Uncle Pascual. In Mama's
time I don't remember our sitting down together *at table*.
Everybody ate according to his or her schedule and in a hurry.

Eating together was something for Christmas, when we would gather around a suckling pig to eat rice and pigeon peas, *asopao* and meat pies . . . But you didn't need a table for that. That was done standing, or among the coconut palms 'and guava trees in the yard. And you didn't drink wine but cane liquor, rum, beer. It was because of that fascinating visit that I fell in love with the idea of studying in Spain. I latched onto that possibility, anything that would get me out of the house. If the truth be known, I felt as if this Uncle Pascual had dropped down from heaven.

For some reason that pertained partly to the collection of photographs of castles that my cousin Elena had at the Boynton School and partly to my television education (La Pantoja dancing flamenco on the screen), I'd imagined the Costa del Sol to be steep, like the uplands of northern Europe, Artana all in green, its inhabitants dressed in bright colors and dancing in the square. The car, however, was going up and down dry hills alongside orange groves that followed one after the other, mile after mile, and, entering the town, we had to pass by two cemeteries, one on either side of the road, and cross a bridge over a canal that bordered the tombs and was lost among the houses and more orange groves. Artana looked like one of those towns in Juan Rulfo's stories, with narrow streets and a few trees that barely protect it from the sun, and very old houses of stone, which, depending on the emotions of the traveler, go up or down, sink into the cement of the alleys, rise up to the square by the church. In 1982 there must have been about fifteen hundred inhabitants. The older people, dressed in black or gray, the young in Lacoste and Levi's. Also, there were three cafés, two discotheques, a movie theater, four boutiques, and in every one

of those places people voraciously smoked their black-tobacco Ducados.

I saw Mariluz for the first time in Artana's old movie theater, which at night was also the town's disco. My cousin María José introduced us.

"La meva cousina de América," she said in Valencian.

It was the fact that she danced alone in a dark corner of the floor that made Mariluz a mysterious character. But, to tell the truth, they all danced alone in that dank, windowless place, in the midst of chairs and cockroaches who fled in fright from people's feet. Movies by day, disco by night, every so often two girls would dance together or a group of boys and girls would form a circle. They must have been between fifteen and eighteen years old. They were merry, good-looking, they laughed, looked at each other, and touched each other on the sofas right under the movie screen, the "reserved seats," according to María José.

Adult gestures, the bodies communicating with each other through dancing and cigarettes. I did everything possible not to look at the tangle of feet behind the red curtain. I looked elsewhere, over the heads, so as not to see. It was something I didn't think myself capable of. I'd get a lump in my throat and want to run away, hide. I remember that I asked María José to take me home.

Outside, Mariluz caught up with us and we walked part of the way together, three girls arm in arm, strung together like a bracelet. Something quite natural in Spain, especially in villages. When we got home my aunt and uncle asked how it had gone. I didn't know what to say and, under some pretext I can't remember, I went up to my room. I was sad and I didn't know why; nor did the others. Aunt María reproached her daughter

for having taken me to the discotheque since I was only thirteen.
According to Blanquita, I was probably just missing Puerto
Rico. I looked tired, maybe the trip had affected me.

It was because of Mariluz, I realized. Because I was think-
ing about how she was tall and thin, like me; but I was simple,
my manners were simple, while she had delicate features. Her
nose was small; it may not have gone with her mouth, but she
still looked beautiful to me. More than her physical beauty, her
mood had impressed me. When she danced she'd close her eyes
and seem to be absent, far away—where? I thought about her,
and also about the other young people. I'd already felt some-
thing like that in Valls d'Ouxo, where Uncle Pascual lived.
We'd just arrived from the airport, and while Blanquita was
buying souvenirs, I went out to look at the town and see what
the people were like. The young people went around on Vespas,
elegantly dressed. They wore jeans but had expensive dress
shoes on their feet. The terrible thing was that they drove like
lunatics, and all of a sudden they were bearing down on me in
one of those narrow streets and I had to hug the wall so as not
to get run over.

My house in Palmas Altas was full of holes; everything
could slip in there, even the wind. Closed houses were the
school, the cloister, the hospital, or the prison. Mariluz's house
was a fortress. In order to get to Mariluz's, you had to go up to
the center of town, about four blocks, turn right at the church,
and continue climbing up to the house on the corner, the one
with the reinforced double door. That's what I was looking for
because that's how my cousin María José had described it, and
when I got there I noticed that not only the doors had been re-
inforced but the windows too. They were ringed with bricks,

three small windows over the large entrance door. We had agreed that I'd stop by for lunch and then we'd go to the ruins of the castle and on the way she'd show me the conservatory where her brother Jaime was studying the saxophone.

The foyer was a dark room. Drying her hands on an apron, Mariluz's mother was trying to adjust her eyes to the light that was pouring in behind me.

Mariluz would be down shortly, she told me, then closed the door and was immediately lost in the darkness of an endless hallway. When I think about Spain, my memories seem to be concentrated on the foyer of that house, as if my memory had condensed two years of my life into that dark little passageway a few steps from the stairs where I'd watched my friend Mariluz come down so many times. Still standing in that foyer, I would try to imagine what her room was like, which of the three windows was her window. What about her father? I knew that he suffered from an incurable illness. ("He's dying and they've got him hidden away somewhere in the house," Aunt María had said.) All I heard from Mariluz was that he traveled a lot. On the wall to my right hung a mirror without a frame, and on my left there was a narrow door that looked just like a closet. I thought that perhaps I should come back later, but at that moment the telephone rang. Mariluz's mother came to answer it and was surprised to see me still standing in the foyer. She'd forgotten to invite me into the parlor. A little surprised, she asked me to follow her, and we went through a room that might have been a bedroom once, and at the end of a dark hallway we went into a kitchen that might have been a bathroom before. I'd never seen a house like that; the ceilings were high, like those in cathedrals, and the only light was a ray that seemed to filter through some crack that opened into the hallway. Nothing matched anything



else. I don't recall having seen a dining room, or even whether there were any windows.

Mariluz came running down the stairs, calling my name and asking me to forgive her for making me wait. While her mother prepared a bite to eat for us, we sat down and talked. It was the month of August. In September, classes would start, and soon I would be leaving for Castellón de la Plana, where I would be a boarder at the nuns' school. Mariluz would also be leaving, but to the public high school, also in Castellón.

So she was one of the few girls in town who studied and came from a family that read books. One day, when I visited her sister's apartment in Castellón, she gave me a book by the poet Antonio Machado. I, in turn, gave her *The Diary of Anne Frank*, which I was in the habit of carrying with me everywhere. We strolled and settled the world along the way, building brotherhood among men along the lines of the first chapter of the *World History* that we were reading in school.

A lock of hair, a pair of earrings. Then the books, then opinions, memories. And when the friendship was safe from words, fantasies. Mariluz was from Spain, from Valencia, from Artana. She too was someone who knew where she was from and who she was. I came from America. My grandfather Vilar, the Episcopalian convert, had been born in Artana, but he was buried in San Juan. Many things were similar: language, tastes. But only on the surface. If the truth be known, only adolescence united us. Artana's teens, male and female, associated marvelous tales with the word "America." They kept on wanting to know about New York, Manhattan, the only America that interested them.

"What's Rockefeller Center like?"

They were disappointed when I admitted, reluctantly, that

I was hearing that name for the first time. I was from the other America. I'd never been to New York.

⤚ *America, New York* . . . Till then New York was mostly a beggar and his dog that lived close to our house in Palmas Altas. I had met him in the town square surrounded by children, showing his dog's tricks. People applauded and laughed at the marvels that dog could do. The one that impressed me the most was called "The Dead": the beggar would punch the dog in the chest and it would sprawl on the ground, not breathing, looking dead. Only it left one eye open. My mother, smiling at my disappointment, explained that that was the way it should be, for then one knew the dog was only pretending to be dead. The open eye testified to this.

But as for the beggar, aside from those moments when people noticed his presence and even seemed to like him, his life seemed quite miserable. The children amused themselves by throwing garbage at him, and the grown-ups crossed the street whenever they saw him coming down the same sidewalk. And when they passed him he would probably overhear the words "beggar" and "nuyorican." But he took on with a certain dignity an air of universal despite, and you would observe a peculiar smile on his face, as if the memory of his years in New York was always present and was enough to entertain him, if sadly, for the rest of his life. He lived in a small house close to the old sugar mill. A constant wind blew clouds of dust over the dirt paths that crisscrossed the canefields. He took this same dust with him everywhere, and so did the dog, which tried in vain to shake it off its muzzle. In his long walks across the fields, he would visit us and tell us about his childhood years, his family's shack, the simmering stew of the day, and the strong

hands of his mother, La Tata, picking the fleas off his head. The landscape of his childhood was very similar to that of his present, but between them there stood the words *New York,* and this geographical accident of his life had conferred upon everything that was the same in principle a different smell, insistent and impossible to erase. My mother seemed not only to like him but to admire him as well. She would serve him lemonade and ask him questions. In exchange the beggar would speak of the terrible evils he had struggled with in town: a stoned seagull, a mouse dying in front of an unreachable piece of cheese, a cat injured by bullets, and his loyal dog, who didn't suffer from flea allergies as it seemed, but from deep burns. This dog moved and trembled around his master, with great gentleness. The beggar had saved him from one of the cane fires with which some cruel foremen try always to beat their luck: prepare the soil for the next sowing and kill as many as possible of the stray dogs that live in the canefields. It was a massacre, the beggar explained, in which these dogs that never barked, that silently traveled the dirt paths, living off almost nothing, cried out with a unique pain. On the contact of their bodies with the flames horrible cries came out of them, the first and last of their lives.

Mother liked to hear about New York. The beggar would have saved them too, the *compais* and *comais* of the factory and the barrio, he used to say. If only they had let him, he would have done by them as he did by the animals he sheltered at home. But they weren't expecting a savior, at least not this one, and who knows whom they did expect, or if indeed they did. These *compais* and *comais* never protested; they seemed to have lost their voices long ago. You could hit them and not one cry

would come from any of them, not one complaint, never a sign
of anger. Like the others in that splendid and ferocious city,
they were so accustomed to being punched by the bosses when-
ever they passed—not out of brutality, not out of hate, but sim-
ply out of habit—that they were not even surprised anymore.
They knew perfectly well from the beginning, before they went
aboard the boats docked in Puerta de Tierra, that this was the
way things were, and they accepted it, and that was that. So it
was that after having bowed themselves so long in order to pass
unnoticed, they had lost those qualities that make a true man or
a true woman. Even the beggar, despite his return, was a half-
man. Only the company of his dog made his days bearable. This
he told us more than once as he drank his lemonade. So that was
New York.

On Fridays after school I'd pack my dirty clothes in a
suitcase that Blanquita had given me and pass through the wide
gates of the boarding school, heading for the bus stop. For the
first time in five days I saw trees, sunny sidewalks, and people. I
went halfway across town, and on the square I strolled among
the sidewalk cafés, killing time until the four o'clock bus ar-
rived. Almost always I took refuge under the awnings of the
shops, because the sun was still intense at that hour, and I would
look into the shop windows and make lists of what I'd like to
have. While filling my imaginary wardrobe with dresses and
shoes, I also watched the people. I was especially taken by the
way pretty women smoked in the open-air café in Castellón de
la Plana. I forgot that I was carrying dirty clothes in my suitcase
and moved a little closer to the tables to get a better look at
them. And that's the way it went until the bus arrived.

One morning in school I woke up soaked from head to toe. I could feel the dampness through the sheets. I took off the blanket and saw the blood. A stretch of sheet hung over the edge of the mattress and right underneath there was a small dripping onto the floor, as if from an eyedropper, forming a red puddle. I touched my panties and realized what had happened. The only time I'd menstruated before was at Boynton School, a year before. Although I'd been expecting it again, I was alarmed by the proportions of it now. I thought that maybe something inside me had burst, that I would bleed to death. Worst of all was the shame. The students would soon be getting up and everybody would find out. It was like wetting my bed.

The headmistress on the floor came into the room, and when she saw me she lifted her hands to her head in horror. The shouting began, and Sister Benigna arrived with the first-aid kit, but they didn't know where to look. They asked what had happened to me, but I was in no mood to tell them. In silence I let them clean me up and change the bedding so time would pass, until I realized that they also knew. Standing on the floor, wrapped in the sheet, I could feel the blood still pouring down my legs. The nun in charge hugged me; a doctor would come soon, I shouldn't worry. They had me lie down and I could see the students waking up and looking at me with pity. Then the doctor gave me an injection of iron, and at the clinic they made tests. They drew more blood. She's anemic, that's all. So you've got to eat, Irene. I really did love the headmistress. I followed her everywhere with my eyes, and she must have noticed it, because one day she took me to her office to help her put stamps on envelopes. I remember that her window was the only one on the floor that

faced the center of town and from there you could see cars and people. I spoke to her about Barceloneta, my town. Did I miss it? Without realizing it, I said yes, and without stopping I described to her what the sugar harvest was like at Palmas Altas and, of course, I spoke of Lassie. I also spoke of Mama, who'd died in an accident four years before, and about Blanquita. And from then on, she began to treat me with affection. Since I wanted to give her something in exchange, I promised that someday I would be a nun too, just like them.

But what about that river that had come from inside me, first as a humiliation and right after that as a baptism? At the bus stop that Friday I bought my first pack of Ducados and I smoked them all up on the bus on the way to Artana. The tobacco was unbearable. I had to make sure I wouldn't cough in front of Pilar Andrés, if I ran into her. But even so, I kept on smoking, I would open my mouth slowly, let myself be enveloped by the smoke, and I would look toward the horizon with the same distant expression as the pretty women in the café in Castellón de la Plana.

I still hadn't got to know Mariluz's room, but I did know the apartment her sister Pilar had in Castellón, near the bus stop. It was small, square; from the bathroom window you could see the bullring. At first I thought that big circle of reddish earth was a baseball field. Pilar almost died laughing when I told her. On the street, before catching the bus, I would read the posters. SIX LARGE BULLS SIX! The blood was running down the poor bulls from all the sticks they'd dug into their backs. There were bulls on their knees facing a man in a black cap who was waving a red cape before their horns as if it were a fan. Pilar told me that they had bullfights in Artana

too. During festivals the people did bullfighting. I remember a photo of my mother in a miniskirt, a vest speckled with black fur, boots up to her knees, also black, and a broad-brimmed black hat tied around her neck. It was a front-view picture and Mama had her hands on her hips, in a challenging pose. Except that the bullfighters stood on tiptoe with their feet close together. Mama, on the other hand, stood with her legs wide apart.

Ever since I've been in Spain all I do is revise the family tree. It only becomes important when I have to decipher where I fit into this puzzle of uncles, aunts, and cousins who live in a different country but speak a similar language. They don't say much about the Episcopalian Vilar, my grandfather; it's said that of the six brothers and one sister he was the most gifted (the Vatican lost a jewel of a clergyman, I heard Great-grandmother Rosario say). They speak even less of Uncle Miguel: they say he was always a cut-up and that if he hadn't been pigheaded he wouldn't have had to live outside the country for such a long time. The other brother, the one who emigrated to Venezuela, they don't even mention by name (it was Jesús, and he corresponded a lot with my grandfather). The one they have a lot to say about, constantly, is the late Uncle Juan, the father of Aunt María, Aunt Carmen, and Uncle Juan. These three live together in the same building in three apartments exactly alike, one family over another, and in the dining room they all have the same picture of Uncle Juan.

*Descansi en pau.*

But now we're waiting for Great-uncle Miguel, my grandfather's eldest brother. Around the table are his nieces and nephew—Aunt María, Aunt Carmen, and Uncle Juan—

and the only brother he's got left alive in Spain: Uncle Pascual. The young cousins are there too: María José, María Elena, and I. It's my great-grandmother Rosario's house, and we've gathered there because on that November day Uncle Miguel is returning to Spain. He has been living in a small village in France called Lisieux and is returning for the first time after forty years of exile. We're waiting for him, sitting around a table full of food, mostly sardines. He'll arrive momentarily and in the meantime the family has begun to discuss ages, how old each one was when the war broke out and how old they were when they saw each other last. How can one explain what it's like to be sitting at a table with a Spanish family awaiting the appearance of someone coming back from exile after so long a time? They're waiting for a son, a brother, an uncle. What about me? For me, waiting for someone who was returning after so long an absence was something out of the movies. The only one who really remembers Uncle Miguel is his brother, Uncle Pascual. And, of course, Grandmother Rosario.

The bell rang and Uncle Pascual ran to the door. Then a tall, hefty man came in, wearing a black beret and a red woolen vest, and, almost without looking at Uncle Pascual (who barely came up to his shoulders), he came directly over to us, the children. He greeted us all with the same smile. Then he turned around, patted Uncle Pascual on the back, and gave him his bundles. Then he went over to Grandmother Rosario, took off his beret, took out a small package he had in his pocket, giftwrapped, and put it in her hand. Grandmother Rosario kissed him on the forehead. What would follow is unforgettable.

As if to break the ice, Aunt María said that he looked just the same as when she'd seen him last. With a little less hair, of course. They all broke into laughter, they knew that back then

Aunt María must have been a child of seven, and also because
Uncle Miguel was completely bald, like many in the family, and
she was putting him on.

This is your niece from America, your brother José
María's granddaughter, somebody said to him. I'll never forget
that hug. With the other uncles and aunts, and even the nieces
and nephews, Uncle Miguel had been rather reserved; me he
held tightly in a warm embrace that never ended and which al-
most took my breath away. All of it without saying anything to
me, not speaking a single word. I must have been so many
things to Uncle Miguel: I reminded him certainly of his dead
brother, my grandfather. But I think that in me, apart from lost
family members, other things must have crossed between us:
youth, America. Exile separated him from the rest of the family
—or joined him to it. I was America, and for those of his gen-
eration, America was the epitome of diaspora, the exile that
had gone before, the exile of so many Spaniards who, for one
reason or another (usually economic), had to go away. It's al-
ways the same. Someone leaves, someone is left behind.

What happened afterward could be blamed on the sar-
dines. The uncles and aunts took turns asking him about
France, about his children, about his wife. What was it like
coming back? Where did he plan to live? At one point I got the
impression that all those questions were boring him. For his
part, Uncle Miguel kept bringing up the subject of the war.
What war, man? There's no war here to talk about, Uncle Pas-
cual had said at one moment. He seemed nervous. Grand-
mother Rosario, for her part, said that those were things that
shouldn't be talked about, the years had passed, and in order to
give the reunion a different tone, she decided to open her pre-

sent. Uncle Miguel had obviously been annoyed. He wasn't smiling anymore, and, as if to get rid of his anguish, he lifted a sardine to his mouth. Then another. With the third sardine he put on a look of great irritation.

"I've never eaten sardines like the ones my mother used to prepare."

Something clicked in my head. Wasn't Grandmother Rosario his mother? Uncle Pascual twisted his napkin, threw it onto the plate full of sardines, and got up, pushing his chair back.

"You haven't changed a bit. Forty years away haven't done you any good at all."

Grandmother finished opening the little box. A rosary of red beads. Red? Grandmother Rosario is devout and leads the rosary at the church three times a day. Her rosaries are black, trimmed with silver. From the severity of her face, it was obvious that Uncle Miguel's rosary had horrified her. Uncle Juan, always so timid, as if to lighten the tension, said sweetly that it must be a French rosary. The aunts began to laugh, and Uncle Miguel did too. But not Uncle Pascual. His annoyance was growing: he was the authority in the family now, and he came over to the table furiously to say that he wouldn't allow anyone to treat his mother that way. Much less now that she was eighty-six. Then it was Uncle Miguel's turn. He also got up from his chair. I was breaking my head trying to unravel the family tangle, the thread of mothers and fathers that united and separated them. Uncle Miguel would clear it up in a moment. He spoke, still addressing Grandmother (something that upset her and made her play nervously with the rosary), and said that he'd talk about the war now and as often as he pleased. His whole life had been that, the war. In some detail he described

what it was like to command a battalion of soldiers surrounded in the Pyrenees. Every day the Fascists were pushing them closer to the cold and to death. His men were done in, so hungry that they were eating worms. That's right, worms, they gobbled them up until there weren't any more worms. Then they started to die, his men, one by one, and the horses ran off, losing themselves in the woods in order to escape the smell of death, which drove them mad. Only he and one comrade managed to cross the border. He had no regrets at having been a red, not even if it broke the *collons* of his Fascist family. And he turned to Uncle Pascual, and in the same tone of voice told him that the only thing that united them was a Francoist father. Fuck it all! So then there was nothing uniting them.

He'd said all that in fury, and now he was unhappy about that. After dropping down into his chair again, and as if he didn't know what else to do, he began to eat the sardines, slowly, still sad and angry. Until he'd eaten them all. Grandmother said it was a very nice present he'd given her. Aunt María asked him again about his children. Uncle Juan, without much conviction, added that he'd always wanted to visit France. Uncle Pascual got up and went out, slamming the door.

By asking questions with much effort and a great deal of timidity, I found out that getting at the truth is an art, especially when it's a matter of penetrating the secrets of a Spanish family. My real great-grandmother had died very young, leaving four sons: Uncle Miguel, Uncle Juan (the father of the three who lived on top of one another), Uncle Enrique, and my grandfather, José María Vilar. My great-grandfather had married Grandmother Rosario very soon after. She was younger and soon gave birth to Uncle Jesús and Uncle Pascual. Grand-

mother Rosario had decided that my grandfather should be a priest and sent him to the seminary. Uncle Miguel never accepted it. He'd always been an anarchist, and enlisted during the Civil War to fight against Franco. The other ones, except José María, stayed behind and in that way were spared the encirclement in the Pyrenees. My grandfather Vilar also emigrated. A short time before the Civil War he landed in Puerto Rico in the garb of a Catholic priest, but he immediately fell in love with a girl in his parish and the Vatican, which doesn't tolerate such things, excommunicated him. In this way he became a priest in the Episcopal church, which for some of the family must have been worse than the war. I never knew my paternal grandfather, but I grew up with a rather romantic story of his conversion for love. The family preferred that story to one of excommunication.

— One day at school I got a long-distance phone call. I thought it might have been Papa, but it was Blanquita's voice I heard. She was calling me from Artana to ask if I was aware that Papa was getting married to another woman. A girl almost my age. She explained that she'd done all she could to salvage things, even to the point of confronting the young woman, but without luck. Before hanging up, she said she loved me. You'll always be my daughter, Irene. I tried to answer, to say something, but I was incapable of anything. I was hanging on to Blanquita's last words. I put the phone down, went out into the hall, and shut myself in the bathroom. What I did next is important to tell. I got undressed, got into the shower, and turned the hot water faucet on as hot as it would go, and standing in the scalding water, I began to weep as though a catastrophe had struck me.

A few days later they called me again, also long distance. I ran down the stairs. I was praying that it was Blanquita so I could tell her everything I had been unable to say the last time. But it was Papa. He wanted to know how school was going, if I was studying, and, also, he had a great piece of news to tell me. Yes? Without any preamble he said that he was getting married in June to a young girl from Barceloneta.

"Her name is Mirna and you're going to like her a lot."

"The same name as Mama," I said.

"Yes, and she's a Taurus too, now that I think of it."

Then he told me that I was to be the maid of honor. And how old is Mirna? Seventeen, but if it didn't look right to me they could wait a little . . . I said that I wanted everything he wanted, that I loved him very much, and then I said good-bye.

Mariluz's mother opened the door for me, squinting as always. I went into the foyer again but it didn't impress me as much and, leaving it behind, I walked down the hallway to the living room. Pilar and Jaime, Mariluz's sister and brother, were there reading. Pilar was glad to see me. She liked the way I talked. She kept turning to Mariluz: Just listen to the words she uses—"*tarea*"! Who says *tarea* these days? Nobody. It's really wonderful, coming from America . . . She would make comments like that all the time. Jaime was more reserved. He played the saxophone and had the reputation for being very studious. He hated fooling around and didn't have many friends, but he got on very well with Mariluz, and, by extension, with me. He also wanted to know about America—Have you ever been to the top of the Empire State Building?

We were in the living room and a moan was heard, a long, thin sigh that reached the room almost as a complaint. The

mother was passing through at that moment and said, "Papa!" and they went out behind her and were all lost in the darkness of the hallway. I didn't know what to do; something was always happening in that house that made me feel like an intruder. I heard the moan again and then I noticed that a door I'd thought led to a closet was ajar and inside they were turning on a yellow light. I went closer. The closet was really a room. They were all standing around a bed in which lay a worn-out, yellowish man, something almost forgotten. He was holding up one thin hand, raised above all of them; and that hand was the only part of that body that seemed alive. It was the father, and they'd kept him there in that closet all that time. Mariluz came out of the room with tears in her eyes and asked me to go with her to her room.

That day I got to know my friend Mariluz's bedroom. I followed behind her, summoned by her voice, while the stone steps rose up in the darkness. We went up, and all the way there was nothing to hold on to, you had to feel your way along the smooth walls on either side of the stairs. Knowing the way by heart, Mariluz went up quickly. I followed her and we finally reached a room with an incredibly high ceiling, an ancient double bed of carved wood in the center with the Virgin engraved in the middle of the headboard. She'd inherited it, along with the dressing table full of porcelain ballerinas and brushes. I sat down on the edge of the bed, thinking that I was seeing something from a different age. How many generations had that bed seen of birth and death? Nothing in that room or on that bed or on those stone walls had anything to do with the adolescent girl who danced by herself at the Artana Cine Disco. Only in Mexican movies were there houses like that. Mariluz was drying her eyes. Of course she couldn't

have imagined what was going on in my head. I was going to tell her but she came out with a white blouse sprinkled with red dots.

"Why don't you try this on?"

We looked at each other. She, too, was going to change her clothes and was getting undressed in front of me. I was hypnotized, tugging at my clothes, not knowing what to do. She was already naked and I hadn't been able to move a step forward. With some effort I went about taking off my dress and when I was getting ready to put on the blouse with red dots I saw her in the mirror, and she was coming toward me carrying a bow that she'd just taken off one of her great-grandmother's dolls. She wanted to see how the bow would look on me. We joked about great-grandmothers and dolls and suddenly I forgot how ancient the house was and the things in the room and I let her take my hair. I closed my eyes. When I opened them she'd just finished making me a wonderful bow. Then I, too, stood in front of the mirror to get a good look at her and I made her two long braids, the kind Mama had taught me to make. And we looked at each other.

That Saturday afternoon we went back to the old movie theater to see if we'd run into Pompi and Renato by chance and we roamed about without much luck, a little aimlessly, until we reached the cherry groves on the outskirts of town. Mariluz looked more sad than happy, and when I asked her if something was wrong she looked at me as if she were going to cry. Artana bothered her, she said. The boring spirit of the people, their lack of imagination. She'd no one to talk to, she spent long hours in her room in silence. But silence bored her too. Her only relief was reading novels. Me too, I told her, I felt the same way she did, and I told her about my father, and she, with

a delicate gesture, from a novel maybe, began picking cherries from a tree and passing them to me. Then she began throwing them at me. They were ripe and all we had to do was touch a branch for whole bunches to fall from the tree. She kept on eating. I sensed that she was looking at me, that she was spying on me when I wasn't paying attention. It didn't seem strange to me because I was looking for a chance to do the same. As we went into an orchard I surprised her and she surprised me too—we were trying to spy on each other at the same time—and when I tried to turn around, Mariluz threw a ripe cherry at me that hit me on the forehead and covered it with red mush. It was nothing but laughter and she had a mouthful of cherries. I decided to counterattack. I picked up a whole cluster from the ground and flung it at her head. She couldn't believe it and she stood there looking at me with her cheeks puffed up and I was going to ask her to forgive me for all those rotten cherries streaming down her hair and forehead, but she lifted up her arms as if to pick some more clusters off the tree and she spat all the fruit in my face. I was going to pick up some cherries off the ground but she jumped on me. It was the first time I felt the pressure of her body; the ground all around was covered with ripe cherries and I could feel them on my skin while Mariluz made a greater effort to hold me down. Cherry juice was seeping through my clothes. Finally Mariluz let up. When she released me, I turned face up, as I'd seen puppies do when they played, and raising both my feet, I gave her a little push. We would probably have kept on that way all afternoon, but suddenly, out of the trees, the gardener's dog appeared, barking and showing his teeth. Mariluz ran out, shouting, saying he was the devil on four legs. I didn't get to see the animal, but I ran out behind her. The dog must have been quite angry because

we could still hear him barking after we took refuge in the church on the square.

At the entrance there was a basin with water in it and we took advantage of it to wash our hands and faces, and we also got rid of all the sweet, sticky cherry juice on our shoulders and thighs. I did it all very quickly because the church scared me. The dog was gone already when we came out. With a burst of laughter, Mariluz said she just realized that we'd cleaned off all the goo in the church's holy water font.

At the café where we used to sit and eat sunflower seeds Jaime appeared one night. He was on his way home from the conservatory. He knew I was going back to America soon and he wanted to know more about the people in America. Was it true that they're very tall there? Somebody had told him that at the age of eighteen children have to leave home. Jaime's questions were interesting, only I didn't have much information on America. I described what my school in Orford was like and the people in New Hampshire. I told him everything I knew about Quakers and the Episcopal church at Hanover. He was amazed to hear that they drew the sap out of trees to make syrup. With pride, I started to tell how I'd learned to milk cows. But none of that seemed to make sense unless I also spoke about Mr. Boynton, and, of course, Louise. Jaime became thoughtful. He was realizing that we weren't talking about the same America. "So you've never been to the top of the Empire State Building?" he asked, clutching his saxophone. No, never. I'd told him everything I knew about America. As if to revive the conversation, Mariluz mentioned that I'd given her *The Diary of Anne Frank* and that she was going to read it as soon as school was over. "What? Didn't you read it in your

first year at the BUP?" Mariluz confessed that she hadn't read it. Nobody really read all of it, they preferred reading the summary at the end of the chapter in the textbook. As he got up to leave, Jaime told her that she'd better read it, and soon, and that way she'd find out how everybody in this country is an anti-Semite.

"Of course. I'll do as you say," Mariluz answered.

Then he came over to me and said good-bye the way grown-ups do, shaking hands and asking me to forgive him because all that practicing on the sax at the conservatory had made a prisoner of him. It was the last time we saw each other. He went off and we sat in silence, eating sunflower seeds. Then I asked Mariluz what the word "anti-Semite" meant. And she, a little ashamed, said she didn't know.

⁓ The morning I was to leave, Aunt María brought some warm milk with sugar to my bedroom. We sat on the bed, and while I was drinking it she began to cry. She'd grown to love me over the time. She also came to give me a present. And she took a little box out of her apron pocket.

"You must always carry it with you," she told me. I opened it and inside there was a little silver chain and a medal. At first I thought it must have been a little Virgin or one of the saints they carry so much in Spain. But it was a round silver medal and in the center it had the letter "A" and a small cross beside it. "It's a medal with your blood type," she told me. "Yours is A-positive." I lowered my head and put the medal around my neck, saying I'd always wear it. "Besides, it's in fashion."

I search for one last scene: I see myself in front of the mirror. Suddenly I come face-to-face with Uncle Miguel, the family

red, eating all the sardines on the table. He's all worked up, he always will be, as if returning for him meant reliving all the sorrows, of war and of peace. What was Uncle Miguel's blood type, and Uncle Pascual's and my aunts' and my cousins', and the rest of this Valencian family of mine?

Another morning and once more Miss Boyd calls for the group therapy session. "Hurry up, hurry up! You're late!"

"Mademoiselle Jenny is not ready yet," says Ana Mani.

Somehow, after breakfast I end up in Jenny's room, watching her get ready while Ana Mani comments on her chronic case of cranial neuralgia, which is slowly but steadily gnawing away her nerves and at the same time adding a certain sharpness to her intellect. Her sickness, she is now convinced, is but a memento of her neuralgia. Anyhow, it's chronic, and it strikes once every few months, sometimes mildly, sometimes seriously. She has tried unsuccessfully to recall her earliest memory of the illness. Dr. O. says she must try harder. The only thing she can recall is a certain intimacy with sadness, the strange yearning for a piercing sorrow,

*a body-wrenching sorrow which bore down upon her and took her captive, at about the age of ten. More than that she can't say. And at this stage of the game, why should she care?*

*She leans toward me, as if to share her secret: "I am a manic-depressive. What about you?"*

*What's your first sad memory, Irene? My earliest sad memory? It has to do with my nanny Diana's metal hip, her right leg that turned a bit to the left. I used to watch her sleep during the day. She slept a lot and would wake up in a jolt, sweating, and look at me with an apologetic smile.*

*Jenny is looking at herself in the mirror, and I've found out through Ana Mani that her face and body have gone through some harsh discipline "and a lot of issues of* Mademoiselle.*" Not so her eating habits, it would appear; there is no discipline in devouring six Snickers bars while trying to find out what's going on in her boyfriend's mind. That's Jenny's story, the same she will tell again and again in the therapy sessions while gobbling Snickers. Jenny watches her boyfriend shaving. He is also the father of her baby. She doesn't look straight at him, but knows what he is trying to tell her. He says he can't promise he'll never leave her or the baby. She asks why not. Why can't he say that? He turns, with the razor in his hand. Because he doesn't feel it, period. But . . . can't you just promise never to leave us, anyway?*

*"Hurry up, hurry up!"*

*"Mademoiselle Jenny is almost ready!" shouts Ana Mani.*

*Later, in the session, Ana will tell her again to watch all those Snickers. "Look at yourself, Jenny!" But Jenny can't look at herself unless she finds a mirror. "Look at yourself, Ana!" says Dr. O. And sure enough, this morning Ana is not looking her best. Maybe it's her chronic neuralgia again, or something else. Then, with an apparent look of complicity, she comes toward*

*Jenny, takes her on her lap, and, pressing her head into her breasts, gives a big laugh. Then the voice of knowledge and sympathy, which is the voice of the manic Ana, tells her that she doesn't realize how lucky she is, being young and single. What more can you dream of? You reach a point where you cannot cry anymore, and you look around you at people you know, at people your own age, and they are not crying either. Something has been taken away, or has simply taken off.*

*Madame K. comes into my room at night sometimes, swirls in through the doorway. Tonight the moon was big and it lit up the room, striping her long hair and face. Stretched out even more than usual, her skin seems covered with a multitude of tiny wrinkles, and in places it seems to hang. Her body is growing slower. Each turn of the head, each move of the fingers, each move of the foot is a complicated and elaborate step in a dance of death. She approaches the edge of my bed and the stripes run up and down her. She calls in a whisper, "Good night, my sweet." She isn't looking at me but straight into the pillow. This time she doesn't take my shoes. I can't help reaching for them under the bed. She is already heading back to her room when I catch up with her in the corridor and offer her my shoes, but she looks at me as if I were someone else.*

*Madame K. Her life bore no relationship to mine. I can dream away long and boring afternoons, gazing at other people's grief, peeking into their lives through my newly found grief, my only key. Looking at those people, I am overcome by a new fantasy of change. I think: I want to be like them, share in their existences . . . I turn on my side and face the wall. It's easier this way sometimes. The wall diminishes everything. Thus Madame K., a familiar figure by now, becomes another three-by-five card:*

*The song of the dance of death (French in origin) appeared first in the form of drawings, Memento Mori, circa 1500. A ravaged body or skeleton, always human, saying with malevolent determination: "Once I was as you, soon you shall be as I."*

*I can still see her looking at me. She no longer speaks, she stares, and one senses that there are things far too big for her to fit into mere words. There seem to be Madame K.'s scattered here and there, each one but an imprint of what she once was—perhaps still is, if one could see deep inside that broken form.*

I see myself as maid of honor, following the bridal couple. Wrapped in lace, I rustle as I walk. I'm carrying plastic flowers that smell like Tupperware. It's hot, everybody is sweating, and, to top it off, the fans in the ceiling of the Episcopal church are barely moving, as if the heavy tropical air were holding them back. I can't stop thinking about Spain: the decor (or the lack of decor) in an Episcopal church is the farthest you can get from the twisted statues of Spanish Catholicism. This Episcopal church is a barren wasteland, and its emptiness makes me daydream, imagining people and scenes on out to infinity. Uncle Miguel is already waiting for us at the altar, wearing a cassock and holding a Bible in his hand. All these images are so inseparable that I can hear the question and don't need to wait for the answer. "Yes, I will."

The same as always. The ceremony is over, the bridal couple kiss. Now to laugh or cry, as it suits one.

⟝— One day, a short time before Papa's wedding, Blanquita called him to say it wouldn't be right to send me to a public school after the four years of excellent education I'd received in New Hampshire and in Spain. Papa asked what she would suggest and she answered: The Immaculate, the same convent school where my mother had been a boarder for one year. The family is Episcopalian, of course, but she'd been thinking about it and would make arrangements to get me in.

Papa agreed.

We found ourselves facing the doors of the school. She took me by the hand and, as we passed through those wide, heavy doors and through the chapel (I didn't tell her that I'd been there once already with Mama), we talked about Spain and what coming back had meant to me. She planned to introduce herself as my father's second wife, and that made me glad, feeling her close once again, hearing her say that she's my mother. After the chapel we came to a place where a Virgin, of wax perhaps, was beaming, and then down a long hallway that led to the inner courtyard, where I could see a sliver of sky that seemed excessively blue to me at the time.

In the admissions office, Blanquita introduced herself as Mrs. Vilar to the Mother Superior, who was reading my grades from Boynton and Spain with surprise, and she quickly explained the reasons for such a strange pilgrimage. Besides, the girl's mother had also been a student at the school.

The Mother Superior must have been suspicious about all this, and I thought for a moment that she was going to question me, but she stood there reading my report cards, especially the

ones from Boynton, looking at me out of the corner of her eye with an almost aggressive coldness, and looking at Blanquita, too, who was holding my hand. Finally, still looking at me, she said it was fine. I could be admitted in spite of the doubts my case aroused in her.

It must have been that element of an organic lie, of crafty symmetries (Blanquita's passing as Papa's wife and making me pass as a devout Catholic), that made me enthusiastic at the prospect of being a student at Immaculate Conception.

We said good-bye in the parking lot of the school. Blanquita had things to do in town and I had to go back to Palmas Altas, to the house that had once been hers too. She hugged me and we promised to get together again, along with some other promises that I can't remember anymore, and then she disappeared into the crowd of people waiting for buses. I felt an urge to run out, but I didn't know where to.

— I liked to read and take notes, but when I did, scenes and fantasies would pass before me and almost all of them had to do with the body. (Later on, at the university, I would listen to my professors, my classmates a few times, talk about sex; sometimes they'd talk about eroticism too, and even revolution.) At that time the body and the intellect (a synonym for politics) were dark poles apart, sometimes in discord. And I'd stay looking at myself there, my arms, my naked thighs; or I'd trace a circle on my little breasts and look at them as if someone else were seeing them. Sometimes I'd grow stiff and then I'd leave the book and go out into the street in order to breathe. Body and intellect. I was my mother's daughter, and Lolita's granddaughter too, and those two women in me couldn't reach any agreement.

～ I can't remember the first time I saw the sky, or what I felt when I ate my first jelly roll stuffed with guava, but I will always remember the voice of Missy Alvarado, my history teacher. I loved her from the moment I entered her class. She was making a sketch on the blackboard, her back turned to us, and since I was late, I remained in the doorway so as not to interrupt her. When she finished, I saw that she'd drawn the map of Puerto Rico half-sunken in a gigantic bucket on which she'd written, in capital letters, the word "SHIT." The girls were laughing and I did the same, and at that moment she discovered my presence. She remained thoughtful, the chalk in her hand. Finally, in an almost perverse tone, she told the class that now that she thought about it, they didn't have to read chapter eleven in the textbook, that it would be sufficient to give some thought to that sketch, and to the spring that nourishes our life and our land. As she said that she gave me a conspiratorial wink.

Like Mama, she'd also studied at The Immaculate. Missy Alvarado was my first true ally. She was short, with something mannish about her, as the nuns said, and in spite of that she was physically and morally attractive. Yes, there's something fascinating about a history teacher in a convent school on an island in the Spanish-American Caribbean who can tell little bourgeois girls that they're sunken in shit, and also—and she said it openly, so that it would get back to their parents—that if the moment arrives, it's advisable to use a contraceptive. (I can see Sister Anailia covering her ears . . . and another nun, whose name I don't care to remember, advising silence and wagging her finger at her. For some reason, Missy Alvarado was untouchable, although she shouldn't have been so, because you don't mess around with the Catholic Church, and it's heresy to

go around saying things like that, even worse for a graduate of Immaculate Conception.)

I was suffering and I really don't know what from; at night, when I turned out the light and turned my back, I could only fantasize and feel the presence of my body. That's what I was suffering from. Missy Alvarado had winked at me and given me a beautiful smile, and that would have been enough to remember as something good in my life.

⌐ Lolita, not the heroine, the other one, the one of literature . . . I was to turn fifteen, and Papa made me a gift of a cruise around the islands for summer vacation. A man of the Caribbean, fun-loving, he probably felt guilty, and to his way of thinking, the best thing to heal old wounds is jewelry . . . a dress . . . a trip . . . A trip, yes. Go with Marisol, Irene.

When we told Missy Alvarado, she reacted as one would expect. She took us aside and suggested the *Boni M.*, because Italians are good lads and the *Boni M.* touches at wonderful ports. I must have stood there with my mouth open, because Missy Alvarado looked at me thoughtfully and then said:

"I'll go along with you. It's a gift I owe my two children."

On board ship we scarcely saw her. Missy Alvarado must have been looking after her two children, one eight and the other nine; and Marisol and I, well, I don't know about Marisol, but I knew how to get along by myself. From the very first moment I must have felt that something was going to happen to me; I would walk tirelessly around the deck, seeking I don't know what, a casual meeting, an inviting, hesitant smile. On the stairs, if I crossed paths with some passenger and he looked at me, I would run to the nearest bathroom and look at myself in the mirror. I liked what I saw, and with that taste in my mouth I'd

return to the salons, walk along the companionways, or go up on deck, looking for myself out of the corner of my eye in the glass, happy with what I saw and felt.

On the second day out, at night, we went to watch a gaucho show. For me it was something unexpected, I knew what a gaucho was, but I'd never seen one.

It was a dark salon. Two illuminated figures were playing with lassos and balls. They weren't just jugglers, because they danced and stamped their feet hard. Suddenly one of the figures took the balls and twirled them in the air. The balls disappeared up above, reappeared, and formed phosphorescent circles in the air. As they exploded they lighted up the room and disintegrated in the shadows. The lassos exploded too, and everything was repeated, over and over and faster and faster, and the balls go up, higher and higher, and come down, forming a circle of light over the people's heads, and short, sharp shouts can be heard, the shouts of the chase, of an animal fleeing in the dark . . .

When the show is over we go up on deck. A man in a chair stares at me and I look back at him. He's an older man, with a sad look. I go on my way, and I know that he's still looking at me. As I turn around, we look at each other again. At that moment I would have liked to run off to look at myself in the bathroom mirror, but I keep on walking until I catch up with Marisol.

The next day I suggested a visit to the discotheque. On board those cruises everything's like a big hotel, dining room, gambling casino, reading room, and, of course, the cabins and the embroidered towels: *Boni M*. I can't remember having looked at the sky or the sea—ah, the sea—I scarcely realized that we were sailing the waters of the Caribbean. That night in

the discotheque we ran into the man I had seen the night before. And by dawn I would be drinking gin in Eduardo's cabin. Eduardo didn't talk. He was watching me with the same sad eyes as the night before. I lay on the couch, waiting, hiding my terror of what surely was going to happen. He kept on watching. Finally he decided to move closer.

"May I?" he said in my ear.

And what follows is simple. First he strokes my knee, then my thigh, then he gets a little closer, and with a gesture that pretends to be something else, he takes me around the waist. I don't know whether my eyes were open or shut, but I let myself go, I let myself be pinned against the wall of the cabin; I let him touch me, I let him put his hand between my legs, and, almost unwillingly, I let myself be kissed on the mouth.

What is real kissing? Is kissing something you have in your blood? Something inherited? In Spain I went to a hard-core movie theater with Pompi and Renato and I saw the most detestable kissing. I was thirteen years old and I let myself sneak through a building in ruins that you had to enter surreptitiously in order to reach the back side of a roof from where you could see everything without being seen. Several walls and three columns was all that was left of that building, apart from the stairway, up which we had to climb in the dark, silently, hunched over so the people down below wouldn't notice. I was scared, and for a moment I was on the verge of going back, and I would have done so if Renato hadn't been leading me by the hand, and the heat of that hand made my heart beat more than the fear did. Suddenly a courtyard opened at our feet, and shrill voices reached us from below, mingled with a strong smell of tobacco, Ducados most certainly. As I emerged I saw a sheet

hanging from some beams, and then I saw the audience. They must have all been men, and they were seated as in a theater, looking impatiently at that white sheet hanging from the roof beams. They were shouting at a fellow who was hunched over a projector to hurry up. At that point Pilar Andrés arrived, panting, saying we were a bunch of rotters for having forgotten her. I tried to explain things to her, but she looked at me mistrustfully, took Renato by the arm, and sat down between us.

"Be quiet," she said. "I'll tell you what happens. It's about nuns. They do everything . . ."

They must have known the film by heart. I can only remember a few images, the refectory of a convent, some young sisters looking worriedly, almost in alarm, at the door and lifting their eyes to heaven as if praying because the shouting could already be heard, closer and closer, and the whinnying of the horses that seemed to be coming through one of the windows had riveted the attention of the nuns. They must know what's about to happen to them, maybe that's why they're hugging each other in terror. Pilar Andrés laughs—she already knows the outcome—and she hugs Renato, who's also laughing. Pompi is laughing too, the people below are protesting. A shout comes from outside the convent, followed by trembling walls and falling doors, and when cowboys burst in furiously, the nuns look at each other in fright, the bread still in their mouths. Then the cowboys start to chase them and the nuns run around the table, even though they might have tried to run away, since the doors are open. The nuns are caught, one by one, and they kick, resist; Renato and Pilar Andrés are also kicking, and it's all quite deafening. With one incredible kick a cowboy knocks down a door. Inside, huddled in a corner, is a little nun. The man takes off his belt, drops his pants, pulls down his under-

shorts. He's still got his shirt on, but he's impatient and he pounces. Lying on the floor on her back, the nun watches him coming. She screams, grasps a crucifix, a rosary, but it's useless, and everybody already knows what's going to happen. Anyway, they're on the cowboy's side and not the nun's. And even though he's on top of her, she still tries to slip out from under him, to dodge his kisses, but she can't escape the hug that follows, the pincer movement of a pair of muscular arms that holds her and bends her over, slowly, until the poor little nun can barely breathe anymore and drops her arms. What else could she do . . .

Pilar Andrés lets out a laugh that echoes throughout the building. Down below there's a commotion, chairs are knocked over, some people run off as if they're afraid of being caught. Extremely angry, somebody in the audience climbs up on a chair. He recognizes Pilar Andrés and then asks her what the hell are you people doing up there, what will your father say if he finds out where his daughter is spending her Saturday nights? Pilar Andrés sticks her tongue out at him, and also at the shouts, and answers him back that she isn't afraid of him and that he'd better zip up his open fly, and she sticks out her tongue again and we run off.

⌐— Eduardo? I didn't know what his body was like, or I'd forgotten, because the six days of the cruise on the *Boni M.* were nothing but pushing against the cabin wall and pretexts. That's what I remember most. I always ended up against one of the corners of the cabin, with him stroking my breasts, trying to put his hands between my legs, but as if he weren't looking for anything, as if not to alarm me. The cruise ended and we said good-bye. According to him we hadn't gone all the way. I didn't

know if that was how it was, the only thing certain is that on the *Boni M.* I'd put my body on the line but I'd left my soul outside, on watch.

One afternoon I was coming home from school and I thought I saw a car parked in front of my house. It was a black car with tinted windows and inside there was a man wearing glasses that were also tinted. I kept on walking. I went along, taking off my uniform, getting down to just the shorts that I always wore underneath as soon as I got to the parking area in front of the house. At that moment Papa came out and when he got to me he kissed me and pinched me on the behind. We laughed. I asked him to give me a piggyback ride the way he used to. Papa hunched over and I climbed on top and put my uniform on him as a hat. I turned around and at that moment the man in the car raised his window. Papa was whistling happily, saying something to me that I couldn't hear because the car behind us had started up and pulled out at high speed, raising a cloud of gray dust.

That night the telephone rang. It was he. He'd come back from one of his trips and he wanted to see me. We arranged to meet after school, across from the supermarket, two blocks from the school. And I hung up.

How can I explain it? It was something altogether new that was happening to me. Facing the uncertainty, I did what I always did. I ran to the bathroom mirror, got undressed, and, as if in need of a vocabulary, I began to review the parts of my body, as a composition theme. I never got beyond my eyebrows. Ever since the cruise on the *Boni M.*, magazines were my only reference, especially those with exercises. They had them for breasts, thighs, waist; instruction on how to make up triangular faces, square faces, round faces; haircuts for fat women, skinny

women, tall women, short women, white women, black women, dark women. Depilation? In the photo showing how to pluck eyebrows there was a pretty woman and she was shown *before* and *after* treatment. In front of the mirror, I pulled out my first eyebrow hair, then the second; by the third I was nothing but a monster with puffy eyes. In the photographs, the *after* woman was quite different from the *before* woman; she was simply prettier. I, on the other hand, had to stay there, clinging to the mirror for a long time in order to assure myself that that swollen, mournful face was mine. (What does it mean to be fifteen? Most of all it means sleeping too much. An adolescent sleeps heavy with the weight of *what ought to be* . . . Maybe that's why, even without knowing it, I slept so much. I wanted to be a ballerina, a pianist, an athlete, a poet, a woman, a saint, a genius, and all at the same time. My models were women who'd been only one thing—somehow, I'd adopted the idea that being many women was a moral problem. In an adolescent's soul a fierce debate rages over these two tendencies, plurality and unity. And in my culture, since they're irreconcilable, the best thing was to sleep.)

The *Salvat Encyclopedia* devotes four pages and three photographs to Argentina. *Argentina, Buenos Aires, Evita, Gauchos.* I would repeat the names and dates aloud. Cattle and gauchos. The tango. Besides, at that time I was reading *Open Veins of Latin America,* by Eduardo Galeano. Sex was one mystery, politics another. I would take the books to bed with me and reread those four pages of the encyclopedia many times until I knew them by heart. We'd have something to talk about.

⟿ He comes from San Juan to get me and we go back to San Juan, to the apartment of a friend of his, which is only a single small room with a bed with black sheets in the center, like a

boxing ring. Eduardo has everything ready. Arms crossed, leaning against the wall, he talks nostalgically of the beautiful nights on the *Boni M.* He's taken a lot of trips, but never one like that. I don't know what to do; I walk back and forth; I busy myself. I manage to take off my shoes, but he stays put. The wall, or maybe the light, makes him look shorter; even his legs look smaller. But the effect of the shadows increases the strength of his eyes. I turn my back on him, to face the window. Now I know he's coming closer. He's behind me and I can hear his breathing, I catch the warmth of his breath. He strokes my neck. I see him in the mirror, I see that he's getting undressed and I feel him undressing me. I turn around and now we're getting undressed together. We're naked, on the floor. Everything is going just the way I'd imagined it, as if I'd lived it before. Only when he stands up, staring at my legs, at that moment, do I feel that something really new is going to happen to me.

⟶ Am I still a virgin? We'd go to the park; we'd park on dark streets; we'd get undressed again in the apartment of a friend of his (a Costa Rican who sold coffee); and Eduardo kept on saying that we still hadn't gone "all the way." I kept on searching in my body for the signs of a change that wasn't taking place. In the daytime I'd look at myself in the mirror, touch myself, explore myself; at night sometimes I'd study until three in the morning. On weekends I'd go visit Grandmother Lolita. I was waiting for something, looking for something, needing something. What? He'd hug me and kiss me and in the midst of such an outpouring of petting he'd promise to take me away to a faraway country where we'd live together, the two of us. Where was far away? Argentina? When I brought up the matter of the country, with the help of the encyclopedia, of course,

Eduardo wouldn't answer, or he'd answer with words that were beyond me. Even though I didn't understand some things, I loved the Argentine accent. He'd talk in euphemisms, like characters I would read about in Cortázar. One day when we were in the friend's apartment he confessed to me that when he got back from one of his trips he'd decided to surprise me and he'd gone to wait for me at the parking lot by the house. He was there for a while and when I finally arrived in my schoolgirl's uniform and he saw me riding on my father's back, he panicked and fled.

"Listen to me. You were just a kid."

"What about now?"

"Now?"

The question must have been unexpected. He remained thoughtful; and when he'd thought it over, he didn't move away. He took out a cigarette, lit it, and, looking me in the eyes, said:

"We've already gone all the way, Irene. You're a woman now."

We wrote to each other. Once I received a tape. I waited until everyone had gone to bed and then I played it on the stereo. It was the voice of the man who had seduced me last summer. Eduardo recited poems to me. All they needed was to be set to music. I listened to them for several nights, and the voice and the repetition calmed me down. I stopped thinking . . .

One day I forgot where I'd put the tape. I think it was because the voice no longer said anything to me.

⟶ The nuns belonged to the Order of Louise de Marillac, which had a mission in Haiti, and in the spring they would take us on a trip to Port-au-Prince. Our guide was speaking at a bus

depot that was all lighted up and air-conditioned, and when I re-
alized what the tour was going to be like, the first thing I did was
to break away from the group and go off on my own. What I
saw was nothing like what I was accustomed to seeing in Puerto
Rico. The people there lived off the remains, the leftovers, the
garbage that the affluent society left behind: bottles, cans, empty
boxes, all decorated in the brightest of colors, real pictures of
horror, even for the most insensitive tourist. There were people
in doorways, on corners, in alleys. On the square by the cathe-
dral the air was unbreatheable, and I sat down on the steps,
worn out. It had rained, but it wasn't one of those cooling rains;
it was hot water that, when it evaporated, left a smell of in-
testines, of a stagnant puddle. Not far from the square, lying on
a collapsed cardboard box, was a woman, young, black, with
sunken eyes so red that they seemed ready to explode. She
wasn't wearing any blouse and her breasts hung down, heavy
and black.

That's where the smell was coming from. The woman had
sat down on the cardboard box as on a toilet, and now, with her
legs out and wide open, she was making an effort, consoling
herself with mumbled phrases while a gelatinous mass blos-
somed from between her legs, a kind of pink, transparent run-
ning water. I felt the gastric touch of vomit coming up my
throat. The woman seemed to me to be on the point of fainting;
she looked as if she might die. I didn't know what to do. I
wouldn't have known how to help her, but maybe in the cathe-
dral, I said to myself, and I ran up the steps, but the cathedral
was closed. When I got back, the woman was still there, lying as
before, and a white man in a cassock that was also white was
going over to her with a pail of water. "*Ma fille, ma fille, ma
fille* . . . ," the woman was sobbing. I was about to go over but I

noticed that the man in the cassock didn't look too kindly on my presence. After all, I was just another tourist, one among so many amateurs in the contemplation of other people's misery.

It was February, and soon I would be sending out my applications to American universities. My own experiences, Boynton, Artana, and what I knew of my family and Puerto Rico might well be a starting point in my education. I wasn't too sure what career I would follow, but if I started with politics and international relations I wouldn't be too far off the mark. Given my personal history, those careers seemed to offer me what was closest to a unity. I'd be somebody.

*April Fools' Day. The nausea is taking its toll. Miss Boyd insists we should exercise. It's good for meditation, she says. We stride down clear sidewalks, past people dressed in black, past the shops and the banks and the snow. No one speaks, only Miss Boyd. Not so slow. Isn't this a beautiful day? Look at the sun. Her voice sounds sweet, indeed, but I never turn my head toward the sun.*

*This morning during group therapy a new patient took the floor and screamed his heart out. For some reason Dr. O. let him go on. In moments like that, when one of the group erupts, a silence will follow. We all are afraid to hear the sound of our voices again. Whoever breaks the silence becomes the target. Now it is Sam's turn.*

*"Tell me, Jenny, why are you here?"*

*"You know why I am here, you know that I am not like . . . You know what I mean."*

He walks toward her, raging. She doesn't flinch. She doesn't move a hair. A strange calm follows. Sam is suddenly vanquished. Ana Mani said it was as if Jenny had turned her usual polished discretion into an impenetrable shield.

*"At any rate,"* says Sam, *"we're all passersby, right?"*

Jenny doesn't answer. She keeps still, serious, almost afraid, though not of Sam but of what Ana calls Jenny's newfound weapon. It's just like with the psychiatrists, Ana tells me; if over the course of thirty years they ever did deign to look at her, it was only to practice their wit on her, to mock, to say something devastating about her dreams. She grabs me by the neck: *"Don't ever let no one practice with you, no way."*

The new patient, a plump, chubby little man, paces around Ana. He is neither angry nor sad. He rummages in his pockets constantly. Finding nothing, he twists his mouth and begins to blink unhappily. He seems to be thankful that no one has come to send him away or put him to bed. Ana stands quietly, gazing dreamily at the walls. Sometimes she cares about what's going on around her; other times, when she is completely absorbed in something, she doesn't care at all.

Another afternoon with Ana. She is showing me some faded Polaroids from her wedding. She wears white. Ana Mani of the clever sparkling eyes, of the pointed chin which stands as an exclamation mark for each of her words. She looked thin and almost innocent back then. She married a cold man. He was special, talented, and could make people laugh. But he made love to her with his eyes closed, all the time. And afterward would roll stiffly over to his side of the bed, and fall asleep. He was a cold man to her at

*the beginning. Now he is just her husband. She stares out the window.*

*"It's nice to be inside."*

*This is one of Ana Mani's favorite sayings. To be inside. She insists that every known physical pain is bearable if one knows beforehand exactly what is going to happen to one. Only the unknown, that which gives one no chance to foresee one's reactions, is bad. This is how she can bear living: knowing that every other month she can come to the psychiatric unit. Outside is the unknown.*

*Noah's ark: Proust said of Noah that probably he never saw the world so clearly as from inside the ark, though it was closed and there was darkness on the earth.*

Grandmother takes me to her apartment in Trujillo Alto for the first time. She walks in front of me, a little stooped, and I realized that the years have left their mark. She must know it too; this old woman with mistrustful eyes, carrying a bundle of keys in her hand, still walks like a prisoner. For me there's also the strength: the woman in the picture in the *New York Times,* a policeman on either side of her and she with her fists clenched.

In the other picture, the one taken in her cell, she's a touch fat, surrounded by irises and crucifixes.

"That's where I received the divine messages."

The nationalist movement has rented an apartment for her on the outskirts of the metropolitan area. Three rooms, a hallway, and, at the end, the bedroom with the double bed in the center. Near the door is the dressing table with the mirror.

Cosmetic cases with the same perfumes that Mama used. In the living room is the piano they gave her not long ago.

"Do you play?"

"A little. I learned on my own, you know."

It's the first time we're going to have a talk, but before that she decides to do her lips, and I notice that just like Mama she also touches up her mole. It's been almost six years since I saw that particular gesture. It was part of Mama's ritual in the bathroom at Palmas Altas. As a child I'd practiced it many times, but without much luck. There are some things that aren't inherited.

She is making up. The woman is suddenly changing now. She leaves behind the aura that envelops her and she's somebody else. She smiles with a touch of youth on her lips, she hunches her shoulders and calls me "my child." She realizes how hard it is for me to call her "Grandmother."

"You can call me Lolita."

I hesitate, close my eyes and open them again, and once more she's the mysterious woman in the mirror, the prisoner back from jail. We talk and I casually bring up Mama's name. She resists the subject. If I force her, she calls Mama "Tatita"; she's never her daughter, and she never refers to her by name. Going over this and other conversations, I live through it as if it were a work of fiction in which three generations of women are talking to each other from a distance, smiling at each other with the morbid smile of the Sirens.

I timidly ask her about the "visions." Lolita reviews the origins and the nature of those mystical experiences. It seems that they began as soon as she entered the prison at Alderson, when a policeman informed her that according to the

papers her son Félix had drowned in Puerto Rico. It must
have been the fall of 1954; lying on a stretcher in the prison's
medical unit she felt a progressive paralysis of her body and
she thought it was death, that she was slowly dying. She felt
that she, Lolita, no longer inhabited her body. She'd been
separated from it and, even though it seemed unusual, while
she was floating above herself, doubled up, she saw and
heard and, of course, understood what was going on around
her, but it was happening to the other woman. When she
began to despair, she saw Jesus, crowned with thorns, mak-
ing his way through the darkness. Jesus was coming toward
her, he took her in his arms, and from that moment on she
learned that the precious truth he was revealing to her was
giving her back her body. She went back to being what she'd
been before. Lolita.

From that day on the messages began to arrive.

I listen to her and I'm not startled at what she says, maybe
because more urgent than the story she tells is the touching con-
viction with which she tells it. She protests, passionately de-
fending the rationality of what's happening to her, and I feel
that I'm witnessing something that can't be repeated in my fam-
ily, or in my culture, and I'm seized with an urgency to preserve
that instant, to assume a responsibility I've never felt before.
She is going on sixty-five, and until this moment I have never
thought much of people's ages, their time. Maybe that is why I
keep trying to go back to the subject of Mama, even if it isn't
pertinent.

"Tell me, Lolita, what was she like as a child?"

"Who?"

"But I just *told* you. Mama."

"Oh, Tatita . . ."

And she changes the subject—now it's the question of Agent Orange, and now it's the destruction of the environment.

On one occasion, when she was praying before her altar, a rain of red roses began to fall from heaven, covering her hair and lips. The petals began to smother her and there was so much ecstasy for her in that moment that all she could feel was the roses, and when she tried to find a pencil and a notebook in which to write down what was happening, her feet refused to obey. She didn't know what the meaning of that experience was, or whether it was hers alone or something universal. Then she decided that she couldn't decide and that her only recourse was silence. Going into the "wilderness" for forty days.

⟶ While she was in prison, one Saturday at dusk the sky turned gray (that must have been the way dusk looked to Moses on Mount Sinai), and suddenly Lolita heard a voice that told her: "Because of the spiritual impoverishment of the earth, many shall succumb." She remained silent, clutching herself with her arms so as not to feel so alone before that voice, and to give her the courage needed to turn to her notebook and write down what she was hearing. The day before, as on every Friday, she'd fasted. In order to prove to herself that she wasn't crazy, she told herself it was her own voice that she'd heard. But even so, she could hear it on all sides. In order to fulfill what seemed to be a mission, starting at midnight on that prophetic Saturday, Lolita closed herself up even more in her cell. She frantically drew up a formal document—complete with names, dates, and places—in which she discussed the destiny of the people of the nuclear age. The Lolita of that document "A Message from God

in the Atomic Age" is no longer the woman who in March of 1954 had climbed the steps of the Congress of the United States with a gun in her purse.

With the same rigor and precision with which she describes her visions, she talks to me now about the problems of Puerto Rico and the world. The chemical-pollution horrors brought on by the tax exemption for American industries on the island are followed by the proposal to construct nuclear plants to generate electricity in areas of great human and environmental vulnerability, like the coastal towns of Manatí and Salinas, to which must be added the U.S. Navy's tests on the islands of Vieques and Culebra, their use of Agent Orange, which is contaminating the streams of the great forest reserve of El Yunque, the disastrous consequences of the petrochemical complex at Guayanilla, the workers poisoned (by mercury) at Beckton Dickinson, the workers poisoned at Puerto Rican Cement. And so on . . .

A part of the "Message from God in the Atomic Age" was sent to President Eisenhower of the United States of America. After a few days two women came to get her. When she saw them coming she knew from experience that this visit wouldn't lead to anything good. The last time it had been to shut her up in solitary for two weeks. And they never gave her any explanation. "It's orders from above, that's all." Every time they came they said the same thing. Maybe that was why Lolita received the two women as she always did and it didn't seem abnormal to her for them to order her to get her belongings together, thinking that they must be transferring her to another cell. But they let her ask questions and she discovered they were taking her far away. Where to? "To a place where they're going to cure you, Lolita," one of the women told her sarcastically. At dusk, in the middle of four men, two policemen and two orderlies, they

would put her, handcuffed, into a van and transport her to an-
other city, to a building complex with the name of St. Elizabeth's
Hospital. She remembered her document and understood. She
felt herself getting nauseous.

What followed was unforgettable for her, and she still
remembers it with indignation. Orderlies and guards dragged
her into a room, shoved her onto a platform in the center, and
seated her on a chair. All around her were people sitting in easy
chairs, as if in a theater. They stood up in a threatening way.
Were they going to burn her?

"Well, it was a circus, and it was my job to amuse them."

The faces of those men, the inquisitorial aspect that
seemed to be lurking behind their white aprons and thick file
folders, the words they used. The English language had never
seemed so overwhelming to her.

"Let's start at the beginning. Why are you in prison, Lolita
Lebrón?"

Lolita sees herself at the defendant's bench again and talks
about her ideals, about Puerto Rican independence.

"Are you a communist?"

"I have a divine mission," she answers with poetic
phrases, the only way she can describe what she feels. She talks
about politics and poetry and her writings.

They accuse her of putting on an act. The language of her
"Message from God in the Atomic Age" is curiously similar to
that of Saint Paul.

"It's the same old accusation, my child, did you know that?"

And then Lolita answers them, in great indignation:

"I do not write like Saint Paul, if that's what worries you.
I write like Moses."

In April of 1945 Ezra Pound is formally accused of treason because of his Fascist broadcasts over Italian radio during World War II. At the request of the defense, the federal court declares him "mentally incapacitated." According to Dr. Winfred Overholser, who headed the group of doctors who interviewed him, Pound was suffering from delusions of grandeur that had caused serious attacks of "paranoia." Pound had told them that he didn't feel the least bit like a criminal. Quite the contrary. He said he'd just finished his translation of Confucius, which would be the greatest contribution ever made to literature, and that alone made him deserving of the respect and honors of the world and, of course, his fellow citizens.

Pound spent thirteen years in a psychiatric hospital. In 1957, Lolita was transferred to St. Elizabeth's. Pound was there. Both had been enemies of American policies, Pound on the right and Lolita on the left. Now they were living under the same roof, and although there are no ideological barriers in a psychiatric hospital, they never got to meet. They had nothing in common. Perhaps poetry, but that was not enough to bring them together.

Lolita smiles. They mistreated her at St. Elizabeth's, of course, and to prove it she has the scars from the "electric torture," as she calls it. During the nine months they had her there they tried to convince her by every means possible that she was crazy, while she fought continually against really going mad.

"They were the months of a hard test, my child."

Sitting by the piano, she talks, and her tone is that of a woman who has lived locked up, in solitude, for a long time. It's the feeling I get from the pictures in the papers. Especially the

ones with her at the defendant's bench. She's thirty-five years old and she's about to be sentenced, and she's awaiting it as if she already knew what was going to happen, as if it had already happened.

NYACK, NEW YORK, 1991. Conrad Lynn: "Lolita was aware of everything that was going on at her trial. Someone suggested an insanity plea, but she refused categorically and even asked me never to make use of that argument. I told her, You know, Lolita, that pistol you took out in the halls of Congress—I can't remember now whether it was a Luger or what—but when you squeezed the trigger, the pistol gave a leap and the shots hit the ceiling, so it could be said that for all intents and purposes you didn't shoot anybody. But she refused to listen to it. I don't want you to use that argument, she said. Her act of protest had consisted in shooting at the Congressmen, not at the ceiling. It was unimaginable that she would let me use insanity . . . The only thing I could say was that what she did was an act of protest against the occupation of Puerto Rico, and that it was a statement in favor of the freedom of her country." (Besides, there was her letter, which she had in her purse: "I take full responsibility . . .")

⟶ Mama is seventeen, she's had her first child, Fonsito, and she's already pregnant with another. It was hard for her to make the trip to visit her mother, and Papa goes with her. They waste a whole morning driving around Washington because nobody can tell them where St. Elizabeth's Hospital is. They finally find it, but inside she is required to show her birth certificate and explain that she's come from Puerto Rico to see her mother. They have to follow a nurse down a corridor lined with countless

doors until they reach a large parlor full of people walking nervously back and forth. Mama starts searching among the women in the room, asks Papa to help her, but the nurse tells them, no, over here . . .

And there she was, sitting on one of the benches, her hair undone, with glassy eyes. She watched them approach without any reaction.

She had a moment of doubt. Then suddenly she leaped up, her arms open.

"Look, just look where they've put me."

Lolita talked on without stopping. She told how they were trying to drive her crazy but hadn't succeeded. They were making her hear "electronic voices," injecting her, experimenting with her, and she repeated this several times during the short visit. Mama listened to her in silence. Maybe she was comparing the image before her with the ones she carried inside, the ones she'd been imagining all her life.

What this encounter meant for Lolita she doesn't say, and I can only imagine. Ever since her arrival at the mental hospital she had fought for her sanity. She would one day tell me how she had waited that morning, pacing furiously up and down the halls, angry at having to see her daughter—no longer an eight-year-old but a woman—in those circumstances. Jail was no problem, but the insane asylum? No way, no way they were going to succeed, and she repeated this to those who came to visit—Gloria, Luis, Aurea. And to herself, aloud, sometimes stopping abruptly to touch the area of her right temple where a childhood scar extends deep into the corner of her eye, just to sigh with relief and resume pacing again.

For Mama, everything must have been different from what she had anticipated. She had spent the previous nights

making up her script, telling herself in the mirror how to look, what to think, what to say. The most simple thing, to take her mother by the hand, to kiss her, and to say, "How are you, Mother?" must have seemed pure deception. But she kept rehearsing every act and movement that might be required of her on the day of the meeting. Telling herself not to cry, to ease Mother's pain. She repeated this to Papa over and over again, and during the trip to Washington. "The main thing is to kiss her and say nothing that might increase her pain. Remember, first we must ease her pain, right?" She had kept on practicing, and that, Papa tells me, is how they got lost in Washington, D.C. Only then did she shut up.

Upon seeing her daughter, Lolita jumped to her feet looking deathly pale, for she was desperate to expose to her daughter how they were trying to convince her that she was hallucinating. "But don't worry, my precious child, because Lolita knows better." And then, Papa tells me, rather sadly, that Mama raised her hand to touch her mother's facial scar, which she thought must surely have come from some sort of jail beatings, and said these simple words: "Aunt Aurea tells me to kiss you." And they kissed silently. Lolita kissed her daughter's hands, and the daughter kissed her mother's scar. It was strange and absurd. Before my mother stood a woman, strong and distant, whom she was seeing now only for the second time in her life—the first time when she was eight, and now she was seventeen—and what she felt at that moment I can only imagine, the stupid, immense pain.

When they said good-bye, Mama took a silver ring out of her purse and gave it to her. Lolita took the hand with the ring and kissed it many times. Then something made them laugh; they laughed loud and long, and Papa says the laughter was

contagious, that it even overcame the people in the parlor and everybody began to laugh, more and more, until it seemed that St. Elizabeth's and all of Washington became a deafening chorus. And then they went away, powerless probably to blend in a feeling of rebellion and absurdity. And to offset with it the pain and the guilt Mama wept, and the farther they drove the more bitterly she wept. Papa attempted once again to calm her down, and chose to turn on the radio. And that was it, he would later say to me, because the sight of one's mother in a madhouse, my child, is not very pleasant . . .

As for myself, it's still guesswork. The first time I saw Lolita was on the day of my mother's funeral. She had grabbed me and sat me on her lap, all the while wrapping me in a Puerto Rican flag. She had pulled me to her without introduction, nor was she looking at me, and sometime later she turned my head toward her and looked directly into my eyes. Then she passed me on to the lap of another, an aunt of mine perhaps, and went on counting, her eyes closed, the beads of her rosary. In that moment, I was certain, though without knowing why, that something had been sucked right out of my body, out of my bones. And now I realize that whatever it was, it had to do with her glance, with the way she looked at something, that no matter how briefly she looked at something, it was an unrelenting, direct look. The thing her gaze fell on, if only for a moment, was forced to give up to her a part of itself and become something else.

So there we are. I listen to the story of Mother's grief as if there is still some new discovery about myself to be made—as if I, and not Father, should have been sitting next to Mother in the car that's speeding back to New York, retracing with her the steps to St. Elizabeth's, sharing her cold tears, a sadness that

unfolds within a tradition of women's loneliness in which Mama found very little that could warm her heart.

⟜ The literature teacher at The Immaculate assigns us to do a mock "news interview" on *Don Quixote*. I proposed it to Lolita and she agreed to be interviewed on tape.

In the classroom, beneath the stern glare of Mr. Maldonado, I turn on the tape recorder. I am listening to the tape for the first time myself. Suddenly I remember the boy with the stone and I am afraid of what might be said in that interview. Lolita was improvising. At first it was a story, though sometimes it seemed more like a doctrinaire discourse. Specific episodes and scenes have faded from my memory, but I still have intact the general feeling and the effect it had on me then. It was her voice on the tape, but it was also that of Cervantes's man on horseback. They were traveling together, and the words that were repeated most often were "imagination" and "freedom." The story of the man on horseback kept changing tone. Sometimes the voice was messianic, at other times the words grew close to being scientific, and at others it made one think of some mystical poem of the Spanish Golden Age. Lolita was speaking from her visionary imagination and the battle with the windmills was no longer the traditional delirium of a wise madman but the struggle of a person intent on an amorous quest. "Everything in you has gone aground," goes a line from Neruda. That's what love must have been for my grandmother. She was talking about cosmic Quixotes who traveled through the galaxies, and I recognized the words of the "Message from God in the Atomic Age." When the tape was over, a lot of us had eyes full of tears, even Mr. Maldonado.

Today, when I hear mention of the "prophetic voices," I

don't feel anything strange in it. Nor am I bothered by the diagnosis of what for her was the most real and bearable thing of her life as a prisoner. But I do understand what a lot of people will feel about that side of her personality, seemingly so at odds with her political militancy. Ever since she got out of jail some of her friends wonder what's going on with Lolita: at one moment, a leftist speech; at the next, a crown of thorns. She puts them off with gestures of arrogance. "They are living in the past." And she doesn't care if they go around saying that she talks to herself. She's used to it.

Others, who admired her once and still love her, feel obliged to accept her with a paternal attitude. "Are you feeling any better, Lolita?" Fidel asks her in Havana.

Or they'll say that it's fine in a García Márquez novel, but not in Lolita the revolutionary.

Or they simply treat her like a madwoman and do what the doctor-jailers of St. Elizabeth's Hospital did—devour her.

A few days before my trip to Syracuse, Papa had bought a house on the outskirts of Barceloneta, and while the bank arrangements were going on, we went to live at the home of one of his wife's relatives. I insisted on going back to the house in Palmas Altas, which was still there, half-abandoned, although I would have to share it with my brother Miguel, who came and went according to the drugs that put him periodically in jail. Since it was only a matter of three days, Papa agreed. The first night I couldn't sleep. In the morning I went all through the house and the grounds. It was indeed a house in ruins. The gate on the fence was twisted and wouldn't close—it had been left open for quite some time. The balconies were deep in dust, and dust blew softly from the long cobwebs that caught and held

everything the wind had abandoned. The gardens were full of weeds. The rose apple tree was no longer there and in its place was a broad stump. Inside, spread out on the floor, were the things I would take to Syracuse. I'd put them there myself, next to the suitcase I planned to pack the last night. I got inside it and, curling up like a snail, I tried to see if I could close it. Papa came to get me several times, but I didn't want to go to Barceloneta with him. I was saying good-bye, and even though I didn't know what it was that had brought me to that house, it was asking me to stay a little longer. I was the last of its women and, before leaving, I should engrave in my memory the doors, the cracks, the balconies, the palm trees, the cobwebs that had made me suffer so much, and also that odd mural in what was once my parents' bedroom. A rainbow of colors sprouting from some faded blue sea crests and, between the crests and the rainbow, Mama and Papa, and in the bottom right corner, brother Cheito's signature and the date, 1976.

I could see it all from where I stood. The little girl was afraid of spiders, and also of the centipedes and lizards that crept around her bed at night. The father watched her sleep and damned the girl's mother for having died, though he suspected it was he who had left and that the one standing at the foot of the bed was just another crack in the house, from which weeds patiently grew. The girl in turn dreamt of guava trees, which in her imagination grew so high that they broke through the ceilings. She didn't need to walk anymore or think about lightness or weight, nor did she need to reconcile them. "That's it!" she said to a face in the mirror that was her own face. She would simply swing herself from one tree to another across the rooms and hallways. This had been her greatest fantasy: to live swinging from tree to tree and walk without leaving tracks. Her

mother had let her climb every tree, and at times they had done it together. For this more than anything else, the girl missed her. What she did not miss were the suitcases suddenly materializing out of nowhere, the trips taken for no reason: "Hurry up! Let's go!" Hanging from a branch, the girl peeks down on the stray dogs in the canefields. She sees herself among them, truly one of them, and together they roam the fields. She scratches her skin, because stray dogs itch a lot. She is thinking about things like that when her mother's voice comes from the house: "Hurry up, Irene!" The girl runs to her mother, since with time she has come, by force of love and fear, to understand what the voice more than the words is saying.

⟶ The last night, while I was packing my bag, my brother Miguel appeared. He sat down on the couch and described his new plan for a fresh start to me. "Beginning tomorrow . . ." I listened to him as I filled the suitcase with old things. For some reason, everything seemed old to me, even if I'd bought it the day before, and I was wishing I could have been in Syracuse immediately, in a classroom, forgetting about the suitcase. And perhaps I also wanted to forget my family, my brother.

My brother Miguel . . . he grew up in the arms of his paternal grandparents. By the time he turned five, and as his grandfather lay gravely ill of asthma, he became convinced within his heart that he did not belong there but somewhere else. Grandmother Irene turned all her attention to the little boy's isolation and tried to fill it up with her own. Through her he knew of his parents and two brothers and of that coldest of places where they had all gone, unable to take him along because he was so small and the cold could freeze him to death.

One day he told his friends that his papa and mama were

coming to fetch him. The first thing Mama noticed about him, says Grandmother Irene, was that he would never turn his eyes from hers, but would look straight into them. Back in their own house, he followed her as he had followed his grandmother, out of love, but later, as his brothers practiced their wit and brute force on him, out of fear. Then his mother disappeared, and when she came back she was holding a baby girl. They all said I looked just like Miguel, brown and hairy. But for him I was probably out of another world, a dark and threatening world that he hid from. He gradually retired into a hermitage of sorts, as far as he could from his brothers and sister. Only our mother brought him into the family; she was the center of gravity of his being, and though she seldom looked at him, he believed she loved him more than the others, in a special way, and this comforted him. But now I wonder if what he thought special was really a woman's fear at the rapture of recognition he symbolized. She had left him behind when he was a baby, after that trip to Santo Domingo. He had been the price of his parents' new beginning. To her surprise, she must have realized that this child was as lonely in life as herself. (Years later it will still be the same, but to my surprise instead of hers.)

I finished filling the suitcase. It was a whole world, a coffer full of clothing and shoes, so full that in order to close it we had to lie down on top of it, Miguel and I, I on top of Miguel, and I can still remember that I had to close my eyes because the suitcase wouldn't close and a painful feeling ran over my flesh, and I felt a lack of air. My poor brother Miguel. He was eight years older than I. I barely knew him, we'd never spent time together. Miguel was never home, and now that I was going away I found him for the first time. Here he was, close by, very close, on top

of a suitcase. With the exception of Lassie, the rest of my family and the landscape of my childhood would be a complete loss.

Or maybe not. In a sense Palmas Altas and Miguel remain a bridge between my family and me. A hesitant landscape, a place I revisit from time to time. The lasting feature of my true makeup.

*As I leave therapy, Dr. O. asks me to wait. A tall man with glasses appears, asks me if I would answer a questionnaire.*

*"I have to warn you that she reads Melanie Klein and Donald Winnicott," Dr. O. says.*

*The man looks at me and smiles. The idea of an interrogation, even if he called it a questionnaire, seemed like a challenge to me. So I followed the man to the second floor. I went along, wondering. Maybe I was already sorry I'd said yes. Scenes from a psychology manual were passing before my eyes. He pushed open some doors and we went into an examination room that seemed somehow too small to me, just a cubicle with a table and two chairs. From his briefcase the man took out some cards with sketches on them. A test. The first one was an open field with a sun sinking into the horizon. What did I think about when I saw the*

*sketch? Hell, I know quite well what he expects from me and I'm ready to help him. I see myself inventing a diagnosis of my soul for him, as if it were a matter of literary composition. Delirious, persecutory, chaotic. Suddenly my moral sense rises up in opposition to my outburst and I punish myself by saying it was all a farce and I leave.*

*All I can do is look forward to my final departure from the hospital. In group session yesterday I talked about my paper on the writer Jorge Luis Borges. Ana Mani seemed preoccupied. No one knew who Borges was, but since it was Syracuse University, the others listened attentively. Then I talked a little about the paper I'd written for my religion course the semester before and how happy it had made me feel because I had succeeded in doing what I hadn't been able to do for too long: finish an assignment and on top of that, to get an A from the professor.*

*Another pass. Professor T., the one who counted dead Mexicans, needed to see me. I don't know where I got the strength to tell him the truth. Before going to his office I spent a whole hour wandering about the neighborhood where the university buildings border University Hospital—College Town. To lie. To tell the truth . . . But I didn't even know what the truth was. I thought that the cleaning people had thrown out the files of the dead people I'd been counting for him and I'd told him that, but all the mini-lies were hiding in that half-truth. Afterward, in his office, the professor sketched out the negative consequences if those files didn't reappear soon. I was on the point of giving up and then it occurred to me to promise him some colonial census documents from San Juan, Puerto Rico. He calmed down. Seeing him content with the possibility of some dead Puerto Ricans, I thought how easy it had been to get out of that bind. To tell the truth, I didn't have the slightest idea whether or not any such census existed, but I*

*promised it all the same. Later on I cursed myself for not having
told the truth—what I thought of him and his dead people.*

*There is a group of midget students on campus, a pair of lit-
tle twin girls who dress alike and a boy who almost walks with his
head. I can see them from the window of the dining room in the
Student Center; they are going down the hill by the Hall of Lan-
guages, with their backpacks, and I have to fight hard not to run
away, the same as when I pass a girl in uniform on campus, or a
dog or a bird or a flower or the belly of a pregnant woman. Or
maybe I'll write another index card:*

*What should I do?*

*Whisper, "Not yet . . ." as she glides out of your bed and
you lie there on your belly between the sheets because the
beginning of another day—that is your secret pact with
her—is unbearable when you are on your back. Make a
list of all the lovers you've ever had. The names are but a
long, tired silence. Lists? Too many lists. A senseless com-
pulsion I've grown into. Turn on your side, toward the
wall, so you don't have to watch the door close after her,
who still wants to believe in that list: "Do Today." You
hear the footsteps loud, then fading down the staircase,
then nothing, your face now blending with those of stu-
dents and professors, a nameless person with a list written
in the face. In bed she will wonder who you are.*

⟶ *"Did you wake up nauseous today?"*

*Yes. The only thing that gives me any relief is peanut but-
ter. When I wake up and before I open my eyes I feel for the jar
between the sheets and taste it with my forefinger in my mouth*

until I bury the revulsion of the morning. Maybe time is passing too fast. Then, when I get to Dr. O.'s office, she too asks me with a placid look if I woke up with nausea today. As if it were the most emotionally moving thing in the world.

"I told Miss Boyd to give you vitamins."

I should tell her what I'm really thinking about this pregnancy, but if she thinks I need six months in the hospital, to solve my problems with another abortion could mean twelve . . .

"Do you remember that psychological evaluation that bothered you so much? The results have come in."

Dr. O. smiles again as she repeats the diagnosis of the doctors on that afternoon—"acutely psychotic individual"—and also the prognosis—"could benefit from long-term hospital stay . . ." She smiles because she doesn't believe the results and I give a swallow of relief. Six months seemed reasonable to her. Long-term is something else.

"Why do you think you are not ready to have a child?"

I'd like to believe her, believe in the solution she's offering me. She opens a desk drawer and takes out a picture. "Tell me, don't you think you'd be capable of loving this child if it were yours? If you held it in your arms?"

She shows me a chubby little girl dressed in yellow lace who's smiling and holding out her arms as if inviting someone to pick her up. Dr. O. continues looking insistently at me, and her smile meets the one in the picture and it's the same infantile smile and it frightens me.

Dr. O. looks at her watch. Our thirty minutes are up. We'll get together tomorrow, at the same time.

Before leaving the office, I casually ask if the girl in the photo is her daughter. I know she isn't married, but I want to hear her say it.

"Yes," she answers in a challenging voice. I close the door behind me. I am worn out. What was the aim of that conversation? All I could do was go over the scene, repeat Dr. O.'s facial expressions, and other expressions: my mother's facing the mirror, for example, and my grandmother's facing history. The women in my life. It wasn't hard to believe that behind that door, sitting in a chair with a photo in its hand, the monster with the thousand heads was still sitting, like my other monsters, wanting to re-create itself, to offer me its same burden.

⎯ Ever since they told him that his parents were coming to visit him, Sam has decided to remain silent. He wants to sew up his mouth. Today he came over to the table when we were having lunch with Ana Mani and said he needed needles and thread. He's playing the loony, Ana Mani says, so he won't have to study. She, on the other hand, is getting better every day. And even though she still chases people with her hairbrush, she is also the one who patches up our differences. She may be sick, she says, but she never really wanted to die. Anyone who really wants to die, does it. Sam's always talking about killing or being killed. He asks the nurses to give him electroshock, to sew up his mouth. Ana Mani doesn't consider that being sick. That's being irresponsible. And me, what did Ana Mani think of me? All she told me is that compared to her I'm lucky. She carries the burden of that chemical malfunction.

⎯ Let's go to the sauna. Ana Mani takes me by the arm. The others stay by the pool, close to Miss Boyd, who's taken us all to the gym. I don't think they've given us permission to go into the sauna. She says that she is too fat, that soon she'll be leaving and her husband will have a fit if he sees her like that. All these rolls

*of flesh, Lord! You're not so fat, I tell her, but she gives me a shove and I don't know how, but I go into the sauna for the first time. In half an hour I'll be rid of this lard, you'll see. She takes off her blouse, her bathing suit, and her panties, walks naked over to one of the corners of the sauna and starts poking at the coals or whatever they are. The temperature keeps rising and I can hardly breathe. Tell me, Irene—you never told me—what brought you to 4B? In half an hour I'll get rid of these rolls. Now tell me, why can't I understand Sam, what's all that about wanting to die? Sometimes when I'm down I hate life, but I've never wanted to die, not like that, not like you people. Tell me. Oh, if there's a knock on the door, don't open it. We left. We're not here. Okay? Now, tell me. But Ana, they are going to worry about us. So what? It's only for half an hour, let them wait. And she lies down on one of the benches, crossing her hands over her belly like one of the women in Boccaccio's* Decameron.

**ON LANGUAGE AND POLITICS.** Professor
S. had just arrived from Paris and rumor
had it that he was hard and spoke the new language of the French
theorists, an anomaly in the Department of Political Science. On
the first day of class, he said he wasn't going to do much talking.
From the head of the conference table he led the discussion:
Barthes, Kristeva, Nabokov, language, politics, the body, illness,
Susan Sontag . . . I think that around that time in Kittredge Au-
ditorium they were showing the French film *Bette Blue*. This
Bette Blue, who made you think of the *poètes maudites,* was an
unpredictable Frenchwoman with black hair and beautiful blue
eyes, who for some reason we never completely understand (*was
there one?*) plucks out her eyes one day in front of a mirror, just
like Oedipus. Bette Blue ends up in a sanitarium with empty eye

sockets, and beside her bed a sad lover weeps for her, or maybe he goes crazy over her. In the final scene, the lover is in the kitchen writing and a white cat walks across the paper. A very proper death. Death had ceased to be a biological act. Before it had been shit, sweat, and snot; now it's a cat on a blank page.

### RANDOM NOTES

At first it was considered something horrible, out of fear of sudden death (animated phantoms). Then the classics would turn it into reasoned sophistication, an act of individual freedom. Although antisuicidal ideas existed with Plutarch, Aristotle, and the Neo-Platonists, they didn't have as much influence on Christian converts as Plato, for whom suicide was an act of abandonment/treason toward the supreme being. But Saint Paul (I Cor. 13:3), speaking of voluntary martyrdom, says that self-destruction is acceptable and honorable for its eloquence. (Ivan sees a contradiction in the fact that my grandmother calls herself a Christian and tried to kill, or kill herself. Maybe, I say, thinking about the notes, she probably felt horror for the earthly world but believed in salvation through faith, and he puts his arm around my waist, strokes me, bites my lips with his, which smell of toothpaste, shaving cream, the earthly world of college. I don't know why, but talking about my grandmother with Ivan is a double-edged sword.)

*In* New Guinea the public executioner would keep the jawbone of the executed, in that way rendering it impossible for the dead man to come back and

reproach him. *In* Australia the aborigines would cut
off their enemies' thumbs so they couldn't throw a
spear at them from death. *In* Athens they would cut off
the hand of suicides, a one-handed ghost was less
harmful. *On* the island of Cos not only did they expel
from the borders of the country the body of a man
who'd hanged himself, but along with the remains
went the tree and the noose. *In* Victorian England they
would drive a stake through the heart and bury them
at a crossroads so they couldn't make their way back.

*Suicide à la Poe:* In the nineteenth century an unfor-
tunate French lover puts together the most atrocious
vengeance. Before killing himself he orders his ser-
vant to make a candle from the fat of his body and
take it to his loved one, lighted, along with a letter in
which he tells her that just as he had burned for her
in life, so has he in death. The proof was in the light
by which she was reading his letter.

In April, I moved in with Isabel, a friend of Ivan's, in an
apartment in Vincent House. It was while living in this new
place that I began to think that maybe Ivan didn't want to be
with me anymore. If Gladys or some other friend came by and
said they'd seen him "over there," I knew they were referring
to the blonde who modeled hats for magazines; and if they said
they saw them necking in a car, I'd start to cry, because, besides
everything else, it was my car and Ivan had borrowed it that
week to run some sort of errands. When Ivan finally called me
to say that in the future I should phone him and let him know
any time I was coming by—"You know, I'm the coordinator of

the student hall and I've got to protect my image"—I reacted as if I'd been stabbed in the back. We fought on the phone. And we made up on the phone too. After three or four quarrels like that Ivan was able to say whatever he wanted, because I could see him going away, with the typical subterfuge of someone who can't bring himself to tell the truth. I can't remember why it was the last fight, but I do know that it was quite painful and from then on, I began to avoid the telephone.

One early morning Ivan appeared without warning, came into my room, and when he turned on the light he saw me in bed with Tom. He came knowing what he was going to find. My roommate had told him. She'd told him that we'd spent the night drinking with friends and finally they'd all left except Tom. What could I expect? What could I add? He took me by the arm and we went out into the hall. We talked, shouted, full of rage and humiliation, and then he brought up my past, everything that, according to him, was rotten in my family, my grandmother, my uncles, my brothers. It was all shit. Even in his small humiliation, Ivan had finally found what he needed, a pretext to leave me and make me carry all the blame, since that was my fate, the one he'd wanted to save me from, and he never wanted to see me again . . . Blacklisted by repetitions.

In May, with the last money I had left, I rented a little place on East Genesee. The landlord, a fat man who ran out of breath when he spoke, said that since I would be the only tenant, he was prepared to lower the rent to three hundred fifty dollars, plus . . . The small three-room apartment was in the attic of a rather rundown house, one of those Victorian houses

so common in Syracuse. Painted an algae green on the outside, and set in the middle of a concrete square that served as a parking area, it looked like something from another world. Just as Irving Street is the frontier between reason and madness, with Syracuse University to the east and Hutchings Psychiatric Hospital to the west, so East Genesee Street is at the borderline of abandonment, the real face of the ghetto. The air is thick there, it doesn't have that little smell of freshly cut grass that abounds in DeWitt, the suburbs. If the air of Syracuse smells of fried food, from East Genesee Street on it smells of garbage and cat piss (especially on the corner of Beech Street).

Where would I get the strength to go on? All I had left of my stay in Spain and at Boynton School were childhood scenes, the little aberrations of an adolescent without too much conflict. Now the past was fast becoming something inseparable from the present, it was guiding my stories of love and my school papers. In Language and Politics we read Nabokov's *Lolita,* on which I should have been able to write a pretty interesting essay, and yet I handed in a few miserable pages that didn't say much of anything.

Every morning the same route uphill to the Quad. On the third floor of Crouse, trying to record dead people: counting, filing. One of those mornings, Professor T. said that a colleague of his in Mexico needed an assistant and he thought a few weeks of research in a Latin American country would look good on my record. That's the way it always is with offers, they come when you least expect them. And they almost always have to do with other people, not with you. It would enhance my record, but for that I had to want something, to live . . . and I had my

doubts. And doubts are no good when summer's approaching and everybody's going on vacation.

Mexico wasn't a parenthesis, it was a typical episode in which the most muddled obsessions are born and grow. Maybe because I was going through one of those periods in which everything was costing me great effort. Besides, I was starving. I told myself don't worry, fasting's good for you; look at the saints, remember Boynton, think about the hunger strikes, about Lolita, who fasts on Fridays. I was going to Mexico as if in a speeded-up silent movie, lowering my head as I made an effort to keep up with the others, with hesitant steps, those of a woman who hadn't finished growing up, deciding, tripping over her feet clumsily every time she had to speak lately, because she was hungry.

Lecumberri had been the worst jail not long ago, and they'd converted it into the most important archives in Mexico. Its rooms were damp. In the cafeteria I heard that the room where I worked was where they'd kept the homosexuals. Hundreds of bulbs lighted that dungeon, transformed it. But I found it hard to stay awake there. (Every day the same siesta, the same sleep, the smell of formaldehyde, shuffling papers in the dark, back and forth across the broad, cold paving stones, the man with bulging red eyes who passes, brushing my cheek with the sleeve of his jacket, a horrible itching on my face, and the microfilm spool spins around without cease.) In my drowsiness I had to keep reminding myself what I was looking for. Parochial census of deaths, 1740–1780, sex of the deceased, age, cause of death, head of the family, resident of, number of inhabitants: halfbreed, Chinese, white, etc. Indians didn't count in the census; I had to maintain a parallel count. The machine was

running, the light was blinding, my eyes were burning, and the slides were showing the symptoms of what must have been a terrible epidemic. Soon Professor T.'s colleague would be presenting her work at a conference in Cuernavaca. Something to do with epidemics during the colonial period (its demographic effects) and with infanticide.

In Mexico I spent my time digging up corpses. Enough. Perhaps going home was what I needed.

Lolita . . . Where to begin? In some corner of my bag I carry a piece of napkin with jottings of poems that I copied and sometimes recite, not without fear. Trying to drum up courage—from where, I don't know—I knock on the door. My grandmother, as on so many other occasions, appears behind the grating that reinforces the door as a second touch of security. Anyone would say that she is paranoid, as they diagnosed her at St. Elizabeth's Hospital, that she's more afraid of sneak thieves than of her political enemies. That perhaps she felt safer with the jailers who tortured her for twenty-seven years than with the sad reality of present-day Puerto Rican society.

She feels threatened; she cannot accept the fact that Puerto Rico is following the same path of violence as cities on the mainland.

Her eye appears in the peephole and the long process for opening up begins. First, the grating on the other side, then the iron bar that doubly fastens the door, then the safety chain, then the key in the reinforced door handle. Then she appears behind the heavy door. She's been filling the pockets of her smock with locks and keys. Finally the act of opening up is complete and she reaches out her hands to me.

"My darling."

I embrace her and I'm taken with the strange feeling that she's floating, that it's impossible to grasp her anywhere. I cross the threshold and it's as if I were entering a tunnel full of phantoms, suspicions, secrets that she's been guarding forever. What is Lolita guarding with such suspicion?

Not long ago I surprised myself with an incredible feeling. We were talking on the phone, and when she learned that I was coming to Puerto Rico for a brief summer visit she became quite happy, but when she offered me her home I stopped talking. I didn't know what to answer. The very thought of listening to her recite her prayers against the red glow of the sunset, of sharing nights with her, was coupled in my imagination with the women from my childhood, Mama, Blanquita, fear accompanied by shame, guilt. Fear of what? Guilt of what? I was no longer a child of fourteen, I was no longer afraid of Martians.

When I get in, I kiss my grandmother and set my bag down near the door. It's the first time I'm going to spend the night in her home. All the doors and windows have their respective grills and locks. And she moves about with her bundle of keys, sentinel of her own prison.

She's disappointed with Puerto Rico. On the street the people come up to touch her: they kiss her hand, ask for something of her as a relic. Others curse her or look at her in silence. The left doesn't understand her, or fears her (they fear the religious Lolita). The right rejects her (we already know why); the center, well, the center has no opinion. Only intellectuals and artists seek her out, some of them devouring her with their obsequious homages and diplomas.

That's her identity and her destiny. The imprisoned woman.

Lolita was never a devotee of *mea culpa*. Rather, she prefers forgetfulness or sublimation. She thinks only about God

and the independence of Puerto Rico. But it's a thought that is not without its paradoxes. She doesn't want to erase March 1, 1954; she wants to erase the horror she must have seen on the faces of the members of the U.S. Congress as, without hatred, she emptied her pistol at them. Today she denies bloodshed and violence as a political strategy. She doesn't want to remember that other face of March 1, 1954.

She prefers something else. In a drawer there's a package with yellow folders. Poems. She'll let me read them now. I reach in and, leaving it to chance, take out a piece of paper with eight lines, seven scratched out. Fear becomes mingled with wonder. I open another of those yellow folders, also leaving it to chance, and I find bits of paper with notations I can barely decipher because of the dust and the ink that has faded with time. She comes back from the bedroom to put those papers aside for a while and we walk down a long corridor that leads to the rooms where everything is pink. Curtains, tablecloths, towels, even rugs—all pink. As we pass, I look for my bag and it's not there. We go into a room and I discover my bag on the bed, empty, and my things laid out on a table, my suit hanging on a clothes rack. (It had been some time since I'd found myself in the midst of such neatness. Mama was just the same. The house always had that smell of pine-scented cleaner floating in the air. And she was accustomed to putting our clothes in the closet the same way; and in the morning when she made the beds she'd sprinkled the sheets with Nenuco cologne.)

It's five o'clock, time for prayer. We'll see each other at dinner. She kisses me on the forehead and takes her leave. A short time later, a pleading voice can be heard. I go out into the hallway and I follow that supplication up to the half-opened door of her room and spy on her. She is leaning before a blue

altar, a blue pause in the midst of so many pink things, and I discover the other face of my grandmother.

We dine. She says goodnight to me but first she entrusts me with one of her poetry folders. In 1983 she'd let me read one of her poetry chapbooks, *Beach Man*. I could barely understand the words. By chance I recall these lines: "Look for me in the deep mystery of things / in hard granite / in the stone that time's cascade rides." It was obviously a love poem. But whom did she love? Her adolescent love, the poet Matos Paoli? To whom was she writing those verses? To the fallen Griselio Torresola? The girl of fourteen didn't know where to put those words that didn't make her think of anybody. What was worse was the fact that they reminded her of her literature teacher mechanically reciting seventeenth-century Spanish poems while she fantasized about Renato, Eduardo. Who could believe in Saint Teresa in 1983? In 1987 those poems were still as abstract as when she'd read them for the first time, but as she read them she could hear Lolita's voice.

I spent the whole night wondering whether the love of a woman in jail became abstract, more of a verbal ceremony with no visible traces in reality.

It was during that last visit to Puerto Rico that Lolita appeared at Papa's place with an older man whom she called The Doctor. She sat me down beside her, took my hands, and without taking her eyes off the floor, said that The Doctor had proposed marriage. The idea of getting married didn't fill her with any great enthusiasm, but you know, my child, it's very hard to get around in this country without a car, it's impossible for me to fulfill my political mission in the solitude and isolation I'm living in. Sometimes there are Sundays when I can't get to mass

because the drivers are on strike, and I will never forget her squeezing my hand, telling me that she'd accept the proposal of marriage only if I gave her my blessing, that's the only way she'll do it, with the blessing of her only granddaughter. Yes, of course, Grandmother.

Then she asked me if I wanted to go to Caracas with her. The Venezuelan Senate had invited the Committee for the Decolonization of Puerto Rico, of which she was a member, to discuss the colonial status of the island in anticipation of hearings before the General Assembly at the United Nations. Also, the government of Venezuela was going to bestow the "national orchid," or some such flower, on her. Of course, Grandmother. Mexico, Puerto Rico, Caracas, whatever it takes to keep moving, to elude what I didn't yet know.

So now I'm Lolita's official granddaughter; at least that's how I felt flying to Venezuela. But I really don't know who I truly am. We're alike, that's certain. They said the same about Mama. It would have been interesting to put the three of us together (I/you/she) and see which one was the most beautiful (outside of time, of course, in a Chinese box). But that would have been all the more confusing. Lolita was now an icon with white hair and all during the trip I felt like an adolescent with typical adolescent problems. The morning we were leaving for Caracas I went into my grandmother's bedroom wearing a white Fruit-of-the-Loom T-shirt and she gave me a startled look. "Irene, that doesn't look right on you. Do me a favor and change." Lolita didn't know what it was to have an adolescent daughter. Luckily I'd brought some other clothes, and this time I appeared before her in black, wearing heels, and doused in some ancient perfume. "Now Lolita's granddaughter is really beautiful!"

Nearing Caracas, I must have been feeling more confident that I wouldn't upset her if I made some personal comments. Lolita was coming back from the bathroom pushing back the white lock of hair that covered her forehead and saying that she didn't know what to do with it. But it makes you pretty, Grandmother. Do you think so? Even her fiancé, The Doctor, from the seat in front turned around to say I was right. Don Sergio, for his part, was the solicitous companion, and as soon as I left he would take her hands and devour her with his eyes. Lolita pushed his hands away; she couldn't admit that she was still capable of holding hands at her age. Everything she'd had she'd given away, once and for all in the past. That wasn't my problem. I hadn't given anything away. Not yet. I would have liked to talk about that with her, but that would have required talking about other things first, love, for example, and desire, and I would have had to tell her the terrible price an adolescent girl has to pay in order to know the difference.

Through the windows the peaks of the mountains were now appearing. Latin America. I took out my compact on the pretext of fixing my lips and in the mirror I caught a glimpse of the man who was looking at me and who must have realized that I realized it. "Let me show you," Lolita says. I suspected that I must have been someone else for her too; maybe through me she was seeing her daughter—"Tatita"—and when she dressed me and put makeup on me and taught me how to be a coquette she was playing a juvenile version of herself in the mirror. I can't remember how much time we spent at that, playing with my compact mirror. The plane was descending now. State dignitaries would no doubt be there to greet her—twenty-seven years in prison were the price for such honors.

But no, it wasn't like that. Nobody came to greet her at the airport. And when the customs official asked for her passport, she gave him her birth certificate instead. He insisted on seeing a passport, but she said, Look here, officer, I am a citizen of Puerto Rico and I refuse to use an American passport. Then you can't enter the country, ma'am. It was yes and no until a man with diplomatic credentials informed the customs official that this woman was Lolita Lebrón, a Puerto Rican patriot, and that she was there as the special guest of the senate of Venezuela, which had conferred the National Orchid on her. If that's the case, there is no problem. The lady should have told me that . . .

⸺ During the daily walks from the hotel to the Atheneum in the company of Don Sergio, it was clear that she didn't want him near her when I was around. She was looking for my approval, but I always pretended to be looking at the sky, or at passing cars. I must have resented her paying so much attention to appearances. She was becoming vulnerable. Don Sergio's surreptitious hand, which in some way was trying to get close to us, was forcing her to be someone else. For her it must have been tragic, all those years of solitude had given her something of a stature, and she couldn't accept reductions. I have, in such a short time, become granddaughter, daughter, and chaperon. But who was I really? Finally, it was during our long walks through the city, to and from political meetings, that I met the man in the hand mirror. It was bound to happen.

⸺ It's our last night in Caracas. Grandmother is already asleep, and I'm in the hotel lobby, reading magazines about the Venezuelan jet set. He comes over, says that he heard us speak-

ing Spanish. His name is Esteban. Don't we know each other? We have seen each other before. Ah, yes, maybe in the hotel lobby or in . . . yes, yes, the airport. We're staying in the same hotel. What a coincidence. He had green eyes and a strange accent and said he was Chilean. What brings you to Caracas? Then I hear myself talking about the Committee for the Decolonization of Puerto Rico, and other things like that. And who was I? And who was he? He's an economist, from Harvard, and he teaches at a university in Santiago, Chile. He's overdressed. I ask him what he thinks of the Chilean sociologist Gunter Frank. Not much, he says. He's too German and too left-wing. No one dares tell him anything because his wife is Chilean too and a leftist. In Chile women on the left make too much noise organizing women. How about some wine? I don't drink, or smoke, but I say yes, perhaps to hear more about Gunter Frank's wife. As if Gunter Frank's wife suddenly meant so much to me. Well, salud!

The first kiss comes on like something inevitable, the second one not so much because I guide him with my eyes, which I'd rather have closed but I kept them open because I was embarrassed. The waiter must have been intrigued by the scene; he kept looking at us. Another drink? I had to get back, I didn't want my grandmother to worry. We left the bar, kissed again in the elevator, and he kept kissing me in the hallway and at the door to my hotel room. We scarcely spoke, but I remember that I lowered my head onto his shoulder, and then he made a move to go into my room. I think I began to laugh inside just thinking about the face Lolita would make if she woke up and saw us.

"Who is your grandmother?"

We were alone, it was two o'clock in the morning and I was

going to tell him who Grandmother was, but he tried to lift up my skirt and I was terrified that Lolita might come out. When does your plane leave? At night. (We were really leaving that same afternoon.) Well, we'll talk tomorrow, I have to go now.

I almost knocked over a chair but I managed to reach my bed in the dark. Then I heard Lolita's voice:

"What time is it?"

"Two something."

"Oh."

— I woke up alone in the room. They hadn't waited for me. Lolita and Don Sergio had gone to have breakfast by themselves. When I went down to the coffee shop, I saw them in the long line at the buffet. One time Don Sergio took her hand and they walked over to the cashier. I felt a spark of joy, or revenge. When she saw me, Lolita released his hand immediately, just as I expected. She came over, smiling, saying how pretty her granddaughter was this morning. Come on now, young lady, I'm going to teach you how to put a little color onto your mouth. I offered her my lips, pursed like a raspberry, and I think she kissed them. Then, for the first time, she mentioned Mama.

"Tatita used to come and see me in prison all fixed up, her hair nicely brushed. Her clothes always the right combination."

"What about her lashes?"

"The lashes too."

"And the wigs?"

"The wigs didn't do anything for her. I don't know why she liked them with that hair of hers. But, child, let's take a walk through the downtown, there are some very pretty churches there."

On the return flight she was reciting her rosary and fingering it, all wrapped up in herself. She had very thin lips, perhaps the narrowest I've ever seen, and wrinkled hands. The hands, someone had told me, is where old age shows itself, creeping in through the veins.

Back in Syracuse, María took me to dinner at Phoebe's. That afternoon I'd got my English composition back. Another C. I no longer knew where I was or what I was doing. I thought about Boynton, one more of so many lost things. We were eating, and as she muttered something aloud and left me alone to be hypnotized by the cold lettuce on my plate, I heard the click of the camera.

"You looked so uptight, it was unreal. It doesn't bother you, does it? You know, I still need ten more pictures of things that aren't moving. And I want them to be original—the other day more than half the class took pictures of the same garbage can, the one that's across from the library, under the No Smoking sign."

Whenever I think about María, her photographs, her camera, something about her gets mixed up with the snow in Syracuse. I would understand in time that our friendship was one between college girls in student dormitories, intense and temporary like the objects decorating our walls and dressers, one with a lot of emotions and a short life. When I got back to my room, I threw myself into bed with my clothes on and slept for a few hours, waking up in the middle of the night. In the silence, I read, and that gave me the feeling that everything was finally coming to an end. Toward dawn the devil appeared. I was naked in a room I'd never seen before, naked on the edge

of a bed—I don't know why there was always a bed in my nightmares—and two women were sleeping on that bed. I knew who they were but I didn't tell myself, and I knew that from one moment to the next the devil would arrive, as he had before in other dreams. I felt a kind of pressure, something that was flattening my body and which I was struggling to get out from under but couldn't. Right after that, a rain of skeletons and stones fell from the ceiling and threatened to destroy me. I didn't know how to escape or where, because there were no doors or windows in that room. I took refuge on the bed, flattening myself out against the sheets, but no sooner did I do that than I felt sure I wouldn't be able to escape. I felt the cold, the anguish of encirclement, and it seemed to make me recall other dreams in which I'd felt the same terror. When I uncovered my eyes, there he was, a few inches from my face, in the form of a fat old woman who was continuously changing shape, sometimes seeming to be Lolita and sometimes Grandmother Rosario. She was laughing and looking at me in a way I could never describe because of the horror it caused in me. She was pointing to her huge belly and nodding her head. "This is you! You!" I shouted no, that I wasn't inside but outside her, away from her. But she kept on pointing to her belly, and she was also pointing toward the door of the room that wasn't there, but just the same, there it was, and there was Mama, exactly as she used to be, and she was approaching with heavy steps, as if bearing the years of being dead and now suddenly pulled out of a long sleep and made to walk. In her smile she wasn't Mama, nor in the eyes either, but she was in the red lips and artificial lashes. She was approaching, hunched over, and she held out her hands. Again I shouted no, that she wasn't Mama, and that I wasn't inside that woman's belly. The devil-woman

had now pulled out a vein from the back of her arm. She was pulling it out and kept on pulling it, a red thread, still throbbing, which poured out an endless stream of blood. "This is you! You!" I said no again, I shouted no at her, I tried to wake up, but the hands of the woman just like Mama chased me and caught me and to defend myself I grabbed them. I recognized the touch. They were Mama's warm, soft hands. It had been so long since I'd felt those hands. How beautiful they felt, I said to myself, and I woke up.

⌁  The habit had started in Professor S.'s class but it would continue until almost the end of the term. At some moment in class, in the middle of a discussion, I would excuse myself to go to the bathroom. I would leave the room with my stomach twisted in a knot and an acid taste in my mouth. What had started out as a fantasy of escape, getting sick and being able to leave the class before it was over, was becoming reality, and, walking down the hall to the bathroom, I'd have to make an enormous effort not to vomit. Once inside the room I'd lie on a couch and try to get my balance back, meanwhile enjoying the persistent thought that I'd finally escaped. Lying there, I had to use up all of my resources of intelligence, bolstered by the intuition that in spite of everything I wasn't foolish or unfortunate. Irene, all you're doing is examining, analyzing yourself. Maybe you should feed that interior monologue, because that's where the cardinal points are located—but the more I listened to myself the more I lost sight of them, and the clearer and more penetrating the voice was, the less I understood what I was saying. I only had a slight inkling, that of being alone, and that I, you, she were nothing but matters of language, nothing more.

When I didn't go to class I went to the library, not so much to study as to wait for something to happen to me: I sit by the window and wait. Boots, boots go up and down the library stairs. Cowboy boots with heels or without, pointed boots with metal tips, black boots from Spiegel's, stained from the snow; I leave, and my gray boots, one by one, search out the footprints of those other boots in the snow. On Marshall Square there's a Persian rug store: huge mystery bins where you can find everything from panties stitched with hearts to silk nightgowns embroidered with flowers and cupids. After class, or when I don't feel like going to class, I stroll among the rugs and those bins; there are mirrors in the most unexpected places, on the back of a trunk cover, in corners, on top of the table with the complimentary coffee. (I never liked coffee, but as soon as I enter that store I head for the coffee, pour it slowly, and spy on myself as I take a fantastic trip through the lingerie and the rugs in the half-light of orange reflections.) At the bank, behind the glass, painted nails count the money, count it again; the nails go to the cash register and have trouble pressing the keys (the fingertips can't reach them); other women pick up the money and leave it on the white counter; they tap on the glass, impatient with the clumsiness of the one with the nails at the cash register; now all the nails come together and put the money into an envelope, I say please to the woman who's gone back to counting the money, even though I'm terribly embarrassed to do so, but I want to see the nails again, I'm sure they're Glazed Rose; they count each bill, two grasping each one on each side like tongs because the flesh of the finger can't reach it; well out of the way, they extend the money to me in the envelope and I can't help myself, I grab it, but as I do I touch them—three coats at least, maybe four. The same thing happens with gloves. On the tiles

of my apartment bathroom floor I've laid a black leather glove that I found in the snow. It still has its index finger lifted, perhaps the last gesture of the owner when he lost it. I sit on the toilet for a long time observing the finger, feeling that it's pointing at me: it's the sorriest thing I've ever seen, not because I feel threatened by objects, much less by a glove, but I throw it into the toilet and pull the chain. Every glove that passes before my eyes asks me to do the same.

—— It's painful to urinate, it's as if a snake were struggling to get out from inside. I'd got into the habit of going to the john whenever I had a chance. I'd sit down with great anticipation, waiting for the little touch of warmth I could feel, I'd urinate with that singular pleasure of warmth nothing else could give me except the little stream of hot urine coming from inside me. The afternoon when Professor S. gave me back my paper on *Lolita* (Nabokov's), I went down the stairs at Maxwell with the premonition that if I didn't get to the bathroom soon I'd piss my pants, so I ran to the bathroom in the basement, dropped my jeans, my wool stockings, my panties, then the paper on the floor, and sat down to wait while I read the professor's comments out of the corner of my eye. The F was in the center of a huge circle and everything was dominated by the F, which held back the action, like in slow motion. I couldn't continue because I was starting to feel that little warmth, the imminence of true happiness.

—— Where had I seen dying? In a book? In a dream? I listen to myself, as if I were talking to somebody else. I know it's not like that. But when you write about yourself and about suicide, you begin by saying "I" and end up in Corin Tellado's soap novels or in the romances of chivalry. It would be the

same if you wrote, for example, "*You* open your veins," "*She* sinks into the waters of the Seine": the pronoun is only there to jog a person's memory. But still, how can you ignore the fact that it's *me* that things are happening to? That *I'm* not dead? All right, then, in January of 1988 I was far from thinking anything like that. I was a student in her last year, things were not going well for me, and I was approaching that dangerous moment that Goya speaks of when reason becomes confused with dreams. Except that a part of me knew it. A part of me would go to the library, attend class, live and think like a student. The other part was slowly slipping away with nothing possible to hang on to: I was no longer the child prodigy, and sometimes I heard the mirror saying so. Nor did I feel Papa's presence. The stories of heretics and solitary beings had become a kind of guidebook. I'd changed residences three times in one year. In December I'd moved to a place with three rooms but I kept on sleeping on the mattress on the floor because I'd never opened my suitcases or fixed up the closets. Maybe I felt it wasn't my final home either. In short, it was on one of those mornings when I was sleeping on the bedroom floor that I thought I heard it raining. I couldn't see the drops, but water was sliding down the windowpanes and collecting at the joints in the windows. I knew it was going to turn to snow at any moment and I tried to get up, but I stayed there, clinging to the mattress, to the rain on the glass, to my own weariness. Then I looked at the calendar, saw the list of classes for that day, and, in the corner, in the shadows of the room, I saw the pile of books I'd organized the night before— philosophy, literature, psychology, Hinduism, my subjects for the semester—and, a little beyond, I saw Mama's picture. The day before, the landlord, who lived downstairs with his wife

and newborn daughter, had come to collect the rent, and when he came in, he saw Mama's picture and said we looked very much alike: "You've got the same eyes." It was one of her last photos, and in it Mama was smiling with resignation. I didn't know where to hang it. Maybe I didn't even want to, because, in addition, that wasn't the woman I remembered. Nor did I feel so much like her. We were quite different. In her adolescence, Mama's model had been Lolita, just as Lolita's must have been Pedro Albizu Campos, the masculine ideal. But mine, oh . . . I was a fan of the Afternoon Telemovie and my hero since childhood had been Cantinflas, because he was an orphan and in all his films he treated children nicely and was always looking for his mother. Just the opposite of what happened in many Mexican movies, in which the hero crosses the country looking for his father. Mama died when I'd just begun to read and write; there I was left with the image of Cantinflas in his baggy pants, running through the streets calling *Mamacita! Mamacita!*

A few years back, when Papa and I were flying to Syracuse for the first time, at the San Juan airport they stopped an old man who was taking the same flight. He was going to the Bronx for the first time to see his grandchildren, and there was a strange bulge in his pants. "I'm from Jayuya," he told the official who was questioning him, "and this is Bushy." Jayuya is a village in the mountains, hick country for people in the capital, and Bushy was a *juey*, no less, a species of land crab very much appreciated in Caribbean gastronomy. But the customs man didn't seem to care that the man was from Jayuya or that he was traveling to see his grandchildren in the Bronx for the first time. It was absolutely forbidden to take animals on board, he told

him. But what if I carry him right here in my pants? The official began to get annoyed: in his whole stinking life he'd never heard of anything as stupid as that. Did he have a screw loose or what? And all that at the top of his lungs. The man from Jayuya was weeping. They were still arguing when we boarded the plane and the last thing the man said before they took him away was that Bushy was his best friend and that if Bushy wasn't going, Don Tito wasn't going either.

Nobody said anything, and once the plane took off, the island of Puerto Rico was suddenly erased, as if it had never existed. The passengers were smoking, drinking, eating, talking, laughing. Only Papa and I were silent. I don't know why. I was going off to school, everything was going to be fine. I wasn't a little peasant girl, and these weren't the days of the *Marine Tiger*. But we must have suspected in some way that history was still the same: someone was leaving and someone was staying.

⟲——— Putting a bureau in order shouldn't have been too hard, especially for someone who'd spent her life unpacking suitcases and putting clothes in closets. But I sloughed it off, as they say. I talked to my classmates as if nothing had happened, as if when I said good-bye I was really going to a house just for me: a room of one's own. But first it would be necessary to take care of the disorder in the bedroom. And that wasn't so easy, because really the disorder was in me. I didn't think it was that way because I still believed in my father's "Everything is going to be all right, Irene." What do I do with my things, then? Well, hang up what you can on the racks and put the rest in the bureau. There'll be plenty of time to decide.

"Don't be such a Gypsy"—that's how the oral diary began, a kind of interior monologue out loud that I would begin

lately whenever I had to do something. Almost always with painful images. The cardboard shacks in Haiti mingled with a beach that stank of urine, just like my brothers' bathroom. "I'm not going to be a Gypsy, so everything into the bureau. You'll see how nice you'll feel with the room all in order." What more could I say? All that was left to do was open up the drawers once and for all. "Let's see if you can get a move on. Let's go, Irene. Let's go!"

But I didn't feel like it, couldn't get a move on, my only space was the kitchen and the bathroom. And since I barely ate, I spent almost the whole month of January studying at the kitchen table or in the bathtub. I was beginning to lose track of my courses. One Irene was reading philosophy and literature. The other one was looking at herself in the mirror or watching the flies go by. One landed on the mirror of the bathroom cabinet and I couldn't help following it. Since morning, for example, it had wandered all over the place until I lost sight of it, and then I decided I'd wait for it. I opened a jar of honey and left it on the table. The fly returned, ate for a very long time and then, like any other fly, tried to shake its wings and fly. But it couldn't. The honey had stuck to its legs, and it flapped its wings until it ran out of strength. Then another one arrived, and another and another, until the whole mouth of the jar was covered with flies. Then one arrived who alighted on top of one of the others . . . But I killed it with a slap. I'd had enough. A whole day of waiting to open the cabinet and take a bath, my very body becoming an obstacle; whenever I felt a conflict I would flee from my body toward a yonder in time where everything that gave me displeasure ceased. The phone rang several times, friends to see if we were going to have lunch, my brother Fonso to bawl me out

because I wasn't home like everybody else, and Papa to see how
I was. Actually I was the one who'd called him and, I don't
know why, but I chose to talk to him about Miguel. On my last
visit to Puerto Rico, at Christmas, we were in Cheito's house
and no one could tell me where my brother Miguel was. At that
moment the phone rang. It was he. He'd escaped from the re-
formatory for addicts. Could we go get him at the bus stop near
the telephone company? My brother had always been a fragile
creature, but now, in addition, he was barefoot, and so thin that
his jeans were slipping down over his hips. He was carrying his
belongings in a paper bag, like a homeless person. I tried to con-
vince Papa that Miguel needed help, but he wanted to change
the subject. Too many years in and out of jail. Those damned
drugs. He'd already done everything possible. Miguel would
never stop being Miguel. And he'd already given him up for
dead. He went back to talking to me about his plans. Great plans
for building. With the help of Farmers Home federal funds, he
was going to build the most ambitious residential complex ever
in Barceloneta. It would be called Artana, just like my grand-
father's hometown in Spain. But there were some problems with
flooded plots. They'd have to get them filled in, raise the
ground level a little. Where? There, Irene, opposite the Palmas
Altas house. The project of planting pineapples had failed.
What do you think about my putting up houses with parks and
everything? Stone on the balcony floors feels too cold on your
feet, I think I'll lay Spanish tiles. What do you think? I think it's
a good idea. I could see it all from memory.

I went back to the bathroom and before turning on the
faucet I decided to put on makeup, as if I were getting ready for
a party. I wanted to have lipstick on. The woman in the movie
*Bette Blue* made hers up in front of the mirror before plucking

out her eyes. And the mirror answered me back that everything was going to be fine. A little while later, on the toilet, that optimistic inner voice disappeared, as if it had gone down the drain when I pulled the chain, and in its place was the clear idea that perhaps I should kill myself. I felt a repugnance for my body. I'd felt it before already, ever since I was a child, but then it was a vague, subterranean feeling. Lately it had become something else, and it was blossoming on the surface. Maybe I was looking for it now. And there I was, studying the new idea, backward and forward, chewing on it like a mint. That same night I lay down in the bathtub with a book by Kierkegaard and a knife between my legs . . .

I was going to die and it wasn't an easy decision. I was prolonging the scene by painting my lips and reading Søren Kierkegaard, who almost always sees himself as if he were someone else and that someone else isn't always the projection of his persona. In a letter to his lover Regina Olsen, he talks about his near misses. I don't know if it's an evasive way of saying good-bye, but no sooner does a person get close to what he wants than he feels that he's forgotten something and moves away. Lately I was using the same tactic, I suppose because I hadn't truly lost the desire to live, even though I was holding a knife in my hand. I had my little list of things that held me back at the last moment. You've got to be excited by something, by somebody, except that in the end, the only excitement is the risk of dying. That's why maybe I decided it was time to go see the university psychologist. After all, I was too young to die.

—— I had to fill out some papers and answer strange questions. Did I drink? Smoke? Use drugs? Any recent abortion? Family history. I'd gone to get some sleeping pills. At least

that's what I told the psychologist in the reception area of the Counseling Center. But I really wanted someone to see my face. From so much looking at myself in the mirror I'd lost sleep. I wanted sleeping pills. But the psychologist let that pass and spoke in platitudes, as if nothing else mattered.

"So why do you need sleeping pills?"

"Because I haven't been sleeping well."

"I can see that. So why haven't you been sleeping well?"

What I said during my stay in that office was what I was feeling at that moment, the only thing I felt. We didn't get beyond the headache and the anxiety caused by exams. For the moment there was no reason to take any sleeping pills. I should take some chamomile tea for a few days and come back the following week—or maybe I wished to talk some more? I didn't know what else to say. Anyhow, I already had a good supply of pills. I left the office, said good-bye to the secretary, a little embarrassed, and went up University Avenue to the Geography Building.

Professor W. was waiting for me. The essay I'd written for his course on South African geography the semester before was incomprehensible. I could hear the collective voice of all my teachers asking me, "What's going on with you?" . . . That's how almost all my interviews began that last semester. Professor W. had expected a paper on Nadine Gordimer but instead he found ramblings about intertribal conflicts in New Zealand. What did New Zealand tribes have to do with Nadine Gordimer? I tried to explain, but I couldn't find the strength. Besides, he was right. Was I going to graduate without knowing how to write a paper? Well, they'd just add another F to my grades. Of course, I didn't have to explain those failures to anyone but myself, since I was living by myself. I went about by myself and sometimes I even talked to myself. Besides, Papa

had blind confidence in me. On the way home I stopped by the
drugstore on Marshall Street and bought a bottle of Tylenol, a
pack of razor blades that was hanging alongside the chocolate
bars, and a bottle of Jean Naté perfume to erase the smell of
detergent in my new place.

Armed with the Jean Naté perfume I spray the sheets
and the books, the walls and the floors. I also perfume myself,
even though it burns horribly because in winter my skin gets
dry and as it dries it splits open, and in the cracks the flesh looks
red and alive. When it gets dark I disconnect the telephone. I
read over essays from my first courses—Jean Franco's Sal-
vadoran mothers, who interested me so much when I was a
sophomore. I go back to a book by Kierkegaard. In July 1840,
he writes to his theology professor: "As I review my life I dis-
cover a continuity, almost a mastery of execution that owes
nothing to me. That is how it is: some act with coherence, I
have lately come to understand coherence after acting." You
can only act alone or hope alone. Kierkegaard knows that and
so do I. But a book is a book. What was I looking for? To feel
myself shaken as I do by the CARE photos that appear on tele-
vision from time to time? The only thing that's certain is the
cold, visible on the window, as sharp as a knife now. I decided
to make a mental note of a persecution dream I'd dreamt sev-
eral times: As I leave the house the redheaded man is walking
behind me. We cross the park and when we get to the shopping
area I know that he's following me; I quicken my step, but
when I get to the bridge he's on top of me and he takes out a
switchblade. As if it were the most natural thing in the world to
attack me, he cuts off my forefinger, and then my pinky. It's
useless for me to scream because I'm all alone. The man leans

against the wall, smiles, making obscene expressions with his mouth, and I know that he's Mama's friend, the man from the Volkswagen. My only hope is to save my thumb. With only two fingers a hand is like a pig's foot. I should run away. But I'm all alone . . . I'm alone in the kitchen and it's three in the afternoon and at that moment I decide to hang up the frame with Mama's picture. Hurry up, Irene. But first I'll fry some eggs, the only thing in the refrigerator, and I light the stove. Gas, it hadn't occurred to me. It must have floated in the air for a while. As I ate the eggs, I could still smell the gas. I made myself a glass of Quik malted milk and kept on smelling the gas. Why hadn't I thought of it before? I'd have to plug up all the cracks, close all the holes, cover all openings. I'd need rags, towels, curtains. Maybe it was time to go into the living room and open up all the boxes, change my clothes. I didn't want them to find me in my pajamas. And for that reason I'd gone back to the bathroom and shaved my legs. I wanted to take good care of my body in death since I hadn't known how to take care of it in life. A girl should always wear clean panties, Blanquita would say, in case she's hit by a car or something like that, so the doctor at the hospital shouldn't see her in dirty panties. How awful. I spread out a towel on the kitchen floor and lay down as if I were at the beach. Then I used the last sips of the malted milk to wash down the whole bottle of Tylenol and all the other pills. And then I downed a full bottle of Popov vodka. Then I closed my eyes and waited to pass out.

At first it's vertigo, the sensation of falling in space. Then comes something like a dream, but it's a different body that's dreaming. I can't manage to get a hold on the body or the dream. I was still awake. Asleep awake on the towel, feeling the

trembling in my legs at the mouth of my stomach, where nausea
starts. The feeling of vomiting is followed by heat on the palms
of my hands and in my arms. Finally sleep comes. I will die far
removed from everybody . . . From whom? I watched it com-
ing. Sleep had been difficult before, now I was able to sleep on
the towel. Nausea, everything turns off, including the light in
the kitchen, and like someone waiting for death, you turn onto
your side, resting your hand on your cheek facing the wall and
in your thoughts the wall looks like a scene out of the Last Judg-
ment. It's still early, you've still got the strength to get rid of the
fear and turn around. The world has closed in, the distance
from your nose to the cold wall is the only measurement that
exists. And as you breathe, a swirling appears in the darkness, a
tunnel, and beyond that, a circle of sky. Up above, nests can be
seen, and the wasps are flying around them, one after the other,
in the thousands. Where can the broom be? Mama is calling me
from the balcony. A fine white powder is falling from the wasp
nest and it clouds my vision. Go put some Visine drops in. How
many times have I told you not to look up when you come into
that room? Hurry up, Irene, hurry up. The land crab goes in and
out of his hole, looking for garbage. I wait for him, huddled
against the wall with a noose of taut rope. When he comes out
I'll catch him with the noose or with a pot of boiling water. If
you pour it out little by little he'll have to come out. Hurry up,
Irene, the red ants are advancing, they're climbing up the back
of a book, they're climbing up my chest, my belly, one of them
gets lost in my navel and can't find its way out. There is no way
out. It's a night with a full moon, and on the road to Palmas
Altas a cow is swinging its tail and looking at the automobile,
which is all lit up. Mama has gotten out to chase it away. She tells
it to get off the road and let us get home. They look at each

other, and the cow retreats, very slowly, looking at Mama all the while. It persists in blocking our way. Mama blows the horn several times. I can barely move my head to see who it is. Out of the darkness, or the dream, comes the sound of footsteps. There are people on the stairs, voices coming up the stairs, it's no longer a nightmare, but it's all the same to me. According to the landlord there must be a leak somewhere. Where? I don't know. I've got a little girl. Open the door! I could barely remember anything about the day before or any of the other days, but I do remember the little girl, and my struggle to wake up. I could see her in her crib. It's early in the morning and it's cold. I pull myself out of my sleep. I leave the kitchen, away from the smell of gas that fills the place. I've still got time to turn off the gas jet and take away all the rags and towels in the kitchen.

I was trying to explain myself through what I felt for the child. From my guilt. That's how I lived through what had just happened in my place on Buckingham Street. In any case, that's how I was trying to explain it to myself. I must have been a typical case for the psychologist. They dream, they deprive themselves, they fall apart, they hate themselves, one day they hate themselves too much, and one day they kill themselves. But I'd gone to his office because I felt humiliated for what could have happened to the little girl. And to me. Well, that's what I felt when I ran out of the house without a coat. Because I was more afraid than cold and the only thing that occurred to me was to go back to the psychologist's office. I wanted to tell the truth about what had happened because I wanted to get out from under the guilt. And while I was telling the psychologist about the knife and about the gas and about other things, he kept coming closer. Not to hear me better—he already knew every-

thing—but to get something out from inside himself. He puts one of his hands on my knee; with the other he discreetly presses a buzzer that they must hear in some other room in the building. He looks at me, worried because I've been trembling since I came into his office. He observes my disheveled look. My confusion. I'll have them bring some clothes from your place. I don't understand. Someone knocks at the door. Then he informs me that according to the laws of the State of New York he couldn't let me leave his office. They're still knocking at the door. I don't know whether out of pride or because I felt rage, but I told him that I refused to accept what he was saying, because I wasn't crazy. That if I'd really wanted to kill myself, I wouldn't have come to see him.

I could make a phone call if I wished. Then, when there was nothing more to say, the door opened and two guards with walkie-talkies came in.

It's one of my last sessions, and Dr. O. says that in order for the cure to be effective it's got to entail a radical change, a kind of metamorphosis, and that will only be possible if I stay another six months in the hospital. Six more months with her, that is. Then we talked about passes. I spend almost the whole session trying to convince Dr. O. to give me two passes in one, one for the week ahead and one for today. My room's become too small, the floor, I want to get out.

All right. Back at five o'clock.

Miss Boyd pokes her smile through the door. I'll be able to use the unit's electric razor now. It's a privilege accorded only to patients who are ready to leave. Or to those who've been cured.

"It won't be easy. It will take time, a lot of time, maybe a

*whole lifetime, but you've already uncovered a large part of the clues."*

*"I know it won't be easy. But just the same, I want to leave."*

*"Why?"*

*"I want to be with my family in Puerto Rico." Etcetera, etcetera. The pretexts. She's giving me my first prenatal classes. Breast-feeding. Very important. Natural childbirth. Painless birth. What do I do now? The peanut butter, where's the peanut butter? She's realized that the lesson makes my nausea worse. But she's going to talk to Dr. O. Don't worry. Tell me, Irene, have you given it any thought? Miss Boyd will never know how much I thanked her for that question.*

*Dr. O. had said again that six months in the hospital would be the ideal time. Six months meant August.*

*"But I'll give you your release because you say you're going to your father's house." Only for that reason. And because you've got to take care of your pregnancy.*

*I couldn't tell her the truth then. Maybe she didn't even know herself. But for Dr. O. motherhood must have been the antidote for sadness. Underneath it all, the old version of hysteria. After all, she was a daughter of Hippocrates. I'd begun to like her; she'd begun to like my pregnancy.*

*"You have to know that your examination three days ago still shows traces of psychosis."*

*An autistic fantasy life.*

*When you leave you will have to consult Miss Boyd regularly and see a doctor twice a week and . . . She must have suspected that it wasn't my intention to go to Puerto Rico. We'd gotten to know each other. I learned that I had to speak in enigmas, and she accepted that her function was to see through those*

*enigmas. But toward the end, dialogue became difficult. We couldn't fool each other anymore.*

*"Let's suppose," she said, "that your nightmares come back someday, the grief . . . What will you do?"*

*In spite of everything I felt relieved at being able to talk about that once more, even if it was to review the list of refuges Miss Boyd had made me memorize.*

*1. Hutchings Outpatient Clinic*
*2. Upstate Hospital Emergency*
*3. 4B*
*4. Miss Boyd*
*5. Transitional Living Services*
*6. 911*

*Very good.*

*Today, if all went well with Dr. O., it would only be a matter of going up the hill to the Quad. I'd make peace with Hendricks Chapel. I'd sit on its steps and organize my schedule for the next few days. I knew already that I wouldn't graduate in May, but that didn't bother me. At least there is no snow on the street, and besides, the sun has moved past the sky, past the blue, and gold glowing leaves behind my tarnished thoughts.*

SAM. *Little by little, my friends are leaving. First it was Madame K. Today Sam's parents are coming to get him, tomorrow Jenny's, then Ana's husband . . . A question is making the rounds of the fourth floor. What will Sam do when his parents arrive? Will he be able to resist the temptation? No, Jenny says, he'll kill them. No way, says Ana Mani, it's all a pretext. Sam likes the hospital. And I, who have discussed the matter with her at length, say that*

*in my opinion Sam is a closet surrealist. What's that? Dali? Yes, Dali. It seems that he doesn't leave his room now and spends the whole day packing his bags. You know, I don't believe he's thinking about killing his parents. What a pity, Jenny says. Well, who knows? All that time we were talking in the hall, he was packing his bags in the room. His parents finally arrived, a little before lunchtime. His mother came in first, and it was a scene of strong hugs and lots of tears. Then Sam showed them his room and gave them a general tour. The good host. Then I realized that Ana was right. Sam liked the hospital. After the introductions and the greetings, he said good-bye to each of us as if he'd been vacationing at a hotel in the Swiss Alps and was leaving with the promise to come back. Maybe next year.*

JENNY. *Jenny's leaving was one of the saddest, almost a nightmare. When she left we couldn't tell whether it was a person or a bundle they were taking away. Jenny was in her room when they told her that her family had arrived. They were coming to get her, they said. But it wasn't true; they were coming to torture her. That's what I felt when they arrived. When I saw them, first her father and then her stepmother with a little girl in her arms, I understood what Jenny's life was like. Jenny wanted to hug the little girl, kiss her. But her stepmother wouldn't allow it, and when Jenny protested—after all, it was her daughter—her father ordered her to be quiet. Finally he picked up the suitcase, took his daughter by the arm, and pushed her along to the elevator.*

*Jenny's problem wasn't with being a mother, it was with being a daughter.*

ANA. *Ana, on the other hand, left as happy as could be. It was obvious which of the two Anas was leaving. The happy one, with her*

*husband and three children running after her. When she said good-bye, she stood looking at me and asked if I'd made my mind up. I was evasive. Yes and no. But I would be leaving soon too, and everything was going to be all right. Ana scratched her head, and while we kissed, she whispered to me, so that Miss Boyd wouldn't hear. Don't think about it for too long. Either you follow through with the pregnancy or you don't. And if you want my opinion, you shouldn't. I'll give you my telephone number just in case.*

IRENE. *I left like Odysseus, the way one always leaves a labyrinth, traps, encirclements: by means of a subterfuge. I said I was going to have the child. The doors of the elevator were closing when Miss Boyd came running, her voice breaking, asking me if I really was going to leave the hospital without saying good-bye. She handed me a cassette with meditation exercises and said they would protect me from the "cloud," as she called my anguish. When you see it coming, listen, and remember to close your eyes. Thank you. Good-bye, Miss Boyd. A kiss. Thank you. Miss Boyd stood looking and smoothing her skirt as the elevator doors closed.*

*Outside, the sky was still as firm and blue as the sky of forty days before. It seemed like a joke, as if there were no other sky in the world, nor any other light but that one.*

⬿ *I didn't go home to wait out the term of my pregnancy. I went to make an appointment with the gynecologist for the abortion. Then I passed by the library. They were selling caps and gowns and graduation pins. It would be my turn soon enough, someday. At home the landlord had left my mail in a pile on the stairs. In it was a letter from Professor T. in which he informed me that I had received an F because I hadn't turned in his dead peo-*

*ple. It doesn't matter. I made the appointment with the doctor; a few days later I canceled it, then made it again. One night, not knowing what to do, I took an overdose of a cathartic. In the morning I made breakfast, and when I sat down at the table I felt a very sharp pain in my abdomen, a jab, and I was only able to cry out when the flow of blood came on as though something had broken open inside me. It was a watery blood, I almost slipped on it; I vomited, and I could barely manage to hold on.*

MISCARRIAGE. *I tried to close my eyes. In the hospital room four men were talking to me. They wanted me to close my eyes and go to sleep. I kept on watching them. One of them was silently searching for the vein in my forearm without much luck. An oxygen mask covered my face. Down below, between my legs, I thought I felt cold pinches and everything began to turn into a dialogue between the needles and my body, and the operating table might just as easily have been a dissection table. Was there a sewing machine nearby? Little by little the room and a green washbasin in the rear faded away, as did the voices of the men. The pain also disappeared. Time too. I no longer felt myself rooted to anything on earth. My only links were to the metal railings on the gurney . . . time, the hands on the clock flowed on, the memory of something that had ceased to exist. I was able foggily to make out a body, someone with glassy eyes pushing the gurney along the hall.*

# EPILOGUE

The Sirens: a very dangerous species, especially at noon, the time when the sun is strongest. Homer doesn't say how many of them there are, he only describes the fascination that their song produces. But further on, he will suggest that there are three of them: Ligeia, Leucosia, and Parthenope. All daughters of the sea seem to come in threes: the Gorgons, the Hesperides, the three Graeae (a single eye and a single tooth among the three). There are those who refer to them as the three moons of the lunar cycle of Indo-European myths: crescent moon, full moon, waning moon. Nine is likewise important because each of the three Sirens, or cycles, carries within the other three: the little girl, the nymph, the old woman.

It is said that they lived among skeletons and that Aphrodite, in anger, changed them into monsters for refusing to love

either men or gods. It is also said that in the beginning, when they had something birdlike about them, they challenged the Muses to see who could sing better. They lost and the Muses took their wings.

What did the Sirens sing? There was but one witness, Odysseus. The Argonauts, in order to avoid temptation, preferred to concentrate on the dulcet song of Orpheus. But Odysseus, on the advice of Circe, ordered the ears of his sailors plugged and had himself tied to the mast of his ship in order to hear that somber song and not succumb. They sang with such sweet voices that no sailor could resist. And they built their nests out of the skeletons of sailors fascinated with the beyond, the place of total silence.

⟶ I had to use a subterfuge because my story wasn't Dr. O.'s. The hospital, for me, was the only place where nothing was asked of me. Until they began to ask, and then my only recourse was not to tell them the truth. When the psychologist showed me the card with the resplendent sun, I knew the answer he was looking for, and I said Hell. When the doctors questioned me, or when Dr. O. wanted to know what I was going to do about my pregnancy and showed me the picture of a little girl with an enchanting look, they were also saying, Hurry up, you can only be one of us. They were the Sirens too. Except that their songs were not as seductive.

To defend abortion is absurd. It brings with it an equal dose of life and death, like those gods in the Gita, a birth can be like a death and a death like a birth, it depends on the side of life one wants to be on. And I was carrying much more death inside than that abortion could produce. But it would be just as absurd to say that a person is prisoner of her fate as to say that she has

managed to escape it . . . Besides, I knew what fate is. You make
a decision, and that leads to other decisions, and one fine day
that is your life. But you can escape the fate that others—doc-
tors, family—want to impose on you. Telling Jenny's father no.
Breaking with the congealed expressions we carry inside. The
question is whether or not you want to make up your own ex-
pression. And say it (. . . I can be her, she can be me, one can al-
ways edit oneself, one can always abort).

The cloister, like prison, is not always a punishment.
Sometimes it has the virtue of being all paths. Sometimes none
at all. The road to Damascus was that for Saint Paul: a no-man's-
land from where he was able to begin again. Grandmother
Lolita was tortured and raped in the prison at Alderson, but
when they left her alone she knew how to find her voice in soli-
tude. Mama was a free woman in Puerto Rico and she ended up
flung onto a road like a character in a gothic novel.

I carried models, ways of offering the body as something
given in exchange for something one wants: to be accepted,
loved, the so-called "love" of some people. At the university it
was constantly necessary to choose classes, friends, lovers. The
future. And the only thing I had to offer was a family history
and my body.

It's just as hard to know how to be young as to know how
to grow old.

Blacklisted by repetitions.

When I left the hospital I knew it wasn't easy to change.
But what can you aspire to? At the end of the *Diary of a Seducer*,
Johannes (read Kierkegaard) writes to Cordelia (read Regina
Olsen) to tell her that he's going to leave her and that it's irre-
mediable, but that if he were God, to save her he would do what
Neptune did with the nymph, change her into a man. I didn't

want to be a man. I wasn't looking for power or revenge. I wanted to try other ways of being.

And so I began to write, bits and pieces and self-figurations, as if by writing "I"—the much despised "I" of Virginia Woolf—a personal history would become a valid, legitimate source of progress and direction. But the bits and pieces of this pronoun became the life stories of my grandmother and my mother, all kinds of stories set free to roam like a medieval incubus, impregnating everything it touched in its cruel transmigrations. In these exchanges my grandmother Lolita, the Puerto Rican heroine, the public figure, the invariable one, straight out of José Martí's tradition, a woman who dreamed a nation, who used the epic "in the beginning," who abhorred dependence, cannot evade my mother, the erratic, inconsistent one, who stood and walked in bleached jeans, topless at times, at others barefoot, wearing Afro wigs, who dreamed marvelous love stories, who liked idle talk, who longed for dependence . . . Of the two characters my mother is perhaps the closest to me, though not because of her disposable 1960s traits but because of her fascination with getting lost, which she had done since a little kid throughout till her death, continually getting lost in order to be found, to be born again, thriving like this always at the edge, truly *caribeña*.

My grandmother, in turn, goes on along the path of the hidden romantic seeker of that cultural past which has been violated and buried; sentinel of a majestic cemetery, she safeguards the corpses that make up the nation we never had.

For a while I wondered how it would have been if I had been able to arrest Mother's leap, to stop her from dying—if my strength had been greater than hers. But, as I myself approach her years, as I recall my college readings, I suspect one thing:

that perhaps my mother's death was not necessarily my doom but my redemption. Her lost-and-found game and eventually her death granted me the most precious image. Before the psychologist declares her a casualty, hiding her behind a diagnosis, I prefer to write about her as lost, *an empty nest that was once inhabited* . . . Mother has died, therefore I am. Not a nation, it is true, but a presence that remains. A book.

"Haddock and sausage meat," Virginia Woolf wrote, "I think it is true that one gains a certain hold on sausage and haddock by writing them down."

The song of the Sirens is the great paradox that suicides and madmen know. It is the paradox, too, of every book on suicide written by suicides: they make their nests from the skeletons of dead authors. It's contagious—beware.

# NOTE

In the afternoon of September 21, 1994, my brother Miguel, not yet thirty-four, was buried in the town of Barceloneta, Puerto Rico. We were all present there, as we had been seventeen years before. Looking at each other, it was clear that more than in my brother's facial scars, the drugs' random violence lay in those seventeen years, in the mounting longing that echoed in them: a housing project; a bus stop; a drug needle; a ditch; a small, skinny body, arms reaching out; and somewhere a last thought, that separation from a loved one is the most painful foretaste of death. So it was that 1994 could as well have been 1977, after my mother's funeral, my brother on the steps of the house at Palmas Altas, so sunk in thought he does not hear me calling him . . . Back and forth between Grandmother Irene and the others, I saw his longing fade into the drug haze, so that it became difficult to know what it was he wanted. Eventually we all decided it was the drugs, and the case was closed. For a while he fared well enough, between one more jail sentence and one more promise of recovery. Only Grandmother Irene saw the quiet decline behind the noisy progress. Only she, tapping into that first love of theirs, knew in her heart that this was fate, and she gave all she could to assure that her truest of children would be loved to the end of his descent. Still, as his casket was lowered above that of our mother, few realized that a circle had been completed.